D0945921

THE PLACE OF THE ANTIQUE IN EARLY MODERN EUROPE

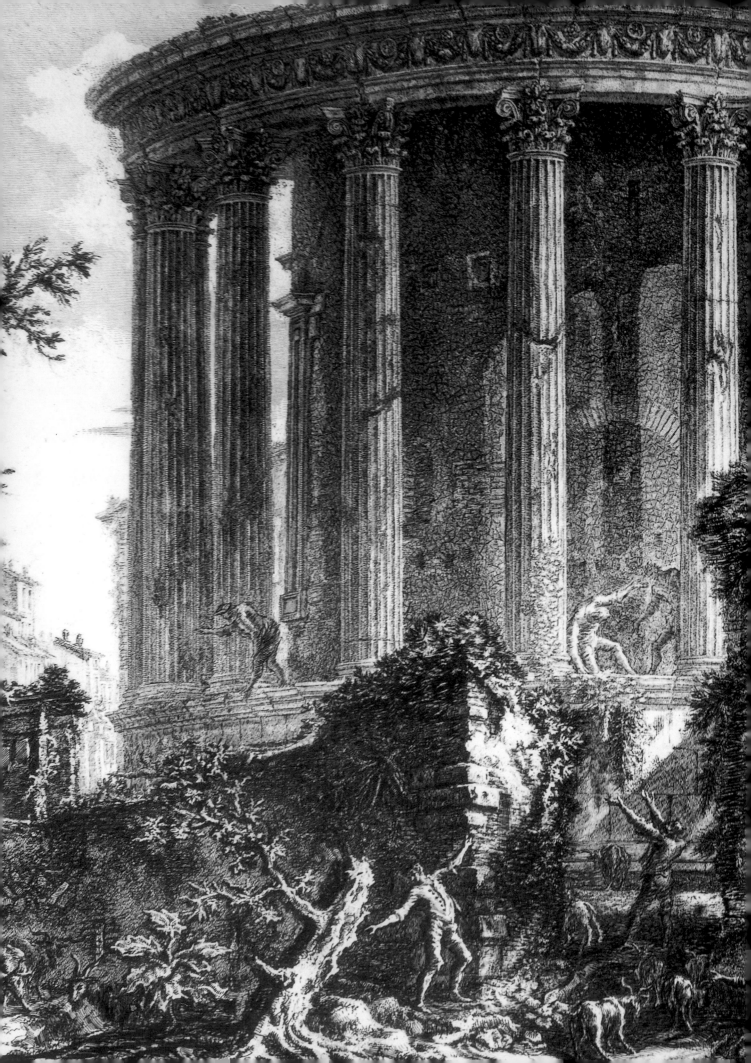

THE PLACE

OF THE

ANTIQUE

IN

EARLY MODERN

EUROPE

Ingrid D. Rowland

WITH CONTRIBUTIONS BY

Craig Hanson, Noriko Matsubara, Mario Pereira, and Allie Terry

THE DAVID *AND* ALFRED

SMART MUSEUM *OF* ART

THE UNIVERSITY OF CHICAGO

Catalogue of an exhibition at
The David and Alfred Smart Museum of Art
The University of Chicago
23 November 1999–29 February 2000

The research for this catalogue was funded in part by
a multiple-year grant from the Andrew W. Mellon
Foundation to the Smart Museum to encourage inter-
disciplinary use of its collections by University of
Chicago faculty and students both in courses and
through the format of special exhibitions. Funding
was also provided by the Acorn Foundation, Inc.

Design and typesetting: Joan Sommers Design
Production and Copy Editor: Elizabeth Rodini
Printing: C & C Offset Printing Co., Ltd, Hong Kong

Cover: detail of Louis Dupré, *Portrait of M. Fauvel*,
1980.33 (see cat. no. 55) and Giovanni Battista
Piranesi, *Temple of the Sibyl*, 1982.6 (see cat. no. 44)

Photography Credits: Photography by Tom Van Eynde
unless otherwise noted; cat. nos. 3, 4, 8, 12, 14, 15, 19,
24, 28, 30, 32, 35, 53, 54, and fig. 3, Smart Museum
Archives; cat. no. 27, photograph © The Metropolitan
Museum of Art, all rights reserved; cat. no. 48, photo-
graph by Robert Hashimoto, © 1999, The Art
Institute of Chicago, all rights reserved; cat. nos. 2, 23,
and 54, Courtesy of the Department of Special
Collections, University of Chicago Library; cat. nos.
36 and 37, Prudence Cuming Associates Limited,
London, with permission of the lender; fig. 1, Venice,
Biblioteca Nazionale Marciana/Foto Toso; figs. 2 and
4, New York, Alinari/Art Resource; fig. 6, V&A
Picture Library.

Library of Congress Catalog Card Number: 99–75837

ISBN: 0-935573-28-3

TABLE *of* CONTENTS

CONTRIBUTORS TO THE CATALOGUE

JG Jean Goldman
CH Craig Hanson
NM Noriko Matsubara
MP Mario Pereira
ER Elizabeth Rodini
SR Stefania Rosenstein
IDR Ingrid D. Rowland
AT Allie Terry

A NOTE TO THE READER

All works are in the collection of the David and Alfred Smart Museum of Art unless otherwise noted. Height precedes width precedes depth in all measurements unless indicated.

FOREWORD *AND* ACKNOWLEDGMENTS

The Smart Museum of Art is pleased to present the exhibition *The Place of the Antique in Early Modern Europe*, and grateful to Professor Ingrid Rowland for defining and undertaking the project. The exhibition's aim is to show the influence of antiquity (or a particular historical conception of antiquity) on a range of artistic production in Europe during the sixteenth through eighteenth centuries. The exhibition and its accompanying catalogue also endeavor to highlight the various contexts in which antiquity served as an inspiration: from the use of Ovidian myth to influence on religious practices, antiquarian and proto-scientific scholarship, and the papal banquet.

The Place of the Antique in Early Modern Europe is one in a series of projects made possible by a grant from the Andrew W. Mellon Foundation to encourage innovative uses of the Smart Museum collection by University of Chicago faculty and students for teaching and research. This topic was the focus of a graduate seminar taught by Professor Rowland in 1998; she and her students have since continued their work to choose objects from the Smart collection complemented by several key loans, to research and write the catalogue, and to plan and install the exhibition. The goals of the Mellon grant—to give students and faculty members the opportunity to think about museum objects in a thematic context, to provide a forum for student research and publication in a museum context, and to give students an insight into the work-

ings of a museum and the many considerations involved in mounting an exhibition—allow the university art museum to play its unique role as an educational institution fostering study and research and bringing the fruits of those enterprises to a broader audience.

This exhibition is also significant for the Smart Museum because it inaugurates our new Old Master Gallery, created as part of our Silver Anniversary Renewal Project. This renewal of the museum, which includes a renovation and reinstallation of all galleries, public spaces, and art storage areas, has resulted in an entirely new presentation of our collections, with a focus on significant art historical and cultural themes, rather than a strict chronological display. The Old Master Gallery, in particular, will feature more frequently changing presentations of thematically organized exhibitions drawn from our significant collections of classical, medieval, Renaissance, and baroque painting, sculpture, and decorative arts.

We are grateful to many people who contributed to the realization of this exhibition. We thank Ingrid Rowland, Associate Professor in the Department of Art History, who conceived the project and eagerly undertook it. Her seminar students Craig Hanson, Noriko Matsubara, Mario Pereira, and Allie Terry helped to choose the objects for study and exhibition, and wrote catalogue entries and essays under Professor Rowland's guidance; we thank them for their

Foreword and Acknowledgments

hard work and persistence. We are also grateful to Stephanie D'Alessandro, former Coordinating Curator for Mellon Projects at the Smart Museum, and Mellon museum interns Christine L. Roch and Stefania Rosenstein, Mellon research intern Jennifer Haraguchi, as well as Smart staff members including Senior Curator Richard Born, Registrar Jennifer Widman, and Preparator Rudy Bernal. In the Department of Special Collections at the University of Chicago's Joseph Regenstein Library, Curator Alice D. Schreyer and Valarie Brocato, Exhibitions and Conservation Supervisor, also advised us on many aspects of the project with their customary knowledge and skill. We also thank Paul Sereno for his interest and advice.

We are also most grateful to the lenders, whose generosity in parting with objects that are crucial to our presentation is much appreciated. These include Steven and Jean Goldman; the Metropolitan Museum of Art and especially Associate Curator Clare Vincent and Curator Clare Le Corbeiller of the Department of European Sculpture and Decorative Arts; the

Art Institute of Chicago and Ghenete Zelleke, Curator of European Decorative Arts; the Newberry Library and Associate Librarian Mary Wyly; the Department of Special Collections at the University of Chicago; Ingrid Rowland; and the anonymous lender of three important baroque bronzes.

We also thank the Acorn Foundation, which provided additional research funding for this project, and the Kress Foundation for funding conservation of the Farnese Reliquary.

Finally, we thank Angelica Zander Rudenstine, Senior Advisor for Museums and Conservation at the Andrew W. Mellon Foundation, who made this project possible and encouraged its development, and our Coordinating Curator for Mellon Projects Elizabeth Rodini, without whose intelligent guidance and hard work this exhibition and catalogue could not have been realized.

KIMERLY RORSCHACH
Dana Feitler Director
Smart Museum of Art

We would like to thank the Metropolitan Museum of Art, especially the Curators Clare Vincent and Clare Le Corbeiller, for generous permission to study the Antonio Gentili tableware. To the Pierpont Morgan Library, William M. Voelkle, Curator and Department Head of Medieval and Renaissance Manuscripts, and Roger Wieck, Curator of Medieval and Renais-

sance Manuscripts, our thanks for permission to study the Farnese Hours. To Andrew Butterfield, Anthony Grafton, and John Marino, thanks for expert advice and eloquent inspiration. Thanks to the Mellon Foundation and the Acorn Foundation for underwriting our research.

INGRID D. ROWLAND

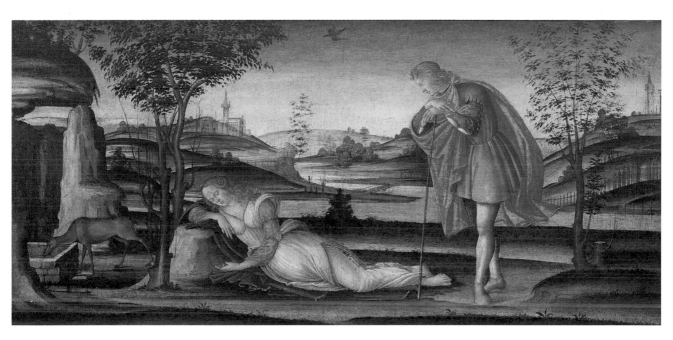

Plate 1
MASTER OF THE APOLLO AND DAPHNE LEGEND
Daphne Found Asleep by Apollo, circa 1500
Cat. No. 6

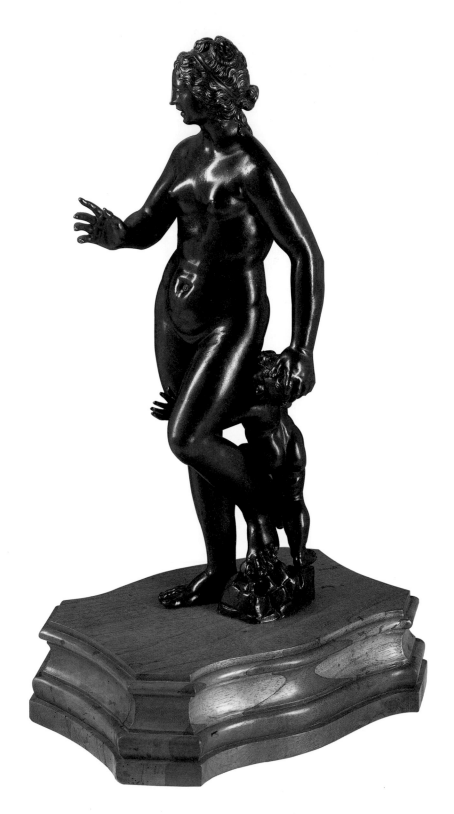

Plate 2
FRANCESCO FANELLI
Venus Chastising Cupid, circa 1635
Cat. No. 10

Plate 3
PETER FLÖTNER
Mars as a Sign of the Zodiac, circa 1540
Cat. No. 18

Plate 4
WORKSHOP OF ORAZIO (?) FONTANA
Birth Bowl (*Ciottola puerperile*), circa 1575
Cat. No. 21

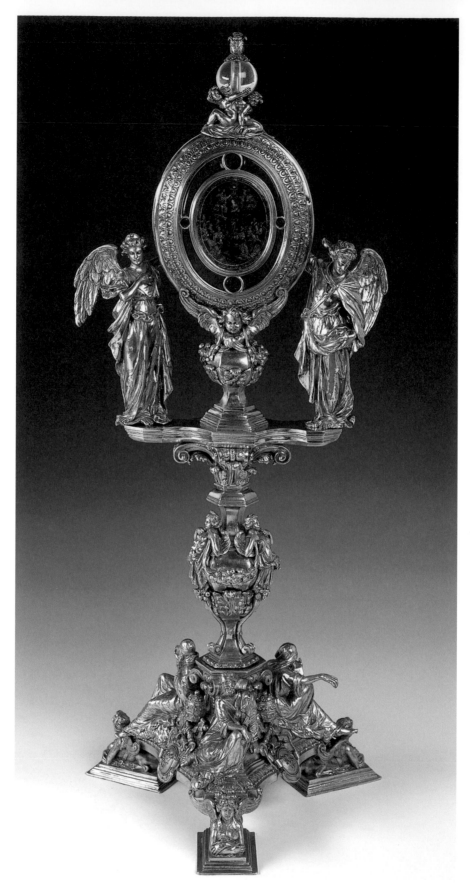

Plate 5
Attributed to
ANTONIO GENTILI DA FAENZA
Farnese Reliquary, circa 1550
Cat. No. 26

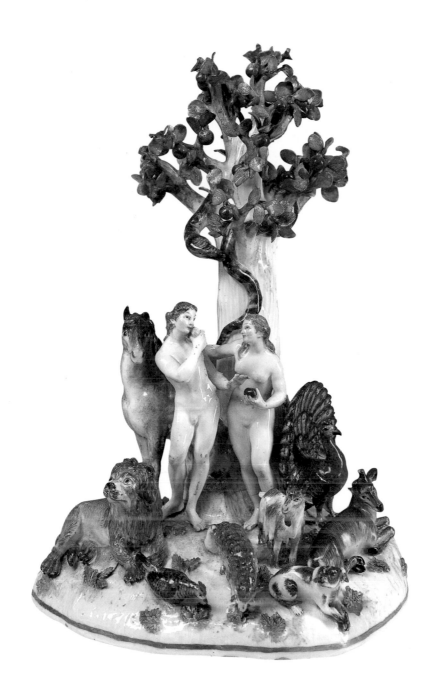

Plate 6
JOHANN FRIEDERICH EBERLEIN (modeler)
Adam and Eve in Paradise, 1745 (design), 1774–1813 (execution)
Cat. No. 47

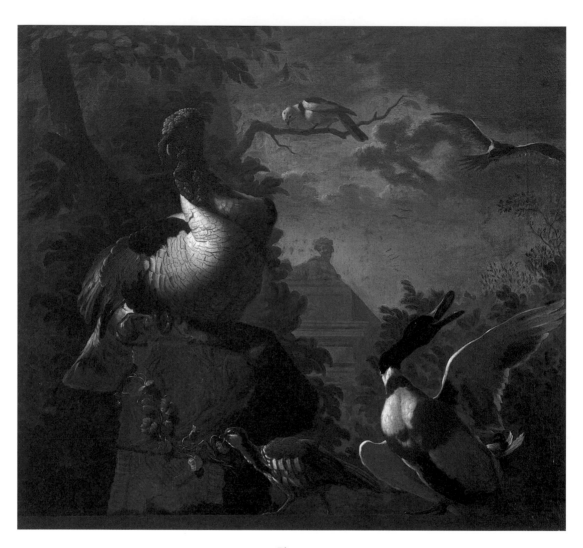

Plate 7
PHILIPP FERDINAND DE HAMILTON (?)
Wild Turkey, circa 1725–1750
Cat. No. 51

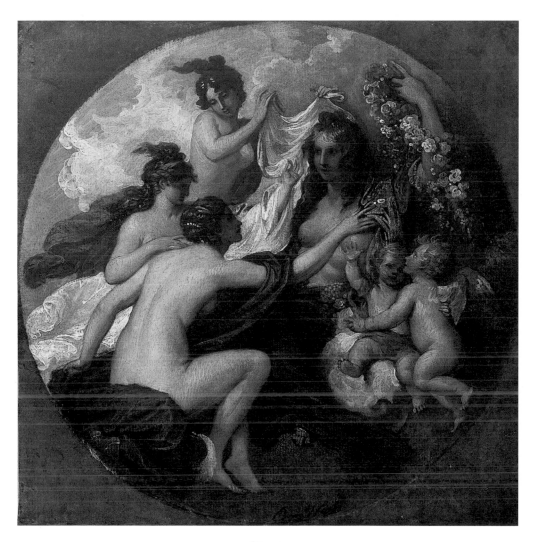

Plate 8
BENJAMIN WEST
The Graces Unveiling Nature, circa 1780
Cat. No. 52

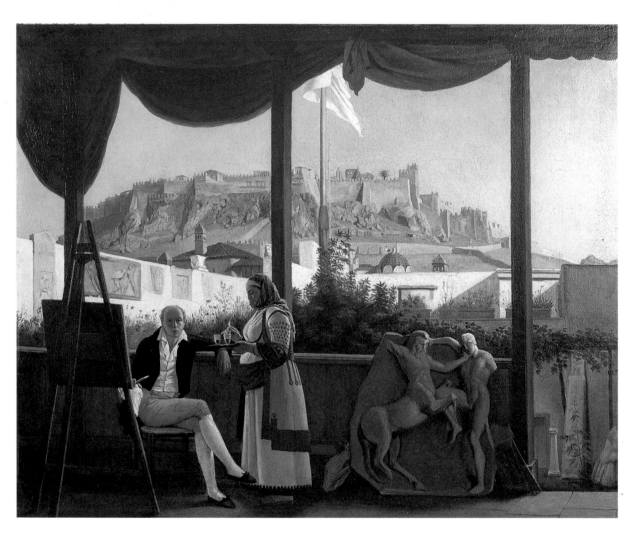

Plate 9
LOUIS DUPRÉ
Portrait of M. Fauvel, the French Consul, with View of the Acropolis, 1819
Cat. No. 55

THE PLACE OF THE ANTIQUE IN EARLY MODERN EUROPE

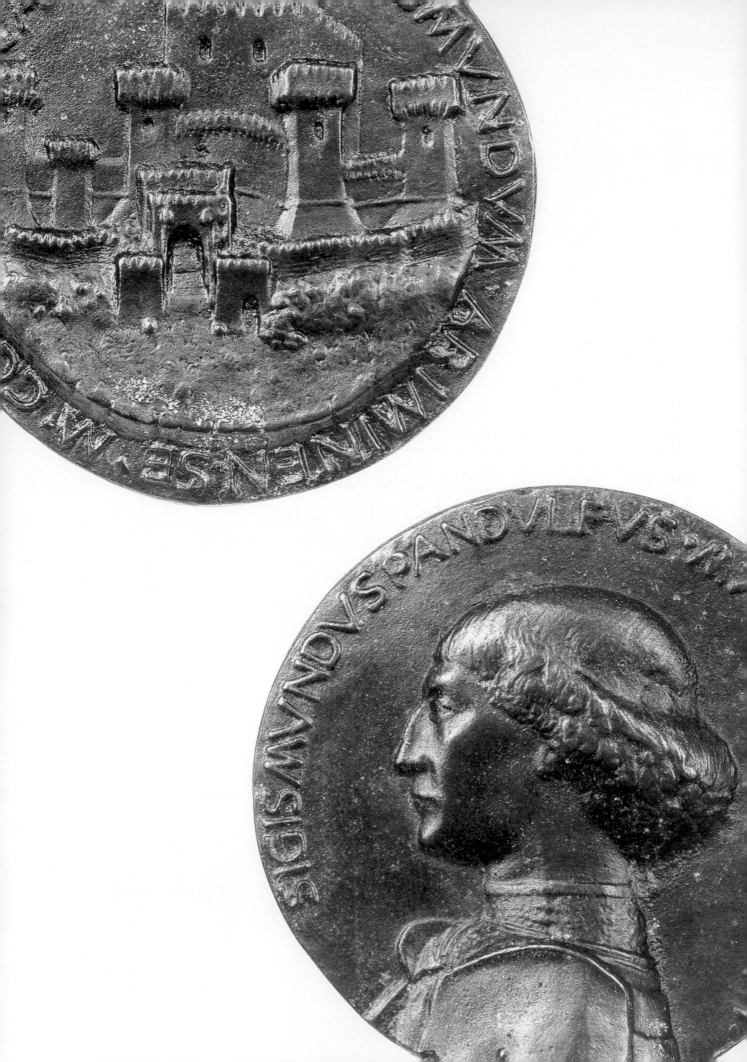

THE PLACE OF ANTIQUITY

INGRID D. ROWLAND

Ascholar's desk, a warlord's castle, a pope's altar, the mouth of a volcano: in the minds of early modern Europeans, all these places conjured up the memories of more ancient times, of Greek philosophers, Roman emperors, Hebrew prophets, Egyptian pharaohs, and Persian magi. To some extent, this consciousness of history was inevitable for people who lived among the imposing physical remnants of their ancestors' world. The medieval merchants who built the Leaning Tower of Pisa and the Baptistery of Florence in the eleventh century believed that they were carrying on the architectural traditions and republican mores of their ancient Etruscan and Roman forebears, as, in many respects, they were.

Their fifteenth-century descendants, however, turned a general awareness of the ancient past into an obsession, an out-and-out rivalry with the *buoni antichi*, the "goodly ancients" who seemed to have lived so long and so elegantly amid their beauteous surroundings, whether herding sheep in sylvan Arcadia or haranguing the masses in bustling Rome.[1] At the same time, fifteenth-century Italians hoped to best the ancients by leavening their revival of classical elegance in art, writing, and manners with the revelations of Christian faith. When they described their own age as one of rebirth, they meant both the restoration of ancient splendor and the specifically Christian awareness of having been "born again" in spirit. Their idea of Renaissance, built on a vision that transcended differences of time, geography, language, religion, and culture, soon proved infinitely adaptable to local conditions elsewhere in Europe: English poets could write as bucolic Greeks, seventeenth-century Flemings counted themselves among the twelve tribes of Israel, while the Swedish physician Olof Rudbeck revealed that

his native land was none other than Plato's lost Atlantis. The magnificent ruins of Rome lured learned tourists from all over Europe, who sketched and explored and frequently stayed for years. The beauties of the Bay of Naples inspired both the ancient poet Vergil and his sixteenth-century emulator Jacopo Sannazaro. Into the ever-active crater of Sicily's Mount Etna, the ancient Greek philosopher Empedocles, the sixteenth-century Venetian writer Pietro Bembo, and the seventeenth-century Jesuit mathematician Athanasius Kircher all poked their inquisitive heads, and if Empedocles fell in, leaving behind only a single brazen sandal, Bembo and Kircher emerged alive to tell their thrilling tales.

For Kircher especially, as for so many of his contemporaries, antiquity and Nature served in similar fashion as signposts to the larger order of God's plan for the universe. Psalm 19 asserted that "the heavens declare the glory of God, and the firmament showeth his handiwork," just as the ancient Roman writer Vitruvius used the structure of the cosmos to praise Nature as the supreme architect. Wise King Solomon, like Vitruvius and before him Pythagoras, noted that Creation expressed its divine arrangement in quantitative terms: "For Thou hast disposed everything in number, measure, and weight" (Wisdom 11:21).

As a result, quantitative science initially seemed to confirm rather than contradict ancient authorities in the minds of its early practitioners. Even in the aftermath of open breaches between science and religion like the trial of Galileo, seventeenth-century thinkers like Athanasius Kircher still strove to soothe the conflicts between theology and empirical research, hoping that Nature and the ancients could still serve in tandem as secure authorities for the conduct of life. Indeed, as a general rule, the Renaissance impulse to look to the past for inspiration did not necessarily interfere with the ideas of change and progress: no citizen of early modern Europe harbored serious thoughts of abandoning the

magnetic compass, Hindu-Arabic numerals, or New World delicacies like tomatoes and chili peppers. Besides, both the Bible and the ancient writers of Greece and Rome traced the world's carefully calibrated evolution from primitive barbarism to the arts of civilization, mindful that the Egyptians had insisted to generations of Greeks, Romans, and Hebrews that every invention of value had been discovered first along the banks of the Nile.

Our exhibit traces the European revival of antiquity from its origins in the fifteenth century and the flourishing of the movement known as humanism through the Enlightenment of the eighteenth century. A figure like the Italian warlord Sigismondo Malatesta (cat. no. 1) exemplifies the courtly setting so characteristic of the fifteenth-century Renaissance: working from his base in the small city-state of Rimini, the handsome, ruthless Malatesta hired scholars, poets, the painter Piero della Francesca, and the brilliantly versatile artist, writer, and architect Leone Battista Alberti to commemorate his exploits in story, song, poem, paint, medals, and a mausoleum, as if he were an ancient Roman emperor rather than a precariously situated mercenary captain. At the same time, he himself designed fortifications to accommodate the latest innovations in weaponry. A character like Sigismondo Malatesta read the ancient world as an elegant precedent for his own ambitions, an allegorical pattern devised in another age that nonetheless could serve to guide his conduct in the fifteenth-century here and now, especially his voracious pursuit of fame. With the help of Alberti, Piero della Francesca, and a team of other artists, he transformed the Franciscan church where he was eventually buried into a "Malatesta Temple," in whose chapels the ancient gods and goddesses represented the planets of the heavens and the seasons of the year, and where Sigismondo was immortalized in harmony with their eternal cycles. Unfortunately, the intensely personal emphasis of his patronage and his impetuous

personality virtually guaranteed that his grand projects died with him.

Patrons like the Medici in Florence and the papacy in Rome conceived still more ambitious projects, as they could use established institutions to sustain sponsorship of the arts over generations; for Medici aristocrats, popes, cardinals, and their legions of hangers-on, the ancient world provided symbols of timeless stability just as it had for the more evanescent figure of Sigismondo Malatesta. Another important institution for the propagation of the arts was a medieval innovation that drew its ultimate inspiration from ancient examples like Plato's Academy and Aristotle's Lyceum: the university. A wonderful example of the university's role in maintaining interest in the ancient world can be found in the margins of a precious manuscript of Vergil's collected works, copied in the late fifteenth century and lent to this exhibition by the Newberry Library (see Appendix). This elegant parchment book has been given a lovely calligraphic look by its scribe, but the subsequent owner has covered margins and space between the lines of Vergil's poetry with copious notes in a tiny, meticulous script. The content of the notes shows that their writer was a late fifteenth-century student at the University of Rome who had come under the sway of the charismatic professor of rhetoric Giulio Pomponio Leto, who taught there from 1465 until his death in 1498. A man utterly obsessed with ancient Rome, Leto subjected the ancient Latin authors, like Vergil, to rigorous comparison with the city's surviving monuments, great and small; he collected coins and inscriptions, and scrutinized the texts of ancient manuscripts with a careful eye for copying errors. All of these approaches to the ancient world are brought to bear in the discussions that pepper the pages of this Vergilian text. Leto's student was obviously enthralled with his course of study; he goes so far as to imitate his professor's distinctive handwriting.

Rome's rich layers of history also inspired the makers of the sixteenth-century Farnese Reliquary (cat. no. 26), an object that, like Rome itself, was not built in a day—in fact, it probably took decades to complete. With its lavish materials and its ingenious combination of Egyptian, classical, and Christian imagery, the Reliquary shows on the most basic level that the Christian message had been long in its development, but present from the beginning of time in the mind of God. At the same time, it makes a case for the distinguished pedigree of the wealthy cardinal who commissioned it; the Farnese family is by implication to be compared to the hoary antiquity of the sphinxes at the Reliquary's base, and the Farnese's dynastic continuity likened to that of the papacy itself, represented in the figures of a Hebrew prophet, Saint Peter, and—last but hardly least—the Farnese pope, Paul III. The artists and scholars who worked for the Farnese family in the sixteenth century were a more specialized group than their fifteenth-century equivalents—there was not an Alberti among them—just as a patron like Cardinal Alessandro Farnese was a more rigorously educated student of antiquity than a Sigismondo Malatesta. Scholarly rigor came, however, at the price of imaginative freedom; too much had been learned about the ancient world by Cardinal Farnese's time for him to recreate it with quite the same megalomaniac abandon that Malatesta could permit himself.

The seventeenth-century Jesuit Athanasius Kircher (cat. no. 2) has frequently been described as the last man of the Renaissance, both because of his phenomenal versatility as a scholar (he wrote more than forty books, most of them immense folio volumes, on a bewildering variety of subjects) and because of his stubborn adherence to some markedly outdated ideas. But his inclination to draw analogies between nature and antiquity also puts him among the innovative thinkers of his era; for example, the Accademia dei Lincei, the learned Roman gentlemen's academy to which Galileo and several of Kircher's

friends proudly belonged, encouraged both antiquarian and scientific research. A complex figure, Kircher reflects the seventeenth century's besetting uncertainty about the workings of the cosmos and the place of the everyday world in it, uncertainties made more acute by the dread spectre of the Reformation, the Inquisition, and all their accompanying religious warfare. The ancient past still offered its accumulated wisdom and its elegant art, but the methods by which confused moderns were to interpret those offerings sometimes seemed as tormented as questions of religious dogma.

If Kircher was the last Renaissance man, the Florentine book collector Antonio Magliabechi, whose life bridged the seventeenth and eighteenth centuries, is a strikingly modern type (cat. no. 3). Carefully protected by the Medici grand dukes, whom he served as librarian, he exemplifies the academic eccentric to an extreme degree. Historian Eric Cochrane eloquently evokes what a visit to Magliabechi's apartment near Santa Maria Novella was like for the streams of learned visitors who felt obliged to pay a call: "the unaired, unswept house . . . the disorderly piles of books that filled every corner of every room . . . the breadcrusts and apple peels scattered about the floor . . . the stench of clothes never washed and never even taken off."[2] Eighteenth-century bibliophile Gaetano Volpi described Magliabechi as "more than a little stoic by nature, and filthy," reporting that "when he read at the dinner table, and wanted to mark a passage that struck his fancy, he would use the salted sardines in front of him for lack of a better material." Magliabechi himself declared that he had so many books it was easier to buy a duplicate copy of a text he wanted than to search for his first copy in the morass. And yet there was an honored place in the genteel society of grand-ducal Tuscany for this strange, vain man; his energetic correspondence and his monomaniacal devotion to learning made him a useful citizen in that international society known since the fifteenth century as the "Republic of Letters." Yet

perhaps only a highly specialized, complex society could have accommodated him so comfortably, a society in which antiquarian studies held a distinct professional status, and the collecting of books could reach a monumental scale—Magliabechi's personal collection of printed books and manuscripts still forms the backbone of the grand National Library in Florence. In ways that Sigismondo Malatesta and his contemporaries could hardly have imagined, the place of antiquity in European thought had become a place of supreme importance.

A relatively recent entry in our catalogue, Louis Dupré's portrait from 1819 of Louis François Sebastien Fauvel, the French consul in Athens (cat. no. 55), reflects one of the most significant shifts to occur in European attention to the ancient world: the reawakening of interest in Greece as the Ottoman Turks relaxed their grip on the Hellenic peninsula. The dramatic outcrop of the Athenian Acropolis and the scattered remains of ancient sculpture make Fauvel's early nineteenth-century Athenian residence look much like the antiquity-strewn gardens of fifteenth and sixteenth-century collectors in Rome. The Elgin Marbles had just made their way to England, where the great Italian neoclassical sculptor Antonio Canova looked at them and exclaimed "I wish that I could begin again!" With his keen eye for style, Canova realized at once how different the original art of Greece had been from the Roman evocations on which he had trained his hand, and he must have felt the same kind of thrilled shock as the humanists who pulled ancient statues from the layered soil of Rome three and four hundred years before. Antiquity, once again, had become something new.

NOTES

1. Ingrid D. Rowland, *The Culture of the High Renaissance: Ancients and Moderns in Sixteenth-Century Rome* (Cambridge: Cambridge University Press, 1998).

2. Eric Cochrane, *Florence in the Forgotten Centuries, 1527–1800* (Chicago: University of Chicago Press, 1973), 267–68.

I **Matteo de' Pasti**
Italian
Active 1441–1467/68

*Sigismondo Pandolfo
Malatesta, Lord of Rimini,
1432–1463* (obverse), *View of
Castel Sismondo, Rimini*
(reverse), 1446

Cast bronze
Diameters: horizontal 3 ⅛ in.
(7.9 cm), vertical 3 in. (7.6 cm)

Purchase, Gift of Members of
the Baroque and Rococo Tour,
1983.6

Like an ancient Roman emperor, the fifteenth-century warlord Sigismondo Pandolfo Malatesta issued a series of bronze portrait medals to commemorate his military victories and his civilian patronage. Medals, in Renaissance Italy as in ancient Rome, acted as more than impressive calling cards; like the coins they so closely resembled, they carried a host of customs and superstitions in addition to their inherent allure as precious metal. Sigismondo, for instance, buried a cache of medals like the Smart Museum's example in the foundations of the remodeled church that eventually served as his burying place. Most of his portrait medals, however, would have stayed above ground, to be presented as gifts to friends, lovers, diplomats, employees, and family.

An extraordinarily handsome if ruthless warrior, Sigismondo was fortunate in having two great medalists cast his portrait in this medium: Pisanello, the courtly artist who effectively originated the Renaissance portrait medal, and Matteo de' Pasti, creator of the Smart Museum's piece, one design in a series of at least ten. Its Latin legend reads: "Sigismondo Pandolfo Malatesta, son of Pandolfo."

Both artists, working within a year of one another (Pisanello in 1445, Matteo de' Pasti in 1446) emphasized Sigismondo's ramrod posture, languorous eyes, and luxuriant hair, together with the distinctive Malatesta profile, as physical clues to a charismatic but dangerous man. The medallion's reverse shows the castle that Sigismondo erected as his stronghold in Rimini on Italy's east coast; the legend reads, in Latin, "Castel Sismondo of Rimini, 1446." This square-towered bastion, begun in 1437, probably reflected Malatesta's own design; he was a proficient military architect as well as a warlord, and his tumultuous life gave him ample opportunity to practice both skills.

Sigismondo Malatesta was not only a warlord, but a capricious one, as renowned for his military discipline as for the lack of it. Because he made his living by heading a troop of mercenary soldiers, Malatesta switched sides in battle when the pay was right, and once made the supreme tactical error of so betraying a reigning pope. Pius II was not amused; in a scathing bull of 1462, he condemned Sigismondo Malatesta to Hell—an almost unheard-of distinction for a living person. Women found Malatesta no less faithless. He was married three times, and suspected of helping the first two wives along to their premature deaths. His last wife, Isotta degli Atti, became his mistress in 1446, and was commemorated, like her future husband, in at least three medals by Matteo de'

The Place of the Antique

Pasti. Partner to Sigismondo's greatest successes, she would also oversee his decline into isolation and sickness after a resounding defeat in 1463 at the hands of his longtime rival, Federico da Montefeltro, Count of Urbino, another local warlord—but one backed by the papacy.

Matteo de' Pasti's portrait shows a twenty-nine-year-old Sigismondo at the peak of his career, when he had assembled a glittering court of intellectuals at Castel Sismondo, including the scholar-artists Leone Battista Alberti and Piero della Francesca. The material legacy of that brief season suggests that Sigismondo Malatesta was a patron of radically innovative taste and had an unerring eye for quality, manifest on a large scale in Alberti's magnificent Tempio Malatestiano— "Malatesta Temple"—a remodeling of Rimini's fourteenth-century Franciscan cathedral in monumental Renaissance style, and on a small scale in frescoes, sculpture, manuscripts, textiles—and medals like this one. —IDR

BIBLIOGRAPHY

Corrado Ricci, *Il Tempio Malatestiano* (1924; reprint Rimini: Bruno Ghigi, 1974); F. Arduini et al., eds., *Sigismondo Pandolfo Malatesta e il suo tempo* (Vicenza: Neri Pozza, 1970), esp. Franco Panvini Rosati, "Le medaglie malatestiane," 105–25.

2 **Athanasius Kircher**
German
1602?–1680

Gigantis Sceleton, from the *Mundus Subterraneus,* Volume 2 (Amsterdam: Joannes Janssonius à Waesberge & Filii), 1678

Woodcut
14⁹⁄₁₆ x 9⅛ in. (37.5 x 23.2 cm)

Department of Special Collections, University of Chicago Library

The German Jesuit Athanasius Kircher spent nearly forty-five years in Rome as a kind of living encyclopedia. The forty-odd books he eventually published covered nearly every branch of human knowledge with energy, erudition, and serene Christian faith. First hired in 1634 as Professor of Mathematics at the Jesuit order's Roman College (Collegio Romano), he quickly moved into a broader and more personalized role as the master of an ever-expanding museum set on the College premises. There Kircher lectured for learned locals and distinguished visitors, spicing his talks with magic lantern shows, sound effects, works of art, wooden obelisks, and sports of nature, all mustered with theatrical extravagance to promote his own doctrinally orthodox but highly particular view of Creation.

Kircher's stormy youth as a Catholic in Protestant Germany inured him early to a world of violent religious strife, of roving mercenaries and hostile neighbors to whom he responded with an impressively serene physical courage; eventually, he entered into academic debate with the same calm certainty. As the Thirty Years' War raged abroad and the Inquisition raged in Rome itself, Kircher made a genial spokesman for the Catholic point of view, serving as a persuasive, sophisticated urban missionary.

At the same time, the violence of Kircher's youth left its trace in various ways on his personality. His uncanny exterior calm housed a mind whose workings he usually described as a firestorm, "mentis aestus." And if he abhorred the violence of human society, he was thrilled by the violence of nature. He climbed deep into the active craters of Etna and Vesuvius, and imagined himself as a space traveler adrift on the roiling seas of the moon. Yet in each of his forty books, often in radically different ways, Kircher strove to prove that the search for order, especially in the depths of apparent chaos, would lead reliably to God.

The Place of Antiquity

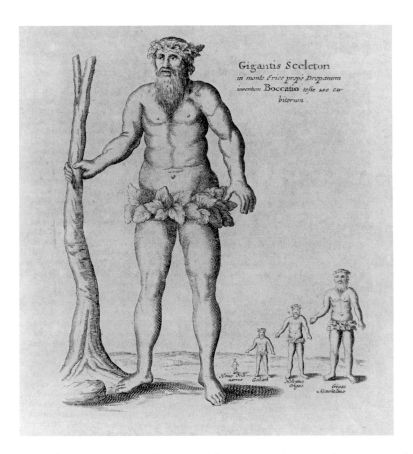

Both Kircher's sense of order and his cravings for turmoil emerge emphatically in his study of *The Subterranean World*, the *Mundus Subterraneus*, where, to quote from the work's compendious full title, "the majesty and wealth of universal Nature are revealed, and the Causes of hidden effects, sought out by pointed inquiry, are made manifest." In this book, whose two volumes range from the composition of Earth and Sun to the formation of fossils and the secrets of metallurgy, Kircher took up the challenge of the physical cosmos with his characteristic mix of hard-headed analysis and what many of his contemporaries already recognized as astonishing credulity.

His discussion of Giants' bones, exhibited here, is a revealing case in point. The immense "Gigantis Sceleton" illustrated in this marvelous woodcut, like modern renderings of dinosaurs, has been reconstructed from fragments of bone first recorded by the fourteenth-century Florentine writer Giovanni Boccaccio on a visit to Sicily. Kircher's own tour of Sicily in 1637–38 quickly convinced him that Boccaccio had fallen victim to a still-thriving local trade in stalactites and stalagmites, snapped off from the island's many limestone caves and purveyed to gullible tourists as "elephants' teeth" or "Giants' bones." (Kircher himself bought several to send his friends and kept some for his Museum.) Observing sagely that the human body was only constructed to function within a certain range of sizes and weights, he also insisted that Giants must have existed because the Bible said so. The diminutive figure of Goliath, standing next to an infinitesimal "homo ordinarius" (who poses carefully out of range of the Sicilian Giant's huge, clumsy foot) shows that those Biblical Giants loomed larger in the imagination than in reality. —IDR

BIBLIOGRAPHY

Thomas Leinkauf, *Mundus Combinatus: Studien zur Struktur der barocken Universalwissenschaft am Beispiel Athanasius Kirchers SJ (1602–1680)* (Berlin: Akademie Verlag, 1993); Walter E. Stephens, *Giants in Those Days: Folklore, Ancient History, and Nationalism* (Lincoln: University of Nebraska Press, 1989).

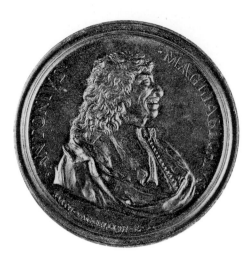

3 **Bartolommeo Giovanni Vaggelli**
Swiss
Died 1744

Antonio Magliabechi (1633–1714), Librarian to the Grand Duke of Tuscany (obverse), *Bookstand with a Book* (reverse), 1714

Cast bronze
Diameter 3⅜ in. (8.6 cm)

Purchase, The Cochrane-Woods Collection, 1979.40

BIBLIOGRAPHY

Eric Cochrane, *Florence in the Forgotten Centuries, 1527–1800* (Chicago: University of Chicago Press, 1973), 267–68; Furio Diaz, *Il Granducato di Toscana*, vol. 1, *I Medici* (Turin: UTET, 1976), 507–10; Gaetano Volpi, *Del furore d' aver libri* (orig. titled *Varie avvertenze utili e necessarie agli amatori de' buoni libri disposte per via d'alfabeto*, 1756; reprint Palermo: Sellerio, 1988), 68–69.

Antonio Magliabechi served for decades as the influential Librarian to Ferdinando II (1621–70) and Cosimo III (1670–1723) de' Medici, Grand Dukes of Tuscany. Magliabechi was a man of staggering erudition, surpassing ugliness, and strange personal habits, who never published either a book or an essay, but did generate a mountainous correspondence. The librarian's pockmarked complexion, beaked nose, sparse teeth, and gum-baring grimace, evident enough in this posthumous portrait medallion, also made irresistible targets for contemporary draftsmen and sculptors, who topped the incredible countenance with the long wig dictated by contemporary fashion (fig. 1). Contemporaries also noted his eccentric behavior and extreme lack of attention to his surroundings—in particular the filth of his study, with its remnants of meals and mounds of unsorted books.

Despite these personal peculiarities, as well as an extreme case of intellectual vanity, Magliabechi's retentive memory, vast erudition, and international network of correspondence made him a power to be reckoned with in seventeenth and eighteenth-century Florence and elsewhere in Italy. Culture had already become the Grand Duchy's chief resource, and Magliabechi, shrewdly aware of Florentine contributions to art and learning, supplied the Medici grand dukes with advice on political appointments and promotions as well as scholarly matters. His connections with Rome afforded him standing permission to read whatever had been put on the Inquisition's Index of Prohibited Books. His portrait medallion, with its symbolic bookstand on the reverse, bears witness to a scholar of extraordinary international influence, an influence preserved in the collection of the National Library in Florence.

The medalist Bartolommeo Vaggelli was probably of Swiss origin, like many skilled metalworkers in the Renaissance and later. Active in the first half of the eighteenth century in Florence, he worked with the Florentine medalist Massimiliano Soldani in the employ of the Medici grand dukes. The date of this medallion, 1714, suggests that it is a posthumous commemorative. —IDR

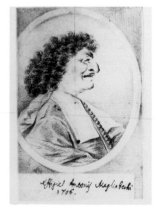

Fig. 1.
ARTIST UNKNOWN
Antonio Magliabechi,
pencil and ink on paper, 1706.
Venice, Biblioteca Nazionale
Marciana, Lat. XIV, 50 (=4238).

The Place of Antiquity

4 Italian

Inkwell: Putto on a Dolphin,
circa 1650–1675

Cast bronze
Height 4½ in. (11.43 cm)

Purchase, Gift of Eloise W.
Martin, 1982.12

This bronze inkwell in the form of a dolphin-borne Cupid must have adorned the desk of a wealthy scholar, cleric, or merchant, injecting a note of cheer into the oft-repeated act of dipping a habitually thirsty quill pen. In an age where women writers had begun to flourish and women had long been accustomed to keeping accounts, there is no reason to suppose necessarily that the inkwell's owner was male.

The infant's lively pose derives from a theme—the flying cupid—dear to ancient Roman art; unlike the Greeks, whose children always resembled miniature adults, the Romans, like the Etruscans before them, made a point of capturing the distinctive proportions, the large heads and short, chubby limbs, of the very young (see pp. 50–51). Gamboling winged infants abound in Roman art, particularly on sarcophagi, acting always as personifications of love; when the loving couples are the mermen and mermaids known as tritons and nereids, their accompanying cupids dive through the waves or ride dolphins just like the *amorino* of our inkwell. Love, in the art of mourning Rome as in the biblical *Song of Songs*, is strong as death; many waters cannot quench it. In 1514, Raphael, who had clearly been looking at a Roman sarcophagus or two adorned with tritons and nereids, brought those frozen marble sea creatures to colorful new life in a fresco of the nymph *Galatea*, executed for the Roman villa (now known as the Villa Farnesina) of a fabulously wealthy Tuscan banker, Agostino Chigi. Thanks to Chigi's lavish parties and Raphael's reputation, the chubby putto in the foreground of the *Galatea*, clinging to the reins of a fierce dolphin team, became almost as popular a figure in its own day as were the two mischievous cherubs from the painter's *Sistine Madonna*. Our exhibit alone has three copies of this lunging child: Algardi's *Infant Hercules* (cat. no. 29), an engraved reproduction

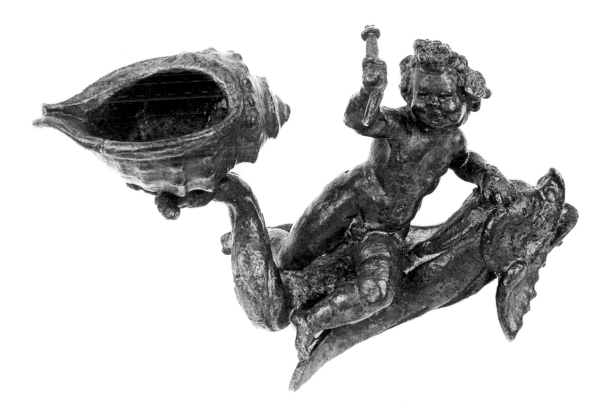

The Place of the Antique

BIBLIOGRAPHY

Michael Koortbojian, *Myth, Meaning, and Memory on Roman Sarcophagi* (Berkeley: University of California Press, 1995); Ingrid D. Rowland, "'Render unto Caesar the Things Which are Caesar's': Humanism and the Arts in the Patronage of Agostino Chigi," *Renaissance Quarterly* 39 (winter 1986): 673–730; Charles Dempsey, "*Et Nos Cedamus Amori*: Observations on the Farnese Gallery," *Art Bulletin* 50 (1968): 363–74.

5 **North Italian, Padua?**

Phoenix Rising from the Flames (Finial from a Firedog), early sixteenth century

Cast bronze
Height 5 ¼ in. (13.4 cm)

Purchase, Gift of Mrs. Chester Tripp in memory of her Husband, 1979.18

of Annibale Carracci's fresco of *Glaucus and Scylla* from the Farnese Gallery in Rome (cat. no. 33), and this inkwell. Love, as this seaborne *amorino* reminds us, has always inspired writers to spill floods of ink, but the putto, in ancient Rome as in Renaissance Europe, also symbolized charm: one more reason to suppose that the owner of this charming inkwell might well have been a woman. —IDR

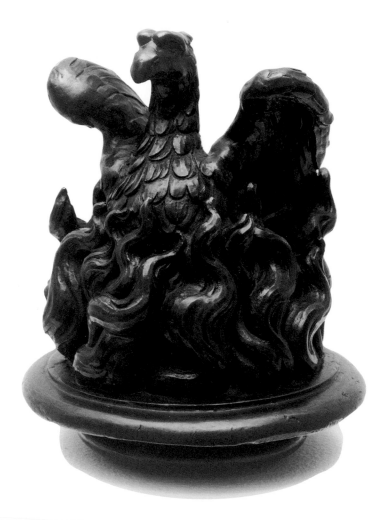

Edward Maser, first Director of the Smart Gallery (as it was then called), purchased this sixteenth-century bronze phoenix for the collection in the belief that "it may have formed a finial on some great bronze gate or grillwork screen in some North Italian church." In fact, several similar bronzes from the Art Institute of Chicago show that the piece almost certainly fit instead onto a more humble domestic firedog, where both its sturdy workmanship and its imagery of a bird rising from the flames make eminent sense. Because firedogs come in

pairs, this bronze must once have had a twin. Each phoenix would have been affixed to the business end of its respective appliance by a thick bolt, threaded through the top.

Professor Maser's interest in the bronze went straight to the heart of the Smart Museum as an institution and its mandate to serve as an enhancement to the intellectual life of the University of Chicago:

> I have always wanted [this piece] to come to the University of Chicago, for the phoenix, which appears infrequently in art, is on the coat-of-arms It was adopted by the University of Chicago in 1910 to symbolize the rebirth of the University in 1890, succeeding the *first* University of Chicago founded in 1857 which later went bankrupt and closed.
>
> The phoenix is, as you know, the legendary bird (it goes back to ancient Egyptian times) which in old age would build its own funeral pyre and burn itself up. However, the miracle was that it rose from the flames, young and reborn. Needless to say, it was quickly adopted by early Christianity to symbolize the Resurrection. Our bronze is to be understood as having this meaning.

Learned Italians of the early sixteenth century would have known the legend of the phoenix, its five-hundred-year lifespan, its fiery self-immolation, and simultaneous rebirth from a host of ancient texts, including the *Histories* of Herodotus, the *Natural History* of Pliny the Elder, Ovid's *Metamorphoses*, and the *Annals* of Tacitus. The mythic bird was said by Herodotus to originate in Arabia, and the griffins of ancient Near Eastern art certainly provide suggestive parallels to its physical appearance. Transferred to a sixteenth-century domestic setting, an image of the phoenix and its legendary resilience, together with its extended symbolism of Christian resurrection, would have made the home fires that much more comforting to the first owners of this Renaissance bronze. Its purchase for the Smart Museum has added a third layer of symbolism to this bird that continually reinvents itself. —IDR

BIBLIOGRAPHY

Edward Maser to Mrs. Chester Tripp, letter, June 5, 1979, Smart Museum Archives.

Transformation of the Antique

Metamorphic Representation in the Renaissance

ALLIE TERRY

The Renaissance has long been distinguished as a period of remarkable change. Dramatic transformations in outlook coincided with the spatial-temporal expansion of the Renaissance world: as humanists delved deeper toward their classical roots and explorers traversed the vast seas to discover new lands and peoples, Western thought had to readjust to a schema of history that extended much further into the past, and accept a new relation to the future. Nowhere is this metamorphosis of thought and culture more evident than in the artistic creations of the time, as Renaissance artists sought inspiration in the themes and styles of the ancients. As Renaissance thinkers became more familiar with the classical past, their textual and visual references to ancient sources grew freer and more imaginative. Classical figures and themes assumed a new, modern vitality that embodied the principles of a culture secure of its position within the world. Only with this confidence could time and space converge, and the ancient be presented hand-in-hand with the modern to create unique but convincingly classical figures and themes.

The humanists—scholars who rejected Scholasticism and vulgarized Latin in favor of a pure Ciceronian style of rhetoric and writing— were at the forefront of this classical revival. Gathered in circles of intellectual exchange, these men of letters basked in each other's knowledge of the literary masterpieces of Athens and Augustan Rome and discussed the virtues of a bygone civilization. Their greatest influence came through the enthusiastic collecting and translating of a vast number of texts that had previously been ignored or misread. The close rereading of classical texts, coupled with archae-

ological discoveries of ancient sculptures, gradually brought Renaissance society to a new level of interest in the classical world.

One of the most vivid classical accounts of pagan cosmology available in the Renaissance came from the collection of myths in Ovid's *Metamorphoses*. In this narrative poem, Ovid (43 B.C.E.–17 C.E.) playfully elaborates upon the mythic traditions handed down from Homer and the Greek dramatists and carried on by the Romans, relaying over 250 tales dealing with metamorphosis and transformation. The physical, emotional, and mythic-historical characteristics of the pagan heroes emerge through Ovid's storylike yet sophisticated use of Latin. Renaissance artists in search of classical models often employed the *Metamorphoses* as a descriptive handbook of the pagan gods and myths. Many works of art in the collection of the Smart Museum—from two early modern *cassone* panels depicting Apollo's arrow-struck desire for the nymph Daphne (cat. nos. 6–7) to Jean-Léon Gérôme's late nineteenth-century oil sketch of the sculptor Pygmalion embracing the transformed statue of Galatea (cat. no. 12)—provide an introduction to the ways in which artists developed unique narrative strategies to represent tales ultimately derived from Ovid.

Ovid's text was not rediscovered in the Renaissance. Unlike many classical works, the *Metamorphoses* had enjoyed a continuous textual tradition, and had frequently been reworked to suit new purposes. For example, the revival of the euhemeristic tradition in the beginning of the Early Christian era provided fuel for the Church Fathers and apologists to dismiss the polytheistic character of the ancient world and to interpret the pagan gods as deified historical figures. In later centuries, Ovid's work was conflated with Christian principles and took on a moralizing function. One result of these many reinterpretations was that the *Metamorphoses* not only remained in circulation but became increasingly accessible and acceptable.[1]

The *Ovide moralisé*, an influential early fourteenth-century form of interpretative play on the *Metamorphoses*, contains some of the first post-antique images of Ovidian characters. Yet as its title suggests, this genre functioned as a didactic tool for educating readers in an exemplary lifestyle. The classical text was reinterpreted as an embodiment of a Christian world view. Pagan gods were equated with biblical figures and images of pagan romps were used to illustrate what should be avoided in a proper Christian life.[2] Similarly, early representations of Ovidian figures on *cassoni*, or trousseau chests, related a moral message to the viewer. The Smart Museum's *Apollo and Daphne* panels, for example, may have been intended to laud the chastity and faithfulness of their newly wed owners.

Medieval and early Renaissance artists also placed Ovid's characters in a celestial context. Pagan gods were used to help explain cosmology and cosmography, and were literally mapped onto astrological charts and dissected in diagrams. The charting of the pagan deities belonged to an ancient tradition of assigning divine nomenclature to the pattern of the heavens.[3] The naming of the planets and constellations, first recorded by the Greeks and later the Romans, connected the gods with the sky both linguistically and visually. Early Christians continued in the astrological tradition, though they reinterpreted the meanings of the stars and planets so as to relate them to the Bible and a Christian scheme of virtues. Another tradition, beginning with the Pythagoreans and continuing in Dante, used the planets as emblems of the seven liberal arts. But it was in relation to the human body, considered a microcosm of the universe at large, that the heavens were understood as particularly potent. The planets were connected to physical ailments, and the signs of the zodiac were interpreted as representations of the qualities, conditions, humors, and temperaments of the body; they also served as metaphors for the ages of man. As Jean Seznec has demon-

strated, this anthropomorphizing of the celestial sphere grew out of the encyclopedic spirit of the Middle Ages, which embraced historical, physical, and moral traditions.[4]

Early Renaissance Neoplatonists, like those situated around Lorenzo de' Medici in late fifteenth-century Florence, attempted to interpret the myths present in Ovid's work as metaphors for the cosmic universe and to establish an interchangeable relationship between the profane and the sacred by seeking hidden meanings within them.[5] Although the roots of these Neoplatonic interpretations may be traced to medieval intellectual theories, the artistic products created for this early group of humanists marked a distinct fissure from their medieval predecessors. The pagan deities, once baldly separated from their original narrative setting in manuscript illuminations, diagrams, and astrological charts, began to appear within a classicizing, mythic context in the works of art of the early Renaissance.[6] No longer metaphors for distinctly Christian values, Ovid's narratives were incorporated into a Neoplatonic religious outlook characterized by its universalism.

Each of the above variations of the Ovidian tradition exemplifies the early Renaissance tendency to manipulate or interpret the text of the *Metamorphoses* for a meaning beyond its words. As the Renaissance progressed and scholars continued to delve further back toward original texts and more accurate translations, Ovid and other classical authors were read increasingly on their own terms. Accurate translations of the *Metamorphoses* revealed more fully Ovid's tendency toward *ekphrasis*, or vivid description, providing artists with a wealth of inspiration and allowing for faithful representations of his narratives. But even more important to the aesthetic life of the Ovidian tradition was the ongoing discovery of ancient visual materials that could be connected to these texts. Many of the paintings and sculptures in the Smart Museum's collection, for example, contain figural poses derived

from antique artistic precedents. The reclining posture of Daphne (cat. no. 6) ultimately comes from the ancient sculptural type exemplified by the *Sleeping Ariadne* or the *Sleeping Nymph*, now found in the Vatican Museum. Angelica's pose in the painting by Cecco Bravo (cat. no. 11) is a direct quote of the antique "Crouching Venus" type, and the bronze *Venus Chastising Cupid* (cat. no. 10) evokes classical statues of the goddess Aphrodite in the Louvre and the Vatican.

Despite models such as these, no images of Ovidian legends were known to have survived from antiquity. Consequently, Renaissance artists interested in reestablishing the original mythic context faced the persistent challenge of inventing effective narrative presentations. Although the obvious disparity between any verbal narrative (which occurs over time) and its visual counterpart (which occurs in a single instant) is difficult to overcome, the myths contained in the *Metamorphoses* presented a particularly daunting task due to the slippery quality of the various narratives, which deal with significant, highly visible shifts over time.[7] Each of the several Ovidian images in the Smart collection treats the act of transformation and its temporal complications differently. In general, early Renaissance depictions, such as the two *Apollo and Daphne* panels, tended to provide a larger context for the narrative, including a reference to the transformation itself.

As the fondness for and familiarity with classical subjects spread and the iconography of pagan heroes became established, artists were able to diverge from traditional mythological renderings. For example, the Smart's *Apollo and Marsyas* panel (cat. no. 8) presents the two Ovidian rivals in the moment of competition rather than showing the subsequent—and more traditional—flaying of Marsyas. Several similar examples can be found in Titian's monumental canvases painted for the humanistic d'Este clan in sixteenth-century Ferrara. His *Bacchus and Ariadne* (London, National Gallery), *Bacchanal*

of the Andrians (Madrid, Prado Museum), and *Worship of Venus* (fig. 2) are inventions corresponding to passages in classical texts.[8] No visual depictions of these subjects survived from antiquity, and so the compositions of these works were wholly Titian's invention (cat. no. 38).

Eventually, mythological characters became so embedded in the Renaissance imagination that they were able to assume a life outside of their literary references. The Smart's cast bronze *Kneeling Satyr* (cat. no. 9) and *Venus Chastising Cupid* (cat. no. 10) are representative of this independence. Both figures are true to the established traditions of depiction: the woodland companion of Bacchus is easily identifiable by his half-goat/half-man physiognomy, and the goddess of love may be recognized by her curvaceous nude figure and the entangled presence of the small boy. Yet they both now stand outside a narrative context. The satyr, without his mischievous companion, has become a desk ornament, and Venus, free of Ovid's storylines, emerges as an emblem of the control of unbridled passion.

Metamorphosis as a narrative structure, an artistic theme, and the description of a historical period have all contributed to the modern designation of the Renaissance as the beginning of a new age. Even though the use of Ovidian myths may be traced to interpretative traditions predating the Middle Ages, their incorporation into works of art, along with a new respect for the integrity of classical models, is unique to the Renaissance. As the entries that follow this essay show, references to antique precedents and the visual manipulation of the tensions inherent in Ovid's narratives were just two of the ways in which artists created dynamic compositions and complex connotations for informed audiences. This conscious reworking of the classical heritage marked the onset of a new mode of recreating and viewing Ovidian characters and themes though, consistently, new forms did not entirely replace the old. Rather, just as Ovid's transformed nymphs and gods often retained a trace of their former states of being, the artistic creations of the Renaissance presented their audience with a new face while at the same time evoking the memory of the classical past.

Fig. 2.
TITIAN
Worship of Venus, oil on canvas,
ca. 1520. Madrid, Prado Museum.

NOTES

1. The pagan myths (many of which were quite risqué) were reinterpreted to such an extent that extracts were even used by a group of medieval nuns as a model for good living: "The abbesses and their flock are obviously Pallas, virgin Diana, Juno, Venus, Vesta, Thetis; the reverence due to you is expressed clearly enough by the cult of so great a deity." Jean Seznec, *The Survival of the Pagan Gods: The Mythological Tradition and Its Place in Renaissance Humanism and Art,* trans. Barbara F. Sessions, Bollingen Series XXXVIII (New York: Pantheon Books, 1953), 92.

2. See Seznec, 110, for illustrations from the *Ovide moralisé* in the Bibliothèque de Lyon, cod. 742.

3. By the time of Eratosthenes (284–204 B.C.E.), the mythical designation of the skies was fairly well codified. For a comprehensive analysis of the astrological tradition, see Seznec, esp. ch. 2.

4. Seznec, ch. 4.

5. Among the recent studies of Neoplatonism, see Paul Oskar Kristeller, *Studies in Renaissance Thought and Letters* (Rome: Edizioni di storia e letteratura, 1996); on Neoplatonism and art, see Edgar Wind, *Pagan Mysteries in the Renaissance* (London: Faber and Faber, 1958).

6. An important early discussion of this shift is found in Erwin Panofsky, *Renaissance and Renascences in Western Art* (Stockholm: Almqvist and Wiksells, 1960).

7. A concise introduction to reading visual narratives may be found in Richard Brilliant, "Introduction: Sight Reading," in his *Visual Narratives: Storytelling in Etruscan and Roman Art* (Ithaca: Cornell University Press, 1984), 15–20. For a specifically Renaissance approach to narrative theory, see Leonard Barkan, "The Beholder's Tale: Ancient Sculpture, Renaissance Narratives," *Representations* 44 (fall 1993): 133–66.

8. Philostratus the Elder provides the description for the *Worship of Venus* and the *Bacchanal of the Andrians*, while the primary source for *Bacchus and Ariadne* is Catullus. See Leonard Barkan, *The Gods Made Flesh* (New Haven: Yale University Press, 1986), esp. 182, for an analysis of Titian in terms of metamorphosis.

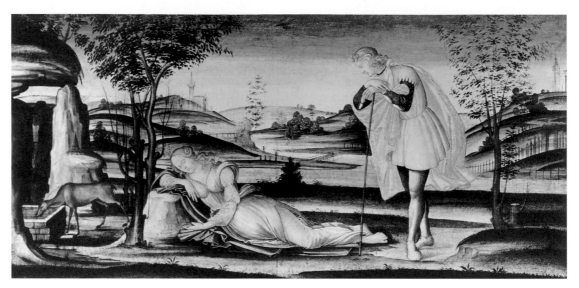

Master of the Apollo and Daphne Legend
Italian, Florentine School
Active end of the fifteenth century

6 *Daphne Found Asleep by Apollo,* circa 1500

Oil, formerly on panel, transferred to canvas
25 5/8 x 53 3/4 in.
(65.1 x 136.5 cm)

Gift of the Samuel H. Kress Foundation, 1973.44

SEE COLOR PLATE 1

7 *Daphne Fleeing from Apollo,* circa 1500

Oil, formerly on panel, transferred to canvas
25 5/8 x 53 3/4 in.
(65.1 x 136.5 cm)

Gift of the Samuel H. Kress Foundation, 1973.45

Her prayer was scarcely ended when a deep languor took hold on her limbs, her soft breast was enclosed in thin bark, her hair grew into leaves, her arms into branches, and her feet that were lately so swift were held fast by sluggish roots, while her face became the treetop.

METAMORPHOSES, BK. I, 548–52

In the first decades of the fifteenth century, representations of classical narratives appeared in the decoration for *cassoni,* or hope chests, of betrothed women. Almost always made in pairs, *cassoni* were traditionally commissioned by the bridegroom or his relatives for the occasion of his wedding, and were used to transport the dowered goods of the bride in a public procession from her parents' house to that of her new husband. The sixteenth-century biographer Giorgio Vasari relates that the sides of these chests were painted "for the most part [with] fables taken from Ovid and from other poets, or rather, stories related by the Greek and Latin historians" By the sixteenth century, decorated *cassoni* had become standard in the ritual of marriage, and made the decorative arts a significant force in the circulation of classical subject matter. The Smart Museum's *Apollo and Daphne* panels provide an excellent example of this genre. Together, they illustrate an interpretation of Apollo's thwarted love affair with Daphne. The freedom of Renaissance artistic imagination is evident here: the painter of these panels took the liberty of placing the figures in an imaginary landscape very reminiscent of Tuscany, and diverged from any classical source in depicting Apollo gazing at a sleeping Daphne.

Despite this narrative departure from the *Metamorphoses,* the mythological figures on the *cassone* panels are immediately recognizable as those described by Ovid. He writes of their billowing garments filled with gusts of wind created by swift movement; his fleeing animals appear on the far left side of the second panel as a shepherd and his charge. Daphne's upstretched hands, sprouting the

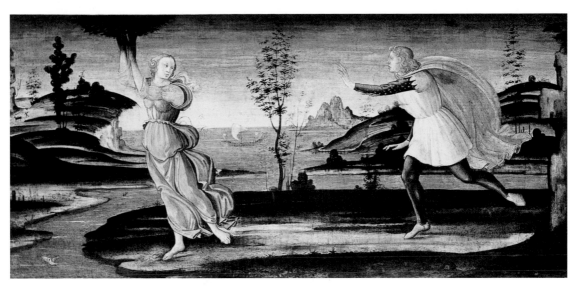

CAT. NO. 7

laurel leaves that Apollo would perpetually revere, are even more faithful to the original text.

Like the Smart panels—based upon a narrative that involves an elusive female and a magical transformation—many of the subjects for *cassoni* and other matrimonial works of art seem inconsistent with a celebration of nuptial union. Often, they present metamorphic tales of thwarted sexual encounters, and even of sexual violence: Jupiter's many sexual escapades, rapes, or forbidden loves (in the guise of a bull, a swan, a golden rain, and so forth) do not evidently support the marital theme of fidelity and devotion. However, Leonard Barkan has suggested that "if we view the practice [of utilizing such subjects] in light of recuperated paganism, then it becomes clear that the occasion of marriage speaks to all those powerful natural drives that operate so triumphantly in the Ovidian world. . . . Metamorphosis plays a particularly significant role because it is a miracle of love; it is joined with all sorts of fabulous subjects, Christian as well as pagan, to suggest the divine emerging from the natural." It is no surprise, then, that the late fifteenth-century Dominican reformer Savonarola objected to images based on Ovid for newly wed couples. In one of his sermons, he exclaimed, "You would say, Ovid's *Metamorphoses* is really good. I respond to you: Ovid is a crazy teller of tales!"

It remains puzzling that grooms, in an age in which women had very little control over the social alliances created through the bond of marriage, would commission images depicting a man's inadequacy in capturing the woman he desires. *Cassoni* functioned in a socio-historical context as markers of the transition into a married state, and of a woman's move toward adulthood. In all likelihood, these narratives were intended as moral and behavioral examples for the young bride. No longer considered a member of her own familial line, she was expected to transfer her goods as well as her loyalty to her husband. *Cassoni* were placed in the nuptial chamber of her new home, where their narrative panels served as a constant reminder of a woman's duties as wife and mother. —AT

BIBLIOGRAPHY

Fern Rusk Shapley, *Paintings from the Samuel H. Kress Collection: Italian Schools XII–XV Century* (London: Phaidon Press, 1966), 129; Ovid, *Metamorphoses*, ed. M. A. Innes (London: Penguin Books, 1955), 43; Giorgio Vasari, *Lives of the Most Eminent Painters, Sculptors, and Architects*, trans. Gaston DuC. de Vere, vol. 2 (London: Philip Lee Warner), 107; Christiane Klapisch-Zuber, *Women, Family, and Ritual in Renaissance Italy*, trans. Lydia Cochrane (Chicago: University of Chicago Press, 1985), 213–46; Leonard Barkan, *The Gods Made Flesh* (New Haven: Yale University Press, 1986); Cristelle L. Baskins, "'La Festa di Susanna': Virtue on Trial in Renaissance Sacred Drama and Painted Wedding Chests," *Art History* 14 (September 1991): 329–44; Baskins, "Griselda, or the Renaissance Bride Stripped Bare by Her Bachelor in Tuscan *Cassone* Painting," *Stanford Italian Review* 10 (1991): 153–75; Peter F. Lynch, "Narratives of Marginalization: De-Centering Women in Tuscan Domestic Painting ca. 1500," *Studies in Iconography* 16 (1994): 139–63.

8 **Artist Unknown**
Northern European,
Flemish (?)

Apollo and Marsyas, circa 1600

Oil on canvas
15 x 20 in. (38.1 x 50.8 cm)

Purchase, The Cochrane-
Woods Collection, 1982.18

When the story-teller, whoever he was, had related the disaster which befell the Lycians, another man remembered the tale of the satyr whom Apollo punished, after defeating him in a competition on the reed-pipes, the instrument Minerva invented.

METAMORPHOSES, BK. VI, 382–85

Ovid's account of Apollo and Marsyas in the *Metamorphoses* relates little information about the crowd that gathered in the woodlands of Phrygia to hear the musical competition between the satyr Marsyas and the god Apollo. Instead, the author vividly describes Marsyas's punishment for challenging and defeating a god, and then describes the transformation of the woodland people's tears into the source of the clearest river in Phrygia, the Marsyas. Similarly, artistic renditions of the story in fifteenth and early sixteenth-century Italy generally focused on the aftermath of the competition: Apollo stands in the center with his lyre and Marsyas, bound to a tree, crouches on the side.

The Smart Museum's canvas imaginatively diverges from the earlier Italian tradition and places the viewer at the scene of a woodland concert. The youthful sun god stands at the center of the composition while satyrs and nymphs look on. The scene is painted in grisaille—a limited palette consisting of black, white, and various shades of gray—suggesting a gathering of fictitious characters rather than of living beings.

Ovid's text and a number of archaeological discoveries contributed to the popularity of this myth among Renaissance artists. So too did the fifteenth-century Medici acquisition of the engraved "Seal of Nero." According to Vasari, this rare antique carnelian intaglio showed "the flaying of Marsyas at Apollo's command," and was used as the Emperor Nero's seal. At once a reminder of punishment and a signifier of power, engraved images of the Apollo and Marsyas story flourished in a moralizing context and as a sign of prestige. —AT

BIBLIOGRAPHY

Ovid, *Metamorphoses*, ed. M. A. Innes (London: Penguin Books, 1955), 144–45; Giorgio Vasari, *Lives of the Artists*, ed. George Bull, vol. 1 (London: Penguin Books, 1965), 114–15; Francesco Cagliotti and Davide Gasparotto, "Lorenzo Ghiberti, il 'Sigillo di Nerone' e le origini della placchetta 'antiquaria'," *Prospettiva* 85 (January 1997): 2–38.

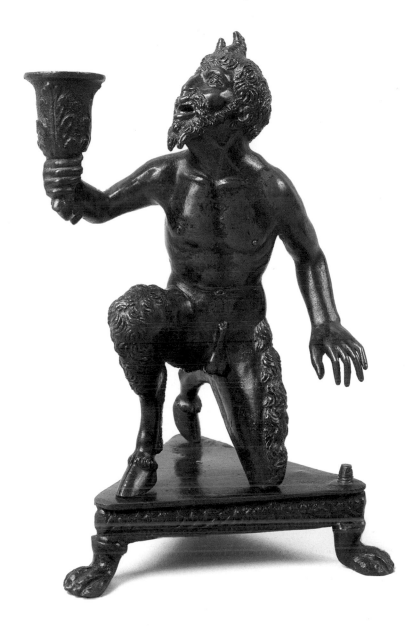

9 **Workshop of Severo Calzetta da Ravenna**
Italian, Padua
Active 1496–1511?

Kneeling Satyr,
circa 1500–1509

Cast bronze
Height with base 9¾ in.
(24.8 cm)

Gift of the Samuel H. Kress
Foundation, 1973.58

Not to speak of almost countless other things, how could I find words and style worthy of the ink-stand you sent me? Though certainly its form is most beautiful, elegant, and apt, this is overshadowed by the truly Phidian skill and workmanship I feast my eyes on. . . . So does the diligence of Art seem to rival the ease of Nature. Often I cannot have enough of the pleasure I find in examining the little figures and the living faces. . . . Nails, fingers, and hair, soft even though earthen, take me in when I behold them. When I look at the open mouth I expect a voice to come from the dumb.

GUARINO OF VERONA, 1430

With lips parted as though to speak, the Smart Museum's *Kneeling Satyr* is an excellent example of the sorts of small-scale bronze desk ornaments produced in northern Italy during the Renaissance. The satyr's bodily contortions on his

triangular base create a dynamic composition for this utilitarian decorative piece that may have once functioned as a candleholder or an inkwell.

The revival of satyric figures in northern Italy from the mid-fifteenth century was undoubtedly connected to the growing antiquarian sentiment of the region. The cast bronze *Kneeling Satyr* was produced in the workshop of Severo da Ravenna in Padua, home to a large number of humanists involved with and attracted to the university.

Padua's growing interest in antique collectibles created a market for small-scale bronze sculptures based upon classical models and themes. While satyr imagery flourished in the early sixteenth century—in engravings like those by Nicoletto da Modena, text and woodblock illustrations such as those found in the antiquarian epic *Hypnerotomachia Poliphili*, or in the minds of humanists rereading Ovid—the pose of the Smart Museum's *Satyr* may have derived directly from classical models of fauns, or perhaps from pieces like the Etruscan bronze sculpture of *Silenus* dating to the fourth century B.C.E. and now in the Staatliche Antikensammlung, Munich.

Severo utilized a method of replica casting to produce a large number of unique sculptures after a single model: each new piece was based upon a slightly altered wax reproduction. This method allowed for variation in the composition of the sculpture while at the same time retaining the delicate workmanship and decoration of the original. —AT

BIBLIOGRAPHY

John Pope-Hennessy, *Renaissance Bronzes from the Samuel H. Kress Collection* (London: Phaidon Press, 1965), 128; Guarino da Verona as cited in Michael Baxandall, *Giotto and the Orators: Humanist Observers of Painting in Italy and the Discovery of Pictorial Composition* (Oxford: Clarendon Press, 1971), 91; Charles Avery and Anthony Radcliffe, "Severo Calzetta da Ravenna: New Discoveries," *Studien zum Europäischen Kunsthandwerk: Festschrift Yvonne Hackenbroch,* ed. Jörg Rasmussen (Munich: Klinkhardt and Biermann, 1983), 107–22; Richard A. Born, catalogue entry in *The David and Alfred Smart Museum of Art: A Guide to the Collection,* eds. Sue Taylor and Richard A. Born (New York: Hudson Hills Press, 1990), 36–37; Patrick M. de Winter, "Recent Accessions of Italian Renaissance Decorative Arts, Part I: Incorporating Notes on the Sculptor Severo da Ravenna," *The Cleveland Museum of Art* 73 (March 1986): 75–138

10 **Francesco Fanelli**
(formerly Italo-Flemish or Franco-Flemish)
Italian, active Genoa, England, and Paris
Active circa 1605–1661

Venus Chastising Cupid,
circa 1635

Cast bronze
Height 15 ¼ in. (38.7 cm)

Gift of Mr. and Mrs. Frank Woods, 1980.27

SEE COLOR PLATE 2

The nude female figure, exemplified by the goddess of love and beauty, emerged in monumental Greek art in the fourth century B.C.E., with the sensuous Aphrodites (or Venus, as she is known in Roman mythology) of the sculptor Praxiteles. Although these sculptures were important for their mythological significance, their appeal lay precisely in the eroticism of their luscious forms. In the Hellenistic age, Praxiteles's voluptuous nudes found many descendents, and these were reestablished in Roman copies of a variety of Venus types, such as the Venus of Doidalsas or the *Medici Aphrodite* (cat. no. 11).

The Hellenistic legacy can also be seen in Francesco Fanelli's playful seventeenth-century interpretation of Venus who, outside of an Ovidian narrative context, disciplines her restless son Cupid, or Eros—the embodiment of love. The chastising Venus has thematic antecedents in the art of the Hellenistic rococo, as seen in the *Aphrodite with Slipper and Pan* of ca. 100 B.C.E. (Athens, National Archaeological Museum), in which the goddess, in a pose similar to that of Fanelli's figure, wards off the satyr's advances by hitting him with her shoe. Fanelli's version combines a sensuousness of style with two categories of content characteristic of the Hellenistic rococo: mischievous children (cat. no. 31) and eroticism.

Transformation of the Antique

BIBLIOGRAPHY

Charles Avery, *Florentine Renaissance Sculpture* (London: John Murray, 1970), 237–56; J. J. Pollitt, *Art and Experience in Classical Greece* (Cambridge: Cambridge University Press, 1972), 157–60; Pollitt, *Art in the Hellenistic Age* (Cambridge: Cambridge University Press, 1986), 127–41; Wendy Stedman Sheard, *Antiquity in the Renaissance* (Northampton, Mass.: Smith College Museum of Art, 1979), 42–43; Patricia Wengraf, privately printed entry for Francesco Fanelli sculpture on the art market (London: Alex Wengraf Limited, n.d.).

An interest in classical subjects on the part of both Fanelli and his patrons is evident from the artist's various Cupids and his ivory *Pygmalion*. Yet, like other European artists at the time, Florentine-born Fanelli interpreted his classicizing figures according to his own stylistic heritage. Like the Mannerist sculptor Giambologna, who studied the art of antiquity in Rome, Fanelli exploited his medium, emphasizing the possibilities of multiple and merging viewpoints through graceful bodily twists and intersections, which allow light and space to play freely amidst the forms. The Venus group's *figura serpentinata* (serpentine or spiraling figure), emphasized by a coiled Cupid winding his way through his mother's legs, elegantly exaggerates the ancient foundations upon which the artist was building. Even the sensuousness of Fanelli's forms reinterprets antiquity: Venus's bulging curves recall the bottom-heavy ideals of the northern European artistic milieu in which Fanelli was working, placing an admired classical ideal comfortably within an early modern context. —SR

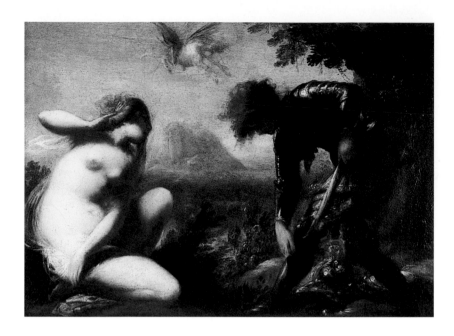

11 Francesco Montelatici, called Cecco Bravo
Italian, Florentine School
1607–1661

Angelica and Ruggiero,
circa 1640–1645

Oil on canvas
12¾ x 17½ in.
(32.4 x 44.5 cm)

Gift of the Samuel H. Kress
Foundation, 1973.42

Then softly to her mouth the hoop conveys,
And, quicker than the flash which cleaves the skies,
From bold [Ruggiero's] sight her beauty shrouds,
As disappears the sun, concealed in clouds.

ORLANDO FURIOSO, CANTO XI, 6

Metamorphic activities in Renaissance literature were by no means limited to interpretations of Ovid. The rather comic escape of Angelica that serves as the subject for Cecco Bravo's narrative painting in the Smart collection comes from an episode of Ludovico Ariosto's *Orlando Furioso* (canto X, 112–15 and canto XI, 1–6). Written between the years 1503 and 1532, this chivalric romance gained in popularity throughout the sixteenth century and appeared in over sixty different editions before 1600. By 1640, when Cecco Bravo most likely began this painting, Ariosto's work would have been quite familiar to viewers of small cabinet pictures like this one.

Cecco Bravo's canvas presents the moment just after Ruggiero has rescued Angelica from the monstrous Orca and just prior to Angelica's magical escape from the eager advances of her brave rescuer. Those familiar with the poem and its various representations in print and paint would have searched in vain for the magic ring that generally adorned Angelica's finger. Cecco Bravo has eliminated this iconographic detail from the painting and has thus pushed the narrative toward the final episode, in which Angelica is transformed into thin air and leaves Ruggiero alone with his unfastened armor. Such a playful deviation from the iconographic standard must have provided entertainment and an intellectual puzzle for the painting's audience: Angelica's escape depends upon the ring, which can only be inside her mouth.

Angelica's pose echoes the classical "Crouching Venus" or Venus of Doidalsas type (named after a third-century B.C.E. bronze by Doidalsas of Bithnyia and known through Roman marble copies). It may also be a response to the works of Giambologna that Cecco Bravo could have seen in the Tribune of the Uffizi.

BIBLIOGRAPHY

Fern Rusk Shapley, *Paintings from the Samuel H. Kress Collection: Italian Schools XVI–XVIII Century* (London: Phaidon Press, 1973), 86; Ludovico Ariosto, *Orlando Furioso*, trans. William Stewart Rose, eds. Stewart A. Baker and A. Bartlett Giamatti (Indianapolis: The Bobbs-Merrill Company, 1968), 93; Gerhard Ewald, "Hitherto Unknown Works by Cecco Bravo," *Burlington Magazine* 102 (August 1960): 343–52; Anna Rosa Masetti, *Cecco Bravo* (Venice: Neri Pozza, 1962); Anna Barsanti, *Il Seicento fiorentino* (Florence: Cantini, 1986), 362; Timothy J. Standring, catalogue entry in *The David and Alfred Smart Museum of Art: A Guide to the Collection*, eds. Sue Taylor and Richard A. Born (New York: Hudson Hills Press, 1990), 50; Wendy Stedman Sheard, *Antiquity in the Renaissance* (Northhampton, Mass.: Smith College Museum of Art, 1979), 42–43.

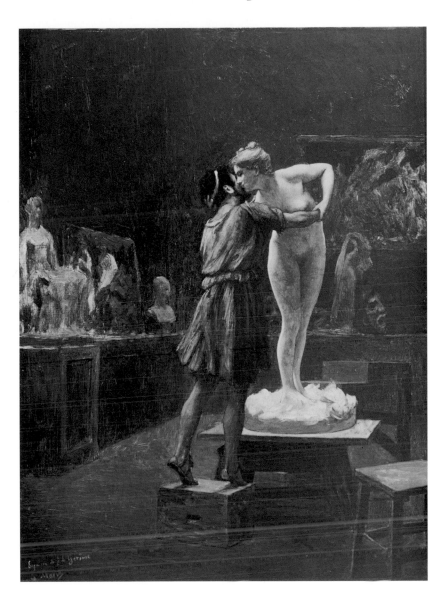

12 **Jean-Léon Gérôme**
French
1824–1904

Pygmalion and Galatea,
circa 1890

Oil on canvas
17⅜ x 13¼ in.
(44.1 x 33.6 cm)

Purchase, Gift of Mr. and Mrs.
Eugene Davidson, 1980.73

*At his touch the ivory lost its hardness, and grew soft: his fingers made
an imprint on the yielding surface, just as the wax of Hymettus melts
into the sun and, worked by men's fingers, is fashioned into many differ-
ent shapes, and made fit for use by being used. The lover stood, amazed,
afraid of being mistaken, his joy tempered with doubt, and again and
again stroked the object of his prayers.*

METAMORPHOSES, BK. X, 282–89

The Smart Museum's *Pygmalion and Galatea,* a preparatory oil sketch by Jean-
Léon Gérôme, captures the moment of metamorphosis of Pygmalion's statue
into a woman: she leans to kiss her creator's cheek as her ivory limbs fill with
color. Though the objects in the studio echo Gérôme's own late nineteenth-cen-
tury works—such as *Tanagra,* a tinted marble sculpture of a seated woman, seen
on the left side of the painting—the Greek sculptor and his beautiful creation
are recognizable in their mythological narrative context.

The predecessor to a larger, more finished painting of this subject in the Metropolitan Museum of Art in New York, the Smart sketch provides insight into Gérôme's working process. The meticulously finished style that earned Gérôme praise in the French Academy is here loose and expressive. The intimacy of the figural placement in the Smart sketch allows the viewer to enter the painting as a spectator, whereas in the final version Gérôme reversed the central figures to shield Galatea's face and turn her back on the viewer.

The Smart sketch is the first of a series of works by Gérôme that deal with the infusion of life into a classical work of art. After completing the Metropolitan's painting in 1890, he painted *Sculpturae vitam insufflat pictura (Painting Breathes Life into Sculpture)* and *Working on the Marble,* and he sculpted his own polychromed *Pygmalion and Galatea.* In each of these works, stone in its sculpted form was imbued with life through paint. Gérôme's interest in this subject was instigated by the Boeotian discoveries of brightly painted Hellenistic statuettes, or Tanagra figures, in the 1870s. —AT

BIBLIOGRAPHY

Ovid, *Metamorphoses*, ed. M. A. Innes (London: Penguin Books, 1955), 231–32; Gerald M. Ackerman, *The Life and Work of Jean-Léon Gérôme* (Dayton, Ohio: Dayton Art Institute, 1972); Ackerman, *The Life and Work of Jean-Léon Gérôme* with a catalogue raisonné (London: Sotheby's Publications, 1986); Naomi Maurer, catalogue entry in *The David and Alfred Smart Museum: A Guide to the Collection,* eds. Sue Taylor and Richard A. Born (New York: Hudson Hills Press, 1990), 92–93.

13 **Richard James Wyatt**
English
1795–1850

Narcissus, 1820–1850

Carved marble
Height 27 in. (68.6 cm)

Purchase, The Eloise W. Martin Purchase Fund, 1982.7

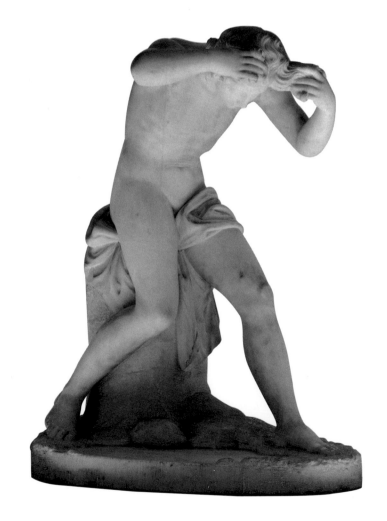

Transformation of the Antique

Spellbound by his own self, he remained there motionless, with fixed gaze, like a statue carved from Parian marble. . . . He returned to gazing distractedly at that same face. His tears disturbed the water, so that the pool rippled and the image grew dim. He saw it disappearing, and cried aloud: 'Where are you fleeing? Cruel creature, stay, do not desert one who loves you! Let me look upon you, if I cannot touch you. Let me, by looking, feed my ill-starred love.' In his grief, he tore away the upper portion of his tunic, and beat his bared breast with hands as white as marble.

METAMORPHOSES, BK. III, 419–21 AND 475–82

Ovid's story of Narcissus is notable for its representation, in text, of an image. Indeed, Leone Battista Alberti considered Narcissus the inventor of painting because of his famous, enchanting reflection. Richard James Wyatt's interpretation of this myth in white Carrara marble highlights the intimacy of this story of infatuation: Narcissus's face, reflected in the pool beneath him, remains hidden from all except himself. Wyatt's composition conforms to the textual tradition of Narcissus, "spellbound by his own self . . . motionless . . . like a statue." Narcissus ignored the loving attention of the nymph Echo in favor of gazing at his own image. Grief-stricken that the intangible reflection could never return his love, Narcissus wasted away, died, and was transformed into a flower bearing his name.

Wyatt was a pupil of Canova in Rome in the 1820s, and is chiefly celebrated for his female nudes. The Smart Museum's *Narcissus* presents a classicizing male nude form in the round. While the sculpture may be approached from a number of angles, Narcissus obstructs a clear view of his face. The viewer is even denied access to his reflection: it belongs solely to Narcissus. —AT

BIBLIOGRAPHY

Ovid, *Metamorphoses*, ed. M. A. Innes (London: Penguin Books, 1955), 83–87; Leone Battista Alberti, *On Painting*, trans. John R. Spencer (New Haven: Yale University Press, 1965), 64; Benedict Read, *Victorian Sculpture* (New Haven: Yale University Press, 1982); R. A. Martin, *Life and Work of R. J. Wyatt* (Ph.D. diss., University of Leeds, 1972).

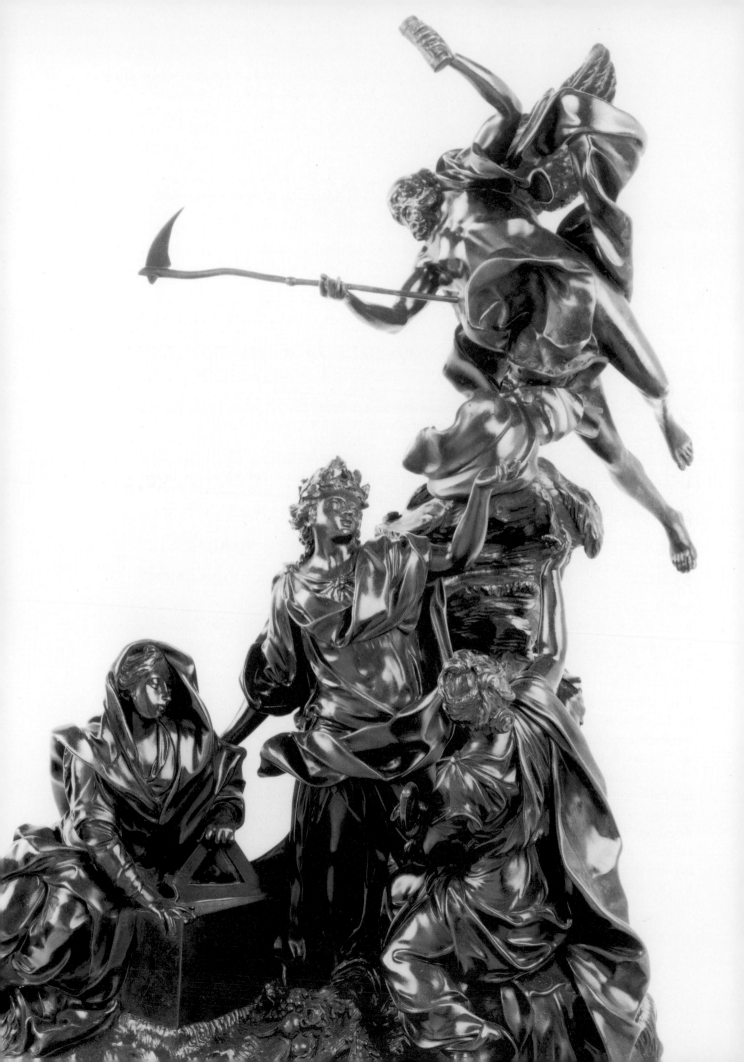

ALLEGORY

NORIKO MATSUBARA

Allegory in the visual arts dates from classical antiquity. Roughly defined, allegory is a means of conveying an abstract idea —such as virtue, vice, fortune, time, and fame— under the guise of a representational image, generally a personification, but at times a complex combination of human figures and other symbols.[1] Most personifications conventionally assume a female form, for many Latin abstract nouns are feminine. Typically, each personification has one or more attributes that permit its identification, such as a balance for Justice, a wheel or a globe for Fortune, and a peacock for Pride. Allegorical types sometimes underwent modification, as in the case of Temperance, who originally bore jugs of water and wine but was later accompanied (after its invention) by a clock.[2]

An allegory, as a medium of making the invisible visible through allusion and substitution, makes no direct references to the idea it is to convey, and operates through a conventional understanding of an oblique relationship between image and concept. Even so, it can be a highly effective means of communication. Indeed, throughout the long history of Western art, allegory has served the ambitious ruling classes as a means of impressing an ideal self-image or an ideology on the general public in order to realize political aspirations. Similarly, it has been extensively employed by Christian authorities, and particularly by the Catholic Church after the Reformation, in shaping and promoting public devotional practices. In a more personal and purely cultural vein, allegory has fascinated learned individuals who enjoyed the rhetorical play of classical origin as a sophisticated pastime, and who received great satisfaction from the artistic merits of allegorical imagery.

The present exhibition allows us a glimpse of how and in what ways allegory in the visual

arts has long attracted people, both as an instrument of propaganda and as a more general form of cultural expression. In order to "place the antique" in an early modern European context, this essay describes how allegorical images were reconnected with authentic classical forms and subjects during the Renaissance. It considers allegory's renewed and extremely prominent place in the visual arts, focusing on its application to small-scale metalwork and, in this context, its role as an element of both sheer artistic interest and other, more worldly concerns.

From its very beginnings, allegory was used not only in the visual arts but also in literary and rhetorical writing. Indeed, visual allegories were drawn initially from Greco-Roman mythology and fables and, in later times, from the Bible and works of Christian theology and moral philosophy.[3] Classically based allegories survived and continued to be employed (together with new inventions) in secular and religious art throughout the millennia, and even into the nineteenth century. But as social systems and ideologies shifted, these allegories also took on changes in appearance and function, and this was especially the case during the medieval period.

The Middle Ages inherited classical allegories and recognized their effectiveness in visualizing the invisible. But allegorical traditions that had been created in a pagan context required substantial transformation to be sacralized and brought into concordance with Christian orthodoxy. They could survive only under a Christian name and appearance: so, the winged female figure of Victory was transformed into the celestial angel (cat. no. 31). Similarly, although they retained their original identification, the personifications of the Virtues and Vices could be used solely in the context of Christian morality. A major literary analogue can be found in Prudentius's *Psychomachia* (398–400), which is among the most important allegorical epics of the Western world. The theme of conflict between the Virtues and Vices elaborated in this work was a favored allegory during the Middle Ages, and often appeared in manuscript illuminations and the relief decoration of Romanesque and Gothic church facades. This sacralization of pagan images was not limited to individual figures but was sometimes extended to interpret entire mythological systems in terms of Christian morality, as in the renowned case of Petrus Berchorius's *Ovidius moralizatus* (ca. 1330).

Contrary to the medieval separation of the classical form from its content, Renaissance interest in the re-evaluation of the Greco-Roman legacy brought about the "recovery" of allegory, which does not mean the recovery from complete oblivion but the restoration to its original form, on the basis of enthusiastic archaeological and philological studies. Allegorical images and personifications, now stripped of their medieval clothing, regained integration of the formal and literary traditions. They were emancipated from the predominantly Christian framework of the previous age and began to be applied more broadly, to various aspects of philosophy and to social phenomena as well. This popularization was partly due to Neoplatonist philosophy, a fundamental element in the formation of Renaissance world views. Neoplatonic thought encouraged the use of allegories, interpreting them as physical manifestations of an Idea which was supernatural and thus otherwise inapproachable for the human being.[4]

It was the publication of a series of emblem books in the middle of the sixteenth century, however, that became the actual driving force in the popularization of allegorical expressions. This publication was itself motivated by the discovery in 1419 of a Greek copy of the *Hieroglyphica*, a text by the fourth-century grammarian Horapollo that elucidated allegorical elements of Egyptian picture writing. This work, which was published in Venice in 1505, inspired Italian humanists to make their own compila-

tions. Andrea Alciati's *Emblematum liber* (1531) was the first Renaissance handbook of ancient symbols and allegories. It was an important model for later works of this kind and was soon followed by the *Hieroglyphica* of Piero Valeriano, published in 1556. The studies on mythology by Lilio Gregorio Giraldi, Natale Conti, and Vincenzo Cartari were also published around this time and helped popularize allegorical representations of pagan gods in literature and the visual arts.[5] The most influential of these emblem books was published in Rome in 1593: the *Iconologia* of Cesare Ripa continued to be translated into various European languages in its entirety and in abridged versions, some very freely adapted, until the eighteenth century. It featured hundreds of concepts alphabetized according to their Italian names, each rendered vivid through the description of a costumed personification bearing symbolic attributes. Ripa's original work was not illustrated, but later editions added plates by contemporary artists to complement the text.

In parallel with the development of allegory, the visual arts became increasingly powerful vehicles of self-glorification and aggrandizement during the later fifteenth and sixteenth centuries. In a period characterized by a growing self-con-sciousness, society's most powerful and wealthy members—kings, popes, princes, and even burghers—sought a lasting inscription for themselves in the pages of history. They found an ideal model for this ambition in portrait medals, which were inspired in both form and political implication by ancient Roman coinage and, consequently, drew heavily on classical allegory.

The Roman emperors appreciated the potential of coins, with their constant and wide circulation, to disseminate political propaganda across a vast territory. An example of the standard content of Roman imperial coins is found in a denarius (silver coin) in the Smart collection, dated from the reign of Augustus's adopted son Tiberius (14–37 C.E.) (fig. 3). The obverse of this coin shows Tiberius laureate in profile, encircled by his name and a reference to his deified father: TI[berus] CAESAR DIVI AVG[usti] F[ilius] AVGVSTVS (Emperor Tiberius son of the god Augustus). The female figure on the reverse may be identified as an allegory of Pax (peace) by the olive branch in her left hand, referring specifically to the peaceful reign of Augustus (Pax Romana), and by the scepter, which refers to imperial authority. Through the combination of these images, the coin aims at establishing Tiberius as the legitimate successor of the divine Augustus.[6]

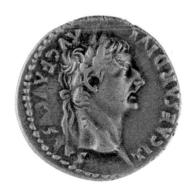 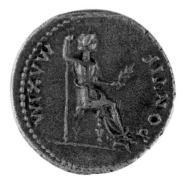

Fig. 3
ROMAN
Imperial Denarius with Head of Tiberius Caesar (obverse), *Seated Figure of Pax* (reverse), 36–37 C.E. (see Appendix).

Renaissance portrait medals borrowed their basic form from Roman imperial coins like this one: the front bore a portrait identified by an accompanying inscription, while the reverse featured a narrative scene, a heraldic or symbolic device, or, important for our argument, an allegory glorifying the virtuous sitter. The Smart's portrait medal of Alessandro de' Medici (cat. no. 15) reveals this characteristic pairing.

Despite these apparent likenesses, however, there are fundamental differences between the official roles of medals and coins. Unlike coins, medals are not intended to circulate as currency but are to remain precious art objects, free from any official controls and existing in smaller numbers for the private viewing of a select audience. In this sense, their closer approximation can be found in Roman medallions, which were struck at the same imperial mints as coins but with the primary purpose of presentation or distribution on special occasions, such as the new year, imperial adoptions, marriages, births and deaths, religious celebrations, and military victories. Medallions were not necessarily subject to the standardizations of coins, but were often larger in size and were, above all, of a greater artistry.[7]

No matter what their direct ancestors were, the formal link that bound Renaissance medals to the ancient Roman world greatly appealed to patrons who admired that glorious history and wished to identify their own domain as a "New Rome." The idea of restoring the past glory of Rome and becoming a "New Augustus"— a recurring theme during the medieval period and, most conspicuously, at the court of Charlemagne—now became a common aspiration of Renaissance rulers.[8] It is confirmed by the portrait medal of Philip II (cat. no. 16), in which the Spanish king assumes the guise of Apollo, the patron god of Augustus.

The production of medals was not limited to the ruling classes but was equally supported by Renaissance humanists with a keen interest in ancient coins as historical or antiquarian evidence, as well as by artists who sought inspiration in numismatic images.[9] Some wealthy humanists felt the allure of allegorical medals with their potential to honor a sitter and make allusions to the ancient world because, like kings and princes interested in raising their social position, they too sought a measure of self-apotheosis.[10] The Smart's portrait medal of Antonio Magliabechi (cat. no. 3) and the medallion of Pietro da Cortona (cat. no. 35), although dating from slightly later, are examples of such ambitions.

In addition to portrait medals, artists of the Italian Renaissance produced plaquettes, single-sided metal reliefs usually small enough to fit in the hand and ranging in shape from simple geometric outlines to more elaborate forms such as shields. These intimate objects were particularly favored by humanists and collectors because they were relatively inexpensive and offered the possibility of diverse subject matter, which was drawn chiefly from classical mythology or Christian iconography and frequently involved allegories. The earliest Renaissance plaquettes, produced in Rome in the middle of the fifteenth century, were actually cast from carved Greek and Roman gems.[11]

The function of Renaissance plaquettes has long been in question: they may have decorated such utensils as writing boxes, coffers, and inkstands, or they may have been independent artworks. Since only a limited number of extant pieces have marks indicating that they were originally affixed to another surface, it seems more likely that they were primarily intended to be collected and appreciated for their own sake, just like portrait medals. The plaquettes of *Mars as a Sign of the Zodiac* (cat. no. 18) and the *Allegory of the Sense of Smell* (cat. no. 19) are pierced along the top, suggesting that they once hung independently on a wall or from a shelf. While the *Allegory of Summer* (cat. no. 20) is not pierced, marks on the reverse testify to its use as an attached decoration, not an unusual function

for plaquettes produced, like this one, in Augsburg.

Regardless of their use, plaquettes played a significant role in diffusing iconographic motifs—which were often classical—throughout Europe. In this regard they paralleled or even surpassed prints, serving as a sort of "pattern book" and providing models for other artistic media, including painting, drawing, sculpture, and various decorative arts, especially historiated majolica (cat. no. 21). This was not the only direction of influence, however, and northern European plaquettes (unlike their Italian counterparts, which frequently presented original designs) were commonly based on graphic works. Peter Flötner's plaquette of *Mars as a Sign of the Zodiac* is an example of this exchange between media.

Classically inspired allegories were applied not only to small objects like medals and plaquettes, but to monumental works in more sumptuous ways and on a grander scale. In the decoration of palaces and official buildings, allegories were incorporated into mythological, historical, and religious programs, often designed to immortalize the name of the patron. The decoration of the Galerie François I at Fontainebleau by the Florentine artist Rosso Fiorentino praises King Francis I (1515–47) with allegorical representations of his deeds and virtues in the guise of fables.[12] Francis's long-standing rival, the Holy Roman Emperor Charles V (1519–56), exploited the potential of allegory in the ephemeral decorative apparatus he employed for civic entrances, ceremonies, and processions. Here, the busts of Roman emperors and a range of allegorical figures propagated his claim as the legitimate successor to the empire of ancient Rome.[13] Glorifying and aggrandizing programs also served state governments: in decorations for the Palazzo Ducale in Venice, the painters Tintoretto, Veronese, and Palma il Giovane represented the Republic of Venice as the female figure Venetia, who enjoys an eternal glory.[14]

The propagandistic use of allegory reached its fullest flourishing in the late sixteenth and seventeenth centuries. In the Palazzo Barberini in Rome, the leading baroque artist Pietro da Cortona celebrated Pope Urban VIII with the illusionistic scene of the *Triumph of Divine Providence*, an allegorical manifestation of the idea that the divine plan would be realized through the virtues of the pope and his family, the Barberini.[15] The Counter Reformation Church itself, in its struggle for the victory of Catholicism over Protestantism, lavishly adopted allegory as a device of propaganda. A prime example is found in the ceiling painting of the *Glory of St. Ignatius*, done around 1690 by Andrea Pozzo for the Jesuit church of Sant'Ignazio in Rome. Pozzo uses allegory to illustrate the domination of the world by the Catholic Church with the fervent support of the Jesuits. St. Ignatius, founder of the Society of Jesus, appears in the center of the illusionistic ceiling, which seems open to the heavens; supporting this image are four female figures, emblems of the four continents and, as such, symbols of successful missionary work throughout the world.

This allegorizing tendency culminated during the reign of Louis XIV (1643–1715).[16] His palace at Versailles was a monumental repository of allegories, which were scattered throughout the compound in honor of the absolute monarch and which identified Louis with the sun god Apollo. The gardens at Versailles, for example, center around the Fountain of Apollo, and a sequence of rooms named after Olympian gods terminates in the Salon d'Apollon. These rooms, filled with allegorical, mythological, and historical scenes by Charles Le Brun and other painters, praised the exploits of the Sun King. Similar programs had been invented by earlier ambitious patrons including Francis I, but Louis's project had no parallel in extent and magnificence. With its ostentatious Apollonian imagery and allegory, Versailles further developed the age-old tradition of the ruler cult, a tradition with roots in ancient

Near Eastern custom and with its classical exemplar in the cult of the emperor Augustus (cat. no. 16). Louis thus made himself into the culminating personification of European absolutism, and his glorious reign was remembered as a "Neo-Augustan Age" by Voltaire.[17]

NOTES

1. Erwin Panofsky, "Iconography and Iconology," in his *Meaning in the Visual Arts* (New York: Doubleday, 1955), 26–30.

2. For more about personifications, see E. H. Gombrich, "Personification," in *Classical Influences on European Culture, A.D. 500–1500*, ed. R. R. Bolgar (London: Cambridge University Press, 1971), 247–57.

3. There were cases, however, where this relationship was reversed and where writers drew inspiration from the visual.

4. For the application of Neoplatonist interpretations to actual works of art, see Erwin Panofsky, *Studies in Iconology: Humanistic Themes in the Art of the Renaissance* (London: Oxford University Press, 1939), and E. H. Gombrich, *Symbolic Images: Studies in the Art of the Renaissance II* (London: Phaidon Press, 1972).

5. Lilio Gregorio Girardi, *De deis gentium varia et multiplex historia in qua simul de eorum imaginibus et cognominibus agitur* (Basel, 1548); Natale Conti, *Mythologiae sive explicationis fabularium libri X* (Venice, 1551); Vincenzo Cartari, *Le imagini colla sposizione degli dei degli antichi* (Venice, 1556). On the publication of emblem books and mythological studies in the sixteenth century, see Jean Seznec, *La survivance des dieux antiques. Essai sur le rôle de la tradition mythologique dans l'humanisme et dans l'art de la Renaissance* (London: The Warburg Institute, 1940).

6. *The Classical Collection*, eds. G. Ferrari, C. M. Nielsen, and K. Olson (Chicago: The David and Alfred Smart Museum of Art, 1998), 193.

7. It is also true that the whole of Roman imperial coinage was to some extent commemorative and that it is difficult to draw a clear line between Roman coins and medallions, leaving many ambiguous pieces. See Jocelyn M. C. Toynbee, *Roman Medallions*, with corrections and intro. by W. E. Metcalf (New York: The American Numismatic Society, 1986).

8. William Hammer, "The Concept of the New or Second Rome in the Middle Ages," *Speculum* 19 (1944): 50–62.

9. Roberto Weiss, "The Study of Ancient Numismatics during the Renaissance (1313–1517)," *Numismatic Chronicle*, 7th ser., 8 (1968): 177–87; John Cunnally, *The Role of Greek and Roman Coins in the Art of the Italian Renaissance* (Ph.D. diss., University of Pennsylvania, 1984), chap. 1.

10. Rudolf and Margot Wittkower, *Born Under Saturn: The Character and Conduct of Artists* (New York: Random House, 1963), chap. 1; Michael Levey, *Painting at Court* (New York: New York University Press, 1971).

11. J. W. Pope-Hennessy, *The Italian Plaquette* (London: Oxford University Press, 1964), 67.

12. S. Béguin, O. Binenbaum, A. Chastel, et al., "La Galerie François Ier au château de Fontainebleau," *Revue de l'art,* nos. 16–17 (1972): 7–174.

13. Fernando Checa, *Carlos V y la imagen del héroe en el Renacimiento* (Madrid: Taurus, 1987).

14. David Rosand, "'Venetia': The Figuration of the State," in *Artistic Strategy and the Rhetoric of Power: Political Uses of Art from Antiquity to the Present*, ed. David Castriota (Carbondale: Southern Illinois University Press, 1986), chap. 6.

15 Francis Haskell, *Patrons and Painters: A Study in the Relations between Italian Art and Society in the Age of the Baroque* (New York: Harper and Row, 1971).

16. On the use of allegory by the French monarchy, see cat. no. 25.

17. John B. Wolf, "The Cult of the King," in *Louis XIV: A Profile*, ed. John B. Wolf (New York: Hill and Wang, 1972), 127–51; Voltaire, "A Neo-Augustan Age," in Wolf, *op. cit.,* 222–28; Louis Marin, *Portrait of the King*, trans. Martha Houle (Minneapolis: University of Minnesota Press, 1988).

14 **Giovanni Bernardi da Castelbolognese**

Italian

1496–1553

*Pope Clement VII
(1523–1534)* (obverse),
*Joseph Reveals Himself to His
Brothers* (reverse), 1529–1530

Struck gilt bronze
Diameter 1 3/8 in. (3.5 cm)

Purchase, The Cochrane-
Woods Collection, 1977.117

Issued by the papal mint, this gilt bronze portrait medal was created by the professional medalist Giovanni Bernardi da Castelbolognese and was mentioned by Vasari in his *Lives*. The obverse presents the bust-length figure of Pope Clement VII (Giulio de' Medici) surrounded by an identifying inscription: CLEM[ens] VII PONT[ifex] MAX[imus]. The reverse presents Joseph revealing himself to his brothers, and is inscribed above the scene: EGO SUM JOSEPH/FRATER VESTER.

This subject has a historical connection to Clement's reconciliation with the Holy Roman Emperor Charles V (1519–56) and his other adversaries. During the 1520s, a war-ridden Italy was plagued by outside forces vying for control of its city-states, and in 1527 the army of Charles V captured Rome. Though the foundations of the papacy were seriously challenged during this period, Clement and the emperor were reconciled in 1529 and the pope's position as Pontifex Maximus was restored. At this time, Clement also helped return control of Florence to his family, the Medici.

The Medici coat of arms attached to the throne on the reverse of the medal explicitly connects Clement to Joseph, here in the act of reconciliation. Not only is the connection meant to convey the pope's clemency, but also to associate him with Joseph's administrative skills. St. Ambrose saw Joseph as the model for an ideal bishop, one who combined civil and administrative abilities. Philo interpreted Joseph as a statesman who created "order in disorder and concord where all was naturally discordant." —AT

BIBLIOGRAPHY

Stephen K Scher, ed., *The Currency of Fame: Portrait Medals of the Renaissance*, (London: Thames and Hudson in association with the Frick Collection, 1994); Nathan Whitman et al., *Roma Resurgens: Papal Medals from the Age of the Baroque* (Ann Arbor: University of Michigan Museum of Art, 1981), 7.

**15 Domenico de' Vetri
(Domenico di Polo di Angelo
de' Vetri)**
Italian
Circa 1480–1547

*Alessandro de' Medici, First
Duke of Florence (1532–1537)*
(obverse), *Allegory of Peace
and Abundance* (reverse), 1534

Struck silvered bronze
Diameter 1 7/16 in. (3.7 cm)

Purchase, Gift of Mrs. John V.
Farwell III, 1977.7

BIBLIOGRAPHY

Christopher Hibbert, *The House of Medici:
Its Rise and Fall* (New York: William Morrow
and Company, 1975), part III, chap. 19;
Andrea Norris and Ingrid Weber, *Medals and
Plaquettes from the Molinari Collection at
Bowdoin College* (Brunswick, Me.: The
Atheonsen Press, 1976), 18–19.

Though rumored to be the child of Cardinal Giulio de' Medici (the future Pope Clement VII), Alessandro was officially the son of Lorenzo de' Medici, Duke of Urbino. In 1532, after a few years of exile, he was appointed ruler of Florence by Emperor Charles V, whose daughter later became his wife. This portrait medal, done two years later, shows Duke Alessandro in profile encircled by his title. On the reverse are emblems of Peace and Abundance. Peace is personified as a seated woman preparing to set fire to a pile of arms with a flaming torch, iconography typical of Renaissance and baroque art. Below her feet appears a symbol of Mars, the war god. In her left hand, Peace holds the familiar attribute of the olive branch and a cornucopia symbolizing plenty. Abundance and peace were often linked, suggesting the generous food supply resulting from justice and good government. The figure and the inscription, FVNDATOR QVIETIS (founder of the quiet), come together to glorify Alessandro as a peacemaker.

Contrary to the ideal image of rulership that this medal was intended to propagate, Alessandro's tyrannical behavior made him far from popular. To confirm the end of Republican Florence and the onset of his own, absolute power, he had the council bell removed from the Palazzo della Signoria and recast into medals that honored the Medici. Alesssandro's reign ended abruptly when he was assassinated in 1537 by one of his family members. —NM

16 Jacopo Nizzola da Trezzo
Italian
1515/19–1589

King Philip II of Spain
(obverse), *Apollo in a
Quadriga* (reverse), 1555

Cast bronze
Diameter 2 11/16 in. (6.8 cm)

Purchase, The Cochrane-
Woods Collection, 1977.114

This medal of Philip is inscribed PHILIPUS REX PRINC HISP ÆT S AN XXVIII (Philip, King of the principality of Spain, age 28). It was executed along with its pendant, that of Mary Tudor of England, in 1555 to commemorate their marriage the previous year. 1555 was an especially important year for Philip because on this date his father, Emperor Charles V, ceded the Netherlands to him as a key step in abdicating rule of a vast empire. On this occasion, Philip adopted a personal emblem with the motto inscribed here: IAM ILLUSTRABIT OMNIA (Now he will illuminate everything). In the emblem's accompanying image, the sun god Apollo rides his quadriga through the heavens, over a landscape and a map representing the New World. The Smart medal leaves out the map, but retains the image of the new territories that Philip would eventually dominate as

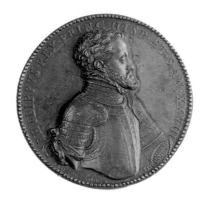

king of Spain (1556–98). In his *Imprese illustri*, the Italian literate Girolamo Ruscelli explained this emblem as a proclamation that Philip's power, like the sun, reaches every corner of the globe and will illuminate a shadowy world.

The connection between a ruler and a solar deity goes back to ancient times. Most important to the Renaissance was the case of Augustus who, influenced by the divine rulers of the East, claimed Apollo as his special patron and made the sun his personal emblem. During the Middle Ages, Christian iconographers promoted the triple association of Emperor-Apollo-Christ, an allegorical motif appropriated and developed by the Hapsburg monarchs. In the figure of Louis XIV of France, this solar allegory found its fullest and most extravagant embodiment. NM

BIBLIOGRAPHY

Marie Tanner, *The Last Descendant of Aeneas: The Hapsburgs and the Mythic Image of the Emperor* (New Haven: Yale University Press, 1993), chap. 12; Stephen K. Scher, ed., *The Currency of Fame: Portrait Medals of the Renaissance* (London: Thames and Hudson in association with the Frick Collection, 1994), 158–60; Girolamo Ruscelli, *Le imprese illustri* (Venice, 1572), 15–16.

17 **Gaspero Bruschi (modeler)**
Italian, active Doccia
Circa 1701–1780
Italian, Doccia Factory
(manufacturer)

Portrait Medallion with Bust of Marchese Carlo Ginori (1702–1757), circa 1757

Hard-paste porcelain
Height 6¾ in. (17.2 cm)

Purchase, The Harold T. Martin Fund, 1979.54

Marquis Carlo Ginori was the founder of the Doccia porcelain factory. A leading figure in contemporary politics, he was also a man of scientific curiosity and invention. While visiting Vienna on diplomatic duties, he met and hired a craftsman who was familiar with the Vienna porcelain factory, with the intention of establishing a center of production at Doccia, near Florence. Ginori's factory remained under the control of his family until 1896, when it was purchased by

the Milanese china dealer G. Richard and came to be known as Richard-Ginori, the only existing Italian porcelain factory to be in continuous operation since the eighteenth century.

The sculptor Gaspero Bruschi served Ginori as head of the porcelain modelers. He shared the marquis's great interest in sculpture and set about translating marble and bronze works into porcelain. Consequently, a significant part of his work was dedicated to the production of sculptures cast from molds after bronzes, especially late seventeenth and early eighteenth-century Florentine examples, of which Ginori had a large collection. He also made porcelain reproductions of ancient sculptures, including busts and cameos of Roman emperors. Even pieces of tableware were treated as bas-reliefs, sometimes featuring elaborate mythological scenes. Bruschi's portrait of Ginori presents his sitter in the robes of a Florentine senator, a position confirmed by the encircling inscription: CAR MARC COM GINORI SEN FLOR LIBVRN PRAES. It also reflects the patron's inclination toward sculptural works and finds a close source in the popular contemporary genre of cast-metal profile portrait medallions which, in turn, were inspired by ancient models. —NM

BIBLIOGRAPHY

Clare Le Corbeiller, *Eighteenth-Century Italian Porcelain* (New York: The Metropolitan Museum of Art, 1985), 12–17; Klaus Lankheit, *Die Modellsammlung der Porzellanmanufaktur Doccia: Ein Dokument italienischer Barockplastik* (Munich: Bruckmann, 1982); Elena Ciletti, catalogue entry in *The David and Alfred Smart Museum of Art: A Guide to the Collection*, eds. Sue Taylor and Richard A. Born (New York: Hudson Hills Press, 1990), 65.

18 **Peter Flötner**
German
1485/90–1546

Mars as a Sign of the Zodiac,
circa 1540

Cast gilt bronze
2⅝ x 4 in. (6.7 x 10.2 cm)

Purchase, The Cochrane-Woods Collection, 1977.115

SEE COLOR PLATE 3

Renaissance cosmologies held that the seven known planets exercised influence on the natures and activities of human beings. Each planet was thought to have control over a specific type of personality, consistent in character with the pagan deity after which that planet was named. In accordance with this belief, a popular type of image was that of a planet represented as the appropriate god or goddess together with his or her own "children," or those particularly under the planet's influence.

Only two of the seven known planets, Mars and Venus, are represented in Flötner's surviving plaquettes, and it is not clear whether he dealt with the other

five. The Smart plaquette represents Mars as the war god pulled through the air on a chariot drawn by two wolves, an animal often associated with him. Its wheels bear the zodiacal signs of Aries the Ram and Scorpio, constellations under the rule of Mars. The god wears a suit of armor and holds an unsheathed sword and a shield. Flötner apparently drew this iconography from a series of German woodcuts of 1531 attributed to Georg Pencz, which in turn had been inspired by the fifteenth-century Florentine engraver Baccio Baldini. However, Flötner adapted the motif to suit an interest in landscape, copying only the chariot after Pencz, omitting his fighting figures, and adding a wooded, mountainous backdrop. Flötner's mastery of landscape is a principal characteristic of his decorative sculpture, and the naturalistic details in this work are reminiscent of his contemporary Albrecht Altdorfer and the artists of the Danube school. —NM

BIBLIOGRAPHY

Konrad Lange, *Peter Flötner, ein Bahnbrecher der deutschen Renaissancen auf Grund neuer Entdeckungen* (Berlin: G. Grote, 1897), 124, nos. 18–19; Jeffrey Chipps Smith, *Nuremberg: A Renaissance City, 1500–1618* (Austin: University of Texas Press, 1983), cat. no. 103; Ingrid Weber, *Deutsche, Niederländische und Französische Renaissanceplaketten: 1500–1650* (Munich: Bruckmann, 1975), pl. 12, no. 47.

19 **Peter Flötner**
German
1485/90–1546

Allegory of the Sense of Smell,
circa 1540

Cast bronze
2½ x 3⅜ in (6.4 x 8.6 cm)

Purchase, The Cochrane-Woods Collection, 1977.116

The theme of the five senses of man was favored mainly in northern Europe, particularly in the Netherlands, and was found in prints more frequently than in paintings. Each sense is often represented as a human figure, generally a woman but sometimes a couple, engaged in symbolic activity and bearing the proper attributes. Since Hearing is associated with music, its personification usually plays some instrument. Sight looks into a mirror, and Taste has a basket of fruit or other foods. Touch may have a hedgehog or an ermine, and a bird may perch on her hand. Smell usually carries a bunch of flowers or a pot of perfume, and is sometimes accompanied by a dog, which has a keen nose.

Flötner's representation of the sense of smell is quite different from the eye-pleasing, elegant iconography typically used for this subject. The center of his plaquette is occupied by a woman who holds a child over her left arm as she attends to the demands of nature. Behind her is another child who covers his nose with his hand, in a remarkably frank indication of a "smell." Flötner adopt-

BIBLIOGRAPHY

Konrad Lange, *Peter Flötner, ein Bahn-brecher der deutschen Renaissancen auf Grund neuer Entdeckungen* (Berlin: G. Grote, 1897), 131, no. 112; D. Wixom, *Renaissance Bronzes from Ohio Collections* (Cleveland: The Cleveland Museum of Art, 1975), cat. no. 169; *Gothic and Renaissance Art in Nuremberg, 1300–1550* (New York: The Metropolitan Museum of Art, 1986), 446–47.

ed the straightforward representation of scatological subjects in some graphic works as well; in this, he was not unlike other northern European artists, including Rembrandt, who made similar sorts of engravings. It is unclear whether Flötner ever depicted the other senses, though his allegory of jealousy does survive and is occasionally misinterpreted as a representation of touch. —NM

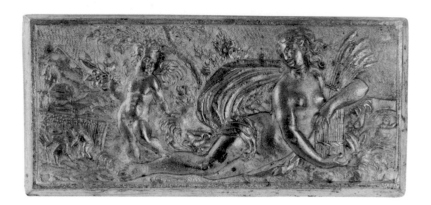

20 Workshop of Matthias Wallbaum (?) or Johannes Flicker III or IV (?)
South German, Augsburg

Allegory of Summer,
late sixteenth century

Cast brass or bronze
1⅝ x 3⅝ in. (4.1 x 9.2 cm)

Gift of Mrs. Ruth A. Blumka in memory of Professor Edward A. Maser, Founding Director of the Smart Gallery, 1973–1983, 1989.6

Along with Nuremberg, Augsburg was a prosperous center in southern Germany. It owed its economic and cultural rise at the beginning of the sixteenth century to a boom in silver and copper mining. Thanks to these abundant natural resources, metalwork became a major industry of the city and eventually allowed it, toward the end of the century, to become the leading German center for plaquette making, surpassing its rival Nuremberg. Most of the Augsburger plaquettes were intended for the decoration of objects such as altars, silver vessels, and cabinets, and were made not from original designs but from prints. Traces of screws on the reverse of the *Allegory of Summer*, which seem to be original to the piece, reveal that it was once attached to another surface.

This plaquette originally belonged to a series of the Four Seasons, which was a popular subject in the workshop of the goldsmiths Matthias Wallbaum and Johannes Flicker III or IV. In fact, this theme can be traced back to the art of the Greek Archaic period. Its standard iconography was established in Roman floor mosaics and the decoration of sarcophagi, and remained remarkably consistent until the eighteenth century. The Smart plaquette follows these ancient models: summer is personified as a naked woman reclining on the ground with a sheaf of grain under her arm and looking toward a putto who holds a branch with fruit. The reaping scene in the lower left corner is another sign of abundance that frequently accompanied the figure of summer. —NM

BIBLIOGRAPHY

Carl Hernmarck, *The Art of the European Silversmith: 1430–1830*, vol. 1 (London: Sotheby Parke Bernet, 1977), 21–25; Ingrid Weber, *Deutsche, Niederländische und Französische Renaissanceplaketten: 1500–1650* (Munich: Bruckmann, 1975), pl. 113, no. 405.

TOP INTERIOR

BOTTOM

21 **Workshop of Orazio (?) Fontana**
Italian, Urbino

Birth Bowl (*Ciottola puerperile*), circa 1575

Polychrome tin-glazed earthenware (majolica)
Height 2⅛ in. (5.4 cm), diameter of mouth 8¾ in. (22.2 cm)

Purchase, The Cochrane-Woods Collection, 1979.42

SEE COLOR PLATE 4

BIBLIOGRAPHY

Andrew Ladis, *Italian Renaissance Maiolica from Southern Collections* (Athens: Georgia Museum of Art, The University of Georgia, 1989), 20, 70, and 96–97; Timothy Wilson, *Ceramic Art of the Italian Renaissance* (Austin: University of Texas Press, 1987); Jacqueline Musacchio, *The Art and Ritual of Childbirth in Renaissance Italy* (New Haven: Yale University Press, 1999).

During the sixteenth century, pottery decorated with narrative painting flourished in central and northern Italy, with production centered in Urbino and the neighboring town of Castel Durante. Many of the stories represented on this historiated majolica (*istoriato*) were taken from classical history and mythology, revealing once again the Renaissance taste for ancient themes. Majolica painters frequently borrowed compositions from contemporary paintings, drawings, engravings, and plaquettes.

The interior of this bowl features a birth scene; underneath there is a cupid who holds a staff. Similar images were depicted on birth salvers (*deschi da parto*), which were traditional wedding gifts. Plates, cups, and bowls such as this one—representing birth and children—were also commonly given on the occasion of marriage. Such pieces conveyed wishes for the health and prosperity of the newly wed couple and the prospective mother; they may even have been valued as magical objects.

The Urbinese workshops of the Fontana family were the most influential producers of *istoriato*. They also specialized in the white-ground *grotteschi*, or grotesque decorations, evident on this birth bowl. Characterized by bizarre monsters and fantastic vegetal motifs, this classically inspired form of ornament became popular after the late fifteenth-century discovery of the grotto of Emperor Nero's Golden House, which featured such decorative schemes (hence the name *grotteschi*). Raphael's use of the grotesque at the Vatican Loggias was especially influential. Diffused through sketchbooks and prints, grotesque forms dominated Urbinese majolica decoration by the mid-sixteenth century. — NM

22 English, Isleworth, Shore and Goulding Factory

Plate with Diana in a Chariot, circa 1790–1827

Glazed molded terracotta
Diameter 7 in. (17.8 cm)

Gift of Kelvyn G. Lilley, 1983.107

BIBLIOGRAPHY

William Chaffers, *Marks and Monograms on European and Oriental Pottery and Porcelain* (London: Reeves and Turner, 1912), 908–9; Arthur H. Church, *English Earthenware* (London: Chapman and Hall, 1884), 110–11.

This terracotta plate was produced in a small factory of both porcelain and pottery at Isleworth, England, which was founded by Joseph Shore of Worcester in 1760. The principal painter of the factory was Richard Goulding, Shore's son-in-law, who was assisted by his own son, William Goulding. The mark S. & G. impressed on the reverse of this plate is thought to represent the initials of Shore and Goulding. Their chief product was "Welsh" earthenware for daily use (jugs, dishes, shallow pans, and so forth), streaked with yellow and brown glaze. But they also made well-modeled terracotta pieces decorated with classical allegorical figures in relief.

The center of this plate shows Diana, here as the moon goddess with a crescent over her brow, riding a chariot pulled by two horses. This subject—a chariot carrying a god or goddess and drawn by two or more appropriately mythical creatures—had been popular since antiquity. It was related to the richly adorned chariots that processed through the streets of ancient Rome carrying victorious generals. Images of gods and heroes were represented on these chariots on the occasion of triumphs and festivals. The chariot motif frequently appeared on ancient coins, triumphal arches, and mosaics; it was later adopted by Renaissance medallion makers, and is found on the Smart's medal of Philip II (cat. no. 16). Chariots were also a popular theme in Renaissance and baroque painting, where they carried mythical, allegorical, or historical figures. —NM

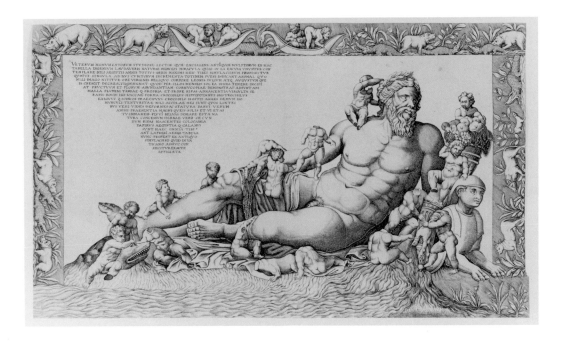

23 Nicolas Beatrizet
French
1507/15–1567

The River God Nile, before
1567; from the *Speculum
Romanae Magnificentiae*
(Rome: Antonio Lafreri, circa
1544–1577)

Engraving
12 9/16 x 21 1/2 in.
(32 x 54.5 cm)

Department of Special
Collections, University of
Chicago Library

This print belongs to the *Speculum Romanae Magnificentiae,* a sixteenth-century collection of engravings primarily illustrating the monuments of Rome. Although sometimes incorrectly categorized, the *Speculum* was not a book but an open-ended collector's album, assembled under a frontispiece designed by Etienne Dupérac and published by Antonio Lafreri, a leading Roman publisher.

This plate was made after the classical statue of the *Nile* now in the Vatican Museum (fig. 4). The statue is considered either a copy or derivation of an original dedicated by Vespasian, or a Roman copy of a Hellenistic statue plundered from Alexandria by Nero. It was probably excavated in 1513 and was installed with its counterpart, the *Tiber* (now in the Louvre, Paris), in the Belvedere statue court at the Vatican by Pope Julius II. Since rivers were worshiped by the ancients for irrigation and subsequent fertility, they were frequently represented as gods, generally in the guise of bearded old men reclining against symbols that helped to locate them. They often supported an urn, from which water flowed.

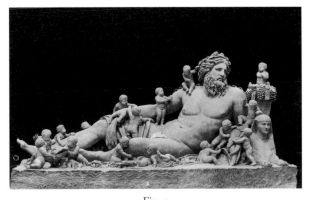

Fig. 4
Nile, marble, Roman, 1st century C.E., after
Hellenistic original (?). Vatican Museum.

BIBLIOGRAPHY

Pliny the Elder, *Natural History*, bk. XXXVI, chap. 11; Phyllis Pray Bober and Ruth Rubinstein, *Renaissance Artists and Antique Sculpture: A Handbook of Sources* (London: Oxford University Press, 1986), cat. no. 67; Francis Haskell and Nicholas Penny, *Taste and the Antique: The Lure of Classical Sculpture, 1500–1900* (New Haven: Yale University Press, 1981), 18 and 272–73; L. R. McGinniss, *Catalogue of the Earl of Crawford's "Speculum Romanae Magnificentiae"* (New York: Avery Architectural Library, 1976).

24 Artist Unknown

The Nile, late eighteenth century

Graphite and sanguine (?) on white laid paper
7⁵⁄₁₆ x 9⁷⁄₈ in.
(18.6 x 25.1 cm)

Gift in memory of Bernard Weinberg by his Family, 1973.10

BIBLIOGRAPHY

Phyllis Pray Bober and Ruth Rubinstein, *Renaissance Artists and Antique Sculpture: A Handbook of Sources* (London: Oxford University Press, 1986), cat. no. 67; Francis Haskell and Nicholas Penny, *Taste and the Antique: The Lure of Classical Sculpture, 1500–1900* (New Haven: Yale University Press, 1981), 272–73; Nikolaus Pevsner and S. Lang, "The Egyptian Revival," in *Studies in Art, Architecture and Design,* ed. N. Pevsner, vol. 1 (London: Thames and Hudson, 1968), 212–48.

The *Nile* is identifiable by the sphinx, and by the group of children symbolizing, according to Pliny, the total number of cubits necessary for the Nile to flood in order to irrigate the valley. Beatrizet's reproduction is almost exact, with the addition of only minor restorations. He even adapted the nilotic reliefs on three sides of the statue's plinth for the borders of his print. —NM

This drawing of the *Nile* also relates to the ancient statue in Rome from which Nicolas Beatrizet made his engraving (cat. no. 23, fig. 4). Like other ancient sculptures uncovered during the Renaissance, the *Nile* was highly praised immediately after its discovery. In addition to the ordinary fascination of Greco-Roman antiquities, the *Nile*'s allegory and exoticism made it an especially attractive object. Artists inspired by its form and its origins dealt with it in prints, drawings, and paintings, as well as in sculpture. A similar image of the Nile leaning on a sphinx appears in the ceiling painting of the *Council of the Gods* at the Villa Farnesina in Rome, by the school of Raphael. Plaster casts made for Francis I of France and Philip IV of Spain indicate the fame of the Vatican *Nile* outside Italy.

Even though interest in Egyptian civilization has seen sporadic surges in Europe from the later Roman Empire through the baroque era (see cat. nos. 26 and 45), it reached its peak during the late eighteenth and early nineteenth centuries, supported by a general inclination toward classical tradition. The Smart drawing probably dates from this period. The fact that the drawing lacks the climbing children and reverses the original composition suggests that the artist did not study the sculpture itself. Rather, this work may be indebted to other media, such as prints (which often reverse compositions as a consequence of the printing process) or drawings after prints. —NM

Allegory

25 **Artist Unknown**
French

Allegory with Truth, Honor, Prudence, Vice, and Posterity, circa 1745–1775

Cast bronze
28 x 12 x 11½ in.
(71.1 x 30.5 x 29.2 cm)

Lent Anonymously, 18.1997

BIBLIOGRAPHY

Wend Graf Kalnein and Michael Levey, *Art and Architecture of the Eighteenth Century in France* (New York: Pelican, 1972); Judith Colton, *The Parnasse François: Titon du Tillet and the Origins of the Monument to Genius* (New Haven: Yale University Press, 1979); Alison West, *From Pigalle to Préault: Neoclassicism and the Sublime in French Sculpture, 1760–1840* (New York: Cambridge University Press, 1998).

This small bronze sculpture fits securely within the rich tradition of allegorical representation that dominated much of the *ancien regime*'s artistic interests. Unrivaled in royal splendor, Louis XIV (1643–1715) had marshaled the arts into the service of his own image. Through the device of personification, sculpture reified noble attributes and commemorated outstanding achievements, thus glorifying the French state and by association the French king. Although his great-grandson Louis XV (1715–74) was a far less remarkable patron of the arts, the world of eighteenth-century memorial sculpture still depended upon the basic conventions so integral to the depiction of Absolutism, above all the theme of a triumph of noble virtue over moral failings.

As described in the text on the base of this statue, Truth, Honor, and Prudence all unite to form a reliable portrait for the sake of Posterity—despite the presence of Vice, who trembles in his own darkness below. Seated on a cube and holding a triangle (attributes often associated with Geometry), Truth on the left-hand side is balanced by Prudence, who holds a caduceus with her left arm and lifts her right arm over her head. She echoes the gesture of Honor, who stands in the middle crowned with a laurel wreath, extending his gift of glory. With hourglass and scythe, Father Time, here signifying Posterity, caps the composition. The smooth, naked flesh of Vice layered over an anguished frame repeats the hard texture of the grotto, while the figures above merge into a mounting swell of swirling drapery that culminates in Time's flight. The sculpture has previously been identified as representing *Louis XV Protecting Religion and Truth from Falsehood*. Regardless of specific iconographical content, the allegory's central point is difficult to miss: in hierarchical terms bound up with themes of eternity, virtue is enshrined over and against faltering vice. —CH

BABIES, BANQUETS, AND BACCHANALS

MARIO PEREIRA

Sixteenth-century artists and thinkers regarded antiquity as the very foundation of the Church. They attributed the oldest books of the Old Testament to Moses, the Hebrew prophet who led his people out of Egypt, and they knew that Christ and the Apostles had lived under the Roman Empire. Many Catholic rituals and ceremonies—even the hierarchical, institu-

tional structure of the early Church—were adapted directly from pagan religious practices and Roman government. As a result, early Christianity was heavily indebted to ancient Rome and, during the Renaissance, the classical cultures of Greece and Rome were profoundly admired and revered. But it was in fact Egypt, with its then illegible script and inaccessible art, that was most highly prized by Christian thinkers for its antiquity, and hence for its proximity to an unadulterated truth. Ancient Egyptian wisdom was considered a precursor of Christianity and some early Christians like St. Paul went so far as to maintain that Moses himself had been instructed in the Egyptian tradition. Thus, Egyptian

religion was believed to have been the predecessor of Judaism; likewise, the Old Testament was thought to foreshadow the New Testament. The Smart Museum's stunning gilt silver Farnese Reliquary (cat. no. 26) is a choice example of how a vibrant classical tradition supported contemporary Christian concerns and beliefs. The Reliquary expresses these antiquarian themes in the artistic idiom known as Mannerism. Mannerist art is easily recognized by its distinctive, elongated figures and distorted proportions, which serve to mock the classical rules of harmony and proportion so typically prized by Renaissance artists. Yet as the Reliquary shows, Mannerist artists could not abandon a classical

visual vocabulary altogether. Neither could they eliminate their classical, religious heritage, known as *prisca theologia*, "primeval theology."

Indeed, this deeply Christian artifact is presented amid classical and Egyptian trappings. Despite its lapis lazuli and *églomisé* (reverse painting on rock crystal) additions, the Reliquary was described by Ulrich Middeldorf as "one of the very few great works of the goldsmith's art surviving from sixteenth-century Italy."[1] It can be compared with only a handful of objects from some of the world's choicest collections, all probably executed by the same team of artists and certainly for the same patrons: Pope Paul III Farnese, identified on the Reliquary by the papal coat of arms and a portrait, or his extremely wealthy grandson Cardinal Alessandro Farnese. The Farnese family also ordered a silver, rock crystal, and lapis box known as the Cassetta Farnese (Naples, Capodimonte Museum), an altar service (two candlesticks and a cross) in the Treasury of St. Peter's (Vatican), and an ornate set of tableware (knife and spoon) in the collection of the Metropolitan Museum of Art (cat. no. 27). The Smart Reliquary was probably commissioned before the death of Paul's opulent grandson, Cardinal Alessandro Farnese (1534–89), and could have been executed by either Manno Sbarri or Antonio Gentili, or possibly by both of them. The artists' characteristic Mannerist style can be seen in the elongated arms and hands of the Reliquary's figures, in their studied poses, and in the profusion of ornament that decorates the object's surfaces.

The Reliquary's subject matter is no less complicated than its ornamental Mannerist style. Yet because this single object provides a guide to the way in which sixteenth-century thinkers conceived of antiquity as the indispensable underpinning to contemporary Christian spirituality, it is worth examining the Reliquary's component elements in detail. As the case of Moses illustrated, the ancient knowledge of Egypt was understood to form the basis of Christianity itself, and

the sphinxes that literally support the Farnese Reliquary forcibly demonstrate that same conviction. On the next level of the Reliquary, a shrouded prophet embodies the Hebrew tradition of the Old Testament, while the Apostolic mission of the Church is manifested in St. Peter, its founder as the first worldly successor to Christ. This position was occupied by the then current pope Paul III, whose portrait comprises the third figure of the Reliquary's base.

Directly above these human figures, three female divinities (Isis, Artemis of Ephesus, and Hecate), depicted in the form of terms, represent a tripartite division of the goddess Diana.[2] In such an immanently Christian context as the Reliquary, these three aspects of Diana signify both Virginity and Fertility simultaneously; the representation of a chaste and fertile goddess must be intended as a direct reference to a "pagan" prefiguration of the Virgin Mary, who is depicted on the oval *églomisé* of the Reliquary. Another iconographical puzzle is suggested by the presence of both Artemis of Ephesus, the fertility goddess of Nature, and the bountiful fruit garlands *all'antica*, which typically symbolize abundance or confer seasonal connotations. Because Artemis and the fruit garlands are located on the intermediate level between the human figures and the divine relic, the profusion of nature's bounty could represent the Fruit of Paradise, which the saint enshrined in the Reliquary has surely sampled at the Heavenly Banquet.[3]

This sanctifying, Christian association of Diana with the Virgin Mary is paralleled in sixteenth-century art by the frequent identification of Dionysus/Bacchus as the forerunner of Christ. Wine, the attribute of this mythological figure, is potentially both orgiastic (carnal) and sacred. In Christianity, both aspects of wine are subsumed in the ritual of the Eucharist, when bread becomes the sacred body of Christ and wine becomes sacred blood. The miracle of transubstantiation is reminiscent of and probably derives

from ancient practices: at Plato's elevated dinner party, or Symposium, drunken, physical pleasure could lead to higher, transcendent rapture. Indeed, Dionysus and his acolytes, the satyrs, provide the theme for the exquisite tableware by Antonio Gentili (cat. no. 27), by conjuring images of an august Christian equivalent of Plato's Symposium, where prelates such as Cardinal Alessandro Farnese, who patronized Gentili, could symbolically imbibe the nectar of the gods. Yet while men like Alessandro enjoyed the ancient concept of a banquet as a means to enlightenment and divine revelation, they would surely also have been reminded of other heavenly repasts, such as the Christian Last Supper with its connection to the Eucharist. Those who sample the wine at the Last Supper truly sip the divine.

Artists like the baroque sculptor Alessandro Algardi ensured that none could forget the ritual significance of dining. Algardi's small bronze *Christ Falling under the Cross* (cat. no. 28), executed around 1650 when he had established himself as a papal favorite at the court of Innocent X Pamphilj, was designed as a table *trionfo*: these fascinating sculptures, made of either sugar or bronze, were originally intended to adorn banquet tables, not museum pedestals. Frequently these *trionfi* were executed as a unified series according to a particular mythological or religious theme. The *Christ Falling under the Cross*, for instance, was probably part of a set representing the Passion of Christ, and it is known that the papacy hosted banquets where such table ornaments, of both sugar and bronze, were utilized. Jennifer Montagu has noted that spending on provisions for baroque banquets could far exceed total household expenditures for fine art.[4] These bronze *trionfi*, therefore, were surely just as rare a sight at table as were Gentili's sixteenth-century tableware and its equivalents. Not surprisingly, they were probably both commissioned by the same segment of society, namely wealthy ecclesiasts.

Montagu considers such luxury objects merely playful and tends to discount the religious significance of food and its relation to the Eucharist, or the body and blood of Christ. She believes that scenes from the Passion of Christ, such as Algardi's *Christ Falling under the Cross*, "should inspire tears" and finds it "hard to reconcile" them with "the jolly and lavish overindulgence in the pleasures of the flesh that we should expect to accompany a banquet."[5] Her implied conclusion is that religious art does not necessarily inspire "pious thoughts," especially if the context is, like a banquet, grossly carnal. But the papacy provided the two most famous seventeenth-century public dinners where allegorical and biblical *trionfi* were employed. In fact, such *trionfi* were restricted to use at solemn banquets only. On St. Stephen's day in 1665, Queen Christina of Sweden was invited to dine at the table of the pious Pope Alexander VII Chigi.[6] The event was both politically and religiously symbolic, for the celebrated Christina, daughter of a militantly Protestant king, had recently converted to Catholicism. Given the significance of this occasion, it has been claimed that Bernini's studio was responsible for the *trionfi*. A sermon was preached during the highly ceremonious banquet, which was also accompanied by sacred music. Several surviving drawings of Pope Clement IX Rospigliosi's banquet table, as it was prepared for a ceremony on December 9, 1668, show it complete with Christian *trionfi*, including a *Christ Falling under the Cross* similar to that of Algardi. Again the honoree was Christina, and solemn music was performed throughout the repast.

Algardi was not solely a religious sculptor; in fact, he was employed throughout his life as a restorer of antique sculpture, and his *Infant Hercules Subduing the Serpent* (cat. no. 29) is a direct beneficiary of this experience. Before considering this mythological image—as we abandon classically inspired religious and gastronomic

themes in favor of a more fleshly topic—it is beneficial to introduce the Roman circle of baroque artists featured in this section of our exhibition. The Farnese continued their patronage of art into the baroque period with the Farnese Gallery, frescoed by Annibale and Agostino Carracci, and later engraved by Pietro Aquila (cat. no. 33). Algardi had trained early on with Lodovico Carracci, the third and eldest member of this artistic family, founders of an influential art academy in their native Bologna. While in Rome, Algardi associated with another distinguished graduate of the Carracci academy, the older painter Domenichino, with whom Pietro Testa also studied (cat. no. 32). Testa in turn soon transferred to the studio of Pietro da Cortona and both artists worked for the immensely voracious patron and collector Cassiano dal Pozzo (cat. nos. 39–42), a prominent member of the extravagant papal court under Urban VIII Barberini. Although the young Cortona shortly left Cassiano's employ, the two men remained on friendly terms. Cassiano prized the work of Cortona, who became one of the more successful painters (and also a highly regarded architect) of baroque Rome (cat. no. 56). Toward the end of his brilliant career, Charles-Jean François Chéron produced the celebratory medal juxtaposing Cortona with Fame (cat. no. 35), and the affable painter Filippo Lauri (cat. no. 34) entered his employ.

Auspiciously, the Smart Museum owns a hand-colored reproductive print of a scene from the Carracci frescoes for the Farnese Gallery in Rome (cat. no. 33). Executed by Pietro Aquila, the *Glaucus and Scylla* print was one of a series of twenty-four images published in 1677 that illustrate the entire Gallery. Indeed, this print enables us to follow Farnese patronage in more detail, from Cardinal Alessandro Farnese (1534–89), who commissioned the Reliquary and the Farnese Hours and was a regular patron of the goldsmith Antonio Gentili, to Cardinal Odoardo Farnese (1591–1626), who not only

commissioned Gentili's silver binding for the Farnese Hours (which he had inherited from Alessandro) but was also responsible for the decoration of the Farnese Gallery. Furthermore, this image of *Glaucus and Scylla* blatantly alludes to Raphael's *Galatea* fresco in the Villa Farnesina, a property that had recently been acquired from the original owners by the avaricious Farnese. In our study of the Farnese Reliquary, we have seen hints of how the Farnese collection of ancient sculpture influenced contemporary art: their statue of Artemis of Ephesus inspired, even determined, its iconographical program. Likewise, the Farnese Gallery was "designed as the centerpiece for the stupendous Farnese collection of antiquities, some displayed in adjoining rooms and some in niches in the walls of the gallery itself."[7] Hence, the subjects and themes of the frescoes, some taken from the works of the Roman poet Ovid, were selected in accordance with the room's function as a gallery for antique sculpture. Ancient and visual quotations are recognizable throughout the decorative program. The Triton figure in our print, for example, mockingly resembles the bust of Caracalla then in the family collection.[8] The ancient contents of the gallery inspired the Carracci to paint in an appropriately classical and idealized style even though the scenes represented were extremely satirical and festive, for the commanding conceit of the gallery was the omnipotence of love.

In the Farnese Gallery, this theme is embodied in impish loves or little *amores*, otherwise known by the Italian term "putti," or babies. In addition to the profusion of putti depicted in ancient art, two paintings by the Venetian Renaissance painter Titian, the *Bacchanal of the Andrians* and the *Worship of Venus* (p. 16, fig. 2), exerted immense influence on seventeenth-century artists from their place in Rome's Villa Ludovisi collection.[9] The influence of Titian's tots was immediately visible in the work of Poussin as, for example, in his two *Children's Bacchanals* of ca. 1625–26 (Palazzo

Babies, Banquets, and Bacchanals

Barberini, Rome). Pietro Testa, who began to study the Ludovisi collection in 1628, endeavored to best Titian by devising a still greater variety of putti postures as a virtuoso display of invention (cat. no. 32). From their assiduous labors, these artists and others, like Algardi, the Fleming François Duquesnoy, and the Carracci, acquired the knowledge and ability to distinguish between a *putto antico* and a *putto moderno*. The *putto antico* was, as its name implies, based on the corporeal proportional system established by the ancients and, so the artists of the seventeenth century believed, subsequently adopted by Raphael. According to Anthony Colantuono, the ancient putto prototype correctly observed the proper rules of decorum.[10] In other words, a putto progeny of Raphael would be, like its ancient exemplar, sufficiently mature to credibly perform the actions he was charged with executing. His body would be correctly proportioned and developed enough to indicate his age, and this would lend the artistic scene a sense of realism, or verisimilitude. Titian's much younger putti, on the other hand, were a completely modern, sixteenth-century invention. His infants, far too young to perform their assigned tasks, stretched the limits of credibility, committing a supposed breach of ancient proportional propriety. The nascent, fleshly forms that populate the images of Poussin and Testa, and that were endowed with tactile, material life by Duquesnoy, all display an adherence to modern, Venetian proportion and sentiment, quite unlike what was held to be the rather chilly classicism of Raphael.

An oversized head, a formidable paunch, and squat limbs characterize this modern, recently designed putto. What motivated artists to promote such discernment in and classification of putti proportion was the belief that every particular set of bodily proportions "expressed a different conceit" or idea. In other words, form could embody abstract qualities or thoughts: pudgy putti, for example, personify Tenderness.

The fact that these small babies performed actions beyond their years enhanced their sentimental appeal by embodying an emotion appropriate to the theme of love. Both Algardi's bronze *Infant Hercules* (cat. no. 29) and Testa's *Garden of Charity* print (cat. no. 32) can be viewed within the context of this giddy baroque profusion of putti.

Yet Testa, like Poussin, was an exceedingly cerebral artist and he identified passion with flesh. Consequently, his putti not only express emotion but, in their corpulent proportions, actually embody it. Just as Gentili's exquisitely crafted yet lusty satyrs serve as a coarse foreshadowing of the refined Christian love present in the Eucharistic banquet, so the tender, succulent *putto moderno* may be seen as a prelude to images of Christian *caritas*, which is often represented as a mother suckling a cluster of infants (cat. nos. 31–32). In a similar example of lofty ideas being given human form, Charles Dempsey discusses Testa's appropriation of the Platonic idea of the winged soul striving to release itself from this earthly, mundane reality.[11] We witness Testa's use of this conceit in the *Garden of Charity* where a plump putto plunges headfirst, Icarus-like, its sheer physicality overwhelming a pair of diminutive, angelic wings; he thus becomes the unfortunate embodiment of Gluttony.

The Smart Museum's small cabinet picture attributed to Filippo Lauri is a pleasant summation of both the jubilant bacchanals inaugurated in the Farnese Gallery and the Bolognese landscape tradition (cat. no. 34). Although Lauri's father, Balthasar, had worked with Cortona during the decade of the 1620s, Filippo received his initial training from his older brother Francesco, himself a student of Andrea Sacchi. Lauri never deviated from this "classical" instruction and adhered to his idyllic landscape idiom, developed from the study of Domenichino and his Bolognese friend Francesco Albani. In 1651, Lauri received his first known commission from Girolamo Farnese, of the opulent Roman family,

and his work must have been a success because he was soon admitted to the Accademia di S. Luca (1654). More impressively, by 1656 he was frescoing the Gallery of Pope Alexander VII at the Quirinal under the direction of Pietro da Cortona, leader or *principe* of the Accademia from 1635 to 1638. At the Quirinal, Lauri collaborated with the landscape artist Gaspar Dughet, Poussin's friend and brother-in-law, whose ideas on landscape were also similar to those of his friend Testa.

Although Lauri is best known for his small-scale, classical compositions, he was also able to obtain, sometimes through the assistance of Cortona, significant public commissions, such as those for S. Maria della Pace and the Palazzo Borghese, where he executed his famous *Bacchus and Ariadne*. Admittedly not the equal of Albani or Claude, Lauri was nevertheless himself elected *principe* of the Accademia di S. Luca (1685–86) and was much desired by aristocratic patrons who greatly admired his mythological landscape scenes, like the *Bacchanal* in this exhibition. His figures, especially his nymphs and satyrs, are particularly elegant, and the mood is frequently festive. Sadly, in the eighteenth century this type of painting gradually degenerated into mere decoration and was forcefully supplanted by the topographical *veduta* (view). Lauri's typically seventeenth-century balance of a pagan celebration and an idealized landscape within a small format no longer seemed relevant.

A very different vision was presented by Giovanni Battista Piranesi (cat. nos. 43–46), who documented the interplay between modern and ancient Rome and decaying, organic nature with staggering monumentality and an unprecedented degree of invention.

NOTES

1. Ulrich Middeldorf, *Sculptures from the Samuel H. Kress Collection: European Schools XVI–XIX Century* (London: Phaidon Press, 1976), 79.

2. Egidio da Viterbo, Vat. Lat. 6325; see Ingrid D. Rowland, "The Intellectual Background of the *School of Athens*: Tracking Divine Wisdom in the Rome of Julius II," in Marcia Hall, ed., *Raphael's "School of Athens"* (New York: Cambridge University Press, 1987), 144–48.

3. Egidio da Viterbo, as in Rowland, 144–48.

4. Jennifer Montagu, *Roman Baroque Sculpture: The Industry of Art* (New Haven: Yale University Press, 1989), 187.

5. Montagu, 195.

6. Torgil Magnuson, *Rome in the Age of Bernini*, vol. 2 (Stockholm: Almqvist and Wiksells, 1986), 150.

7. Charles Dempsey, *Annibale Carracci: The Farnese Gallery, Rome* (New York: George Braziller, 1995), 28.

8. Dempsey (1995), 30–31 and 56.

9. Anthony Colantuono, "Titian's Tender Infants: On the Imitation of Venetian Painting in Baroque Rome," *I Tatti Studies* 3 (1989): 207–209. Titian's canvases, painted for one of the *camerini d'alabastro* of the Este in Ferrara, were transferred to Rome in 1598 and entered the Ludovisi collection sometime between 1629 and 1637; see John Walker, *Bellini and Titian at Ferrara: A Study of Styles and Taste* (London: Phaidon Press, 1956), 75–77.

10. Colantuono, 214.

11. Charles Dempsey, "The Greek Style and the Prehistory of Neoclassicism," in Elizabeth Cropper, ed., *Pietro Testa, 1612–1650: Prints and Drawings* (Philadelphia: Philadelphia Museum of Art, 1988), lvi.

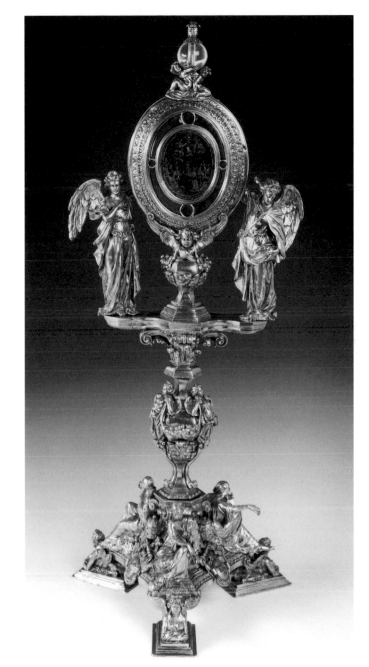

**26 Attributed to Antonio
Gentili da Faenza**
Italian
Sixteenth century

Farnese Reliquary, circa 1550

Cast and wrought gilt silver,
lapis lazuli, rock crystal,
enamel, and *églomisé*
Height 23½ in. (59.7 cm)

Gift of the Samuel H. Kress
Foundation, 1973.54

SEE COLOR PLATE 5

27 Antonio Gentili da Faenza

Set of Tableware, circa 1580

Knife
Silver and gold
Length 8½ in. (21.6 cm)

Lent by the Metropolitan
Museum of Art, Rogers Fund,
1947, 47.52.1

Spoon
Silver
Length 6¹⁵⁄₁₆ in. (17.6 cm)

Lent by the Metropolitan
Museum of Art, Rogers Fund,
1947, 47.52.3

The Smart Museum is fortunate to have received this astonishing gilt silver
Reliquary as a gift from the Samuel H. Kress Foundation. When the Reliquary
was purchased by the Kress Foundation in 1948, it was thought to have been
commissioned by Pope Paul III Farnese, was attributed to the Florentine gold-
smith Manno Sbarri, and was dated to 1545, even though the object was appar-
ently completely undocumented until it entered the Sicilian collection of B.
Licata, Prince of Baucina, possibly around 1800. Ulrich Middeldorf fully refut-
ed the "traditional attribution" to Manno Sbarri. He believed that if Paul III
had commissioned the Reliquary then it was "most unusual for the Pope to have
had his own portrait included," and redated the piece between 1534 and 1549.

The Place of the Antique

He also admitted that the original purpose of the commission and the intended destination of the Reliquary were unknown. But on the basis of style, Middeldorf connected the Reliquary to two bronze candlesticks in the Treasury of St. Peter's which, although themselves undocumented, have nonetheless been attributed to Antonio Gentili. Middeldorf also asserted that the Reliquary and bronze candlesticks were necessary for the realization of Gentili's later works, namely his Vatican Altar Service of 1582. Subsequently, Anna Beatriz Chadour noted affinities between Gentili's Vatican Altar Service, the two bronze candlesticks and the Smart Reliquary. Most recently, Ian Wardropper confirmed the similarity between the Reliquary and other works by Gentili.

CAT. NO. 27

At present it is extremely difficult to make satisfactory attributions for the decorative arts of the Renaissance, because few objects of precious metal survive and those rare examples are frequently undocumented. This problem is exacerbated by the working practices of cinquecento goldsmiths who often collaborated in the manner of a workshop, formed partnerships or, more commonly, worked from the models or designs of accomplished artists. It is known, for instance, that Gentili copied designs of Guglielmo della Porta, owned Michelangelo casts, and on occasion appropriated ideas from Benvenuto Cellini. Gentili's eclecticism was typical of sixteenth-century Roman goldsmiths, and his Mannerist taste and peculiar choice of models were quite similar to those of Manno Sbarri, a student of Cellini and follower of Michelangelo. Both Manno's Farnese Casket (1548–61) and Gentili's work are heavily and obviously indebted to Michelangelo's Medici tombs at San Lorenzo in Florence for their architectural conceptions, broken pediments, and remarkably contorted figures. Indeed, all three artists—Michelangelo, Manno, and Gentili—were patronized by the Farnese for many years.

The work of Manno and Gentili comes together in the Vatican Altar Service, to which they both contributed. Cardinal Alessandro Farnese, who had become Archpriest of St. Peter's in 1543, commissioned Manno to execute the Altar Service sometime between 1548 and 1561. Unfortunately, Manno died after having finished only the cross; in 1578, Gentili received the commission for completing the Altar Service, which he did in 1582. The Farnese must have thought the styles of Manno and Gentili compatible or congruent, for in 1600 Cardinal Odoardo Farnese requested that Gentili execute the silver binding on the prized Farnese Hours by Giulio Clovio (ca. 1540–46; New York, Pierpont Morgan Library, MS M.69), a manuscript he had inherited from its original patron, Alessandro. It is now believed that the original function of Alessandro's Farnese Casket, fashioned by Manno, was to house this fragile book.

Babies, Banquets, and Bacchanals

Despite the parallels of style, iconography, and patronage that link Manno and Gentili, the Reliquary must be attributed to Gentili. Both Volbach and Chadour have attributed the bronze candlesticks in the Treasury of St. Peter's to him, and Middeldorf and Chadour have noted the stylistic connections between these objects and the Smart Reliquary, notably the triangular base supported by sphinxes. The Metropolitan Museum of Art's loan to this exhibition of an extraordinary set of tableware, accepted as a work of Gentili by numerous scholars, permits another revealing comparison with the Reliquary. In both pieces, silver has been cast and sensitively chased with the same consummate technical skill. Likewise, the decorative elements, especially the handling of garlands and fruit and the bizarre elegance of ornamentation, are analogous.

Following this attribution, we may possibly be able to identify the Smart Reliquary with a known but formerly untraced work. In 1578, the Society of Jesus obtained a reliquary of silver and rock crystal that had been fashioned, at an undetermined date, by Gentili. Although the Smart Reliquary incorporates *églomisé* within rock crystal, the *églomisé* is probably not original. Indeed, no other Farnese object features painting of this sort; on the contrary, most Farnese commissions for decorative art in silver, such as the Farnese Casket and the Vatican Altar Service, incorporate rock crystals designed by Giovanni Bernardi. The fact of Farnese patronage also supports a connection with the Jesuits, since Cardinal Alessandro was one of their major patrons and had financed their principal church of the Gesù. He certainly knew and admired Gentili, whom he commissioned in 1578 to complete the Vatican Altar Service.

These circumstances suggest that the patron of the Smart Reliquary was Cardinal Alessandro Farnese (1520–89), rather than his grandfather Pope Paul III (1534–49). Middeldorf's reservation about the impropriety of Paul III including himself as the central figure on the Reliquary, flanked by St. Peter and a Hebrew prophet, supports this claim. In addition, Cardinal Alessandro, not Pope Paul, was widely recognized as one of the most extravagant patrons of the decorative arts in sixteenth-century Italy, equaled perhaps only by his shrewd rival Cardinal Ippolito d'Este, the patron of Cellini. Alessandro often supervised Paul III's artistic projects and commissions, and frequently patronized both Manno Sbarri and Antonio Gentili independently. In contrast, no documented dealings between Paul III and either artist survive. In fact, the inclusion of Paul III on the Smart Reliquary is best explained by Alessandro's patronage: the Farnese Casket (Naples, Capodimonte Museum), commissioned by Alessandro, includes the emblems of both Alessandro and Paul III. Likewise, the Vatican Altar Service, again commissioned by Alessandro, displays inscriptions to the by-then-deceased pope.

Alessandro's patronage of Manno Sbarri for both the Farnese Casket and the Vatican Altar Service can help determine the date and original purpose of the Reliquary. Although Gentili's first documented commission from Alessandro came only in 1578 when he was charged with completing the Vatican Altar Service, the artist had been in Rome since around 1549/50 and may have already been in contact with the young, spendthrift cardinal through mutual friends like Manno. The Reliquary could have been commissioned at this time and then purchased in 1578 for the Gesù.

The Place of the Antique

BIBLIOGRAPHY

Elena Parma Armani, *Perin del Vaga: L'anello mancante: Studi sul manierismo* (Genoa: Sagep, 1986); C. Louise Avery, "Sculptured Silver of the Renaissance," *Bulletin: The Metropolitan Museum of Art* 5 (June 1947): 252–54; Giovanni Baglione, *Le vite de' pittori, scultori et architetti dal pontificato di Gregorio XIII. del 1572 in fino a' tempi di Papa Urbano Ottavo nel 1642* (Rome: Andrea Fei, 1642), facsimile, ed. Valerio Mariani (Rome: E. Calzone, 1935), 109; Rudolf Berliner, "Two Contributions to the Criticism of Drawings Related to Decorative Art," *Art Bulletin* 33 (March 1951): 51–55; Anna Beatriz Chadour "Der Altarsatz des Antonio Gentili in St. Peter zu Rom," *Wallraf-Richartz-Jahrbuch* 43 (1982): 151; Lucia Fornari Schianchi and Nicola Spinosa, eds., *I Farnese: Arte e collezionismo* (Milan: Electa, 1995), 358–61; Mary Jackson Harvey, catalogue entry in *The David and Alfred Smart Museum: A Guide to the Collection*, eds. Sue Taylor and Richard A. Born (New York: Hudson Hills Press, 1990), 39; John Forrest Hayward, *Virtuoso Goldsmiths and the Triumph of Mannerism, 1540–1620* (New York: Rizzoli International, 1976); Hugh Honour, *Goldsmiths and Silversmiths* (New York: Putnam, 1971); Wolfgang Lotz, "Antonio Gentili or Manno Sbarri?" *Art Bulletin* 33 (December 1951): 260–62; Ulrich Middeldorf, *Sculptures from the Samuel H. Kress Collection: European Schools XVI–XIX Century* (London: Phaidon Press, 1976), 79–80; Jennifer Montagu, *Gold, Silver, and Bronze: Metal Sculpture of the Roman Baroque*, The A. W. Mellon Lectures in the Fine Arts, 1990, Bollingen Series XXXV: 39 (Princeton: Princeton University Press, 1996); Clare Robertson, *"Il gran cardinale": Alessandro Farnese, Patron of the Arts* (New Haven: Yale University Press, 1992); John Shearman, *Mannerism* (Harmondsworth: Penguin, 1967); Wolfgang Fritz Volbach, "Antonio Gentili da Faenza and the Large Candlesticks in the Treasury of St. Peter's," *Burlington Magazine* 90 (October 1948): 281–86; Ian Wardropper, "Italian Renaissance Decorative Arts in Chicago Collections," *Apollo* (March 1987): 200–205; Linda Wolk-Simon, "Book Review: E. P. Armani, *Perin del Vaga*, 1986," *Art Bulletin* 71 (September 1989): 515–23.

A date of about 1550 is also appropriate iconographically, for the Reliquary is thematically related to Michelangelo's contemporary Pauline Chapel frescoes at the Vatican (1543–50), which depict the *Crucifixion of Peter* and the *Conversion of Paul*. Paul III's pontificate (1534–49) was distinguished by forceful intervention in both the temporal and spiritual spheres, as demonstrated by his orchestration of Emperor Charles V's 1536 entry into Rome, his recognition of the Society of Jesus in 1539, and his convening of the Council of Trent in 1545. Like the mandate of the Jesuits, the imagery of the Reliquary and of the Pauline Chapel affirms the spiritual authority of the papacy in the face of the challenges addressed by the Council of Trent. The figure of Peter, for instance, asserts his role as the true successor to Christ, thereby validating the supreme religious power of the papacy and the institutional conception of the Catholic Church. St. Paul appears obliquely in the Reliquary, in the guise of Paul III Farnese, who took his pontifical name in honor of the apostle. In gathering together the Council of Trent, the Farnese pope reenacted St. Paul's convening of the first church council, an iconographic connection that would have been evident to contemporaries involved in the debate over the pope's authority to call such councils. An emphasis on papal privilege would also befit the Society of Jesus, a Farnese favorite that answered directly and solely to the pope, and would make the Gesù a logical eventual recipient of this piece.

Paul III died on November 10, 1549, and Alessandro may have commissioned the Reliquary to commemorate his grandfather, source of all his wealth and power. Even the themes of papal primacy and succession, articulated by the inclusion of St. Peter (the first pope) behind Paul III Farnese (the present or recently deceased pope), would have been suitable for the swank cardinal who was in continual competition with Cardinal Ippolito d'Este for election to the papacy—a competition ultimately unsuccessful for both men.

Because the earliest known provenance of the Reliquary is from a Palermo collection, it is pertinent to note that the Farnese Casket was also documented in Palermo, first in 1800 and again in 1807. The Casket was probably transferred to Palermo with the Bourbon collection (which included the Farnese holdings, acquired through inheritance) when the Bourbons fled Naples with Lord Nelson in 1798. After the departure of General Murat in 1815, the Bourbons and their royal collections, including presumably the Farnese Casket, returned to Naples. If the Smart Reliquary was not originally purchased for or given to the Gesù in 1578, it may have instead been a part of the Bourbon holdings transferred to Sicily. Its acquisition by the Sicilian noble B. Licata, perhaps during the monarchy's Sicilian exile, may have been a result of damage to the object that led to its eventual deaccessioning from the Bourbon collection. Thanks to the continued interest and sponsorship of the Kress Foundation, damages to the piece have been repaired and years of tarnish removed in preparation for this exhibition, and the Reliquary has been restored to its earlier glory. —MP

Alessandro Algardi
Italian
1598–1654

28 *Christ Falling under the Cross*, circa 1650

Cast bronze
Height 5¾ in. (18 cm),
length 9¾ in. (24.8 cm)

Purchase, Gift of the Friends
of the Smart Gallery, 1980.48

29 *Infant Hercules Subduing
the Serpent*, circa 1650

Cast bronze
Height 15¾ in. (40 cm),
length 17 in. (38.7 cm)

Purchase, The Cochrane-
Woods Collection, 1977.103

With the pontificate of Innocent X Pamphilj (1644–55), Algardi reached the climax of his fortunate artistic career, as he endeavored to replace Bernini as the preeminent sculptor in Rome. These two small bronzes were probably produced during this animated period. Although Algardi has been associated with contemporary exponents of classicism such as Duquesnoy and Poussin, and therefore opposed to Bernini and Cortona, scholars like Bruce Boucher believe that he forged a moderate balance between the two.

Before he arrived in Rome, Algardi had left his native Bologna to work for the Gonzaga family in Mantua, where he studied their collection of antiquities and their important *Triumphs of Caesar* series by Andrea Mantegna. From 1625 until at least 1633, Algardi restored ancient sculpture for the Bolognese Ludovisi family, who introduced him to Domenichino. Hence his style, decorum, and ideal figure types were understandably indebted to both Domenichino and Guido Reni, also of Bologna. Algardi also collaborated with Bernini in 1630, and by 1634 he was working with Cortona at the church of SS. Luca e Martina in Rome, where he used his knowledge of antiquity to visually evoke the world of early Christianity. Camillo Pamphilj's Villa Belrespiro, begun in 1645, is Algardi's most classicizing project. Conceived as a showcase for antique sculpture, the facade of the villa is ornamented with ancient reliefs and sarcophagi fronts, while Algardi's *all'antica* stucco decoration is based on both ancient (Hadrian's Villa, Trajan's Column) and modern (Raphael,

CAT. NO. 29

BIBLIOGRAPHY

Bruce Boucher, *Italian Baroque Sculpture* (New York: Thames and Hudson, 1998); Jennifer Montagu, *Alessandro Algardi* (New Haven: Yale University Press, 1985); Montagu, *Roman Baroque Sculpture: The Industry of Art* (New Haven: Yale University Press, 1989); Antonia Nava Cellini, *La scultura del Seicento* (Turin: UTET, 1982).

Mantegna) sources. As in the Farnese Gallery (cat. no. 33), ancient sculpture would have been placed within these Roman revival rooms. But classical emphases notwithstanding, the prodigality of inventive detail in Algardi's stucco decoration could compete with any ornamental scheme by Cortona.

Jennifer Montagu considers Algardi's small bronzes to be his supreme artistic expression; he preferred to think on a small scale, where he exploited the freedom and energy of modeling. Montagu dates the *Infant Hercules* to ca. 1650 because of its sense of anatomical structure and volume. But the *Hercules* also reveals features consistent with most of Algardi's infants, such as the marble *Borghese Sleep* (1635–36) which, although executed much earlier in his career, shares many characteristics with the *Hercules*, including the placement of drapery beneath the elongated, twisting body of a youth. If the unkempt hair of *Hercules* recalls ancient sculptures, then his animated pose and spirited movement outdo the more staid infants of antiquity. Conversely, the *Christ Falling under the Cross* is a model of restraint. Fashioned as a small table bronze, the Christ was originally intended for an intimate, private setting, and so he turns in the direction of the viewer. Yet despite its diminutive scale, the bronze figure preserves a feeling of weight. The noble simplicity of this sculpture and its quiet spiritual content derive from the Bolognese tradition of religious imagery and decorum. —MP

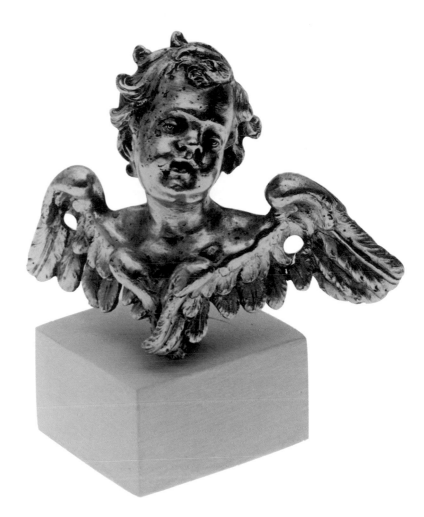

30 Italian

Head of a Cherub, circa 1720

Cast gilt bronze
Height 3¾ in. (9.5 cm)

Purchase, Gift of Members of
the Baroque and Rococo Tour,
1979, 1980.60

While more properly characterized as a cherub than a putto (from the Latin
putus, boy), this charming creature is a close cousin of the winged babies that
populate Renaissance and baroque imagery and, like them, is descended from a
classical type. Greek art provided an important model for the rendering of
abstract ideas in anthropomorphic form; in this framework, Eros, or Desire,
appeared as a young, winged boy. On the Italic peninsula, Etruscan artists rep-
resented both male and female spirits with wings and often associated these fig-
ures with funerary themes. The winged Eros appears in Etruscan imagery from
the second half of the fourth century B.C.E., and took a prominent place in
Roman art where his Latin moniker was Amor.

The evolution of this figure from emblem of desire to bearer of the Christian
message was long and complex. Early on, even in Hellenistic art, Eros appeared
in contexts detached from his original meaning. Most notably, cupids appeared
on pagan sarcophagi, where they played heraldic roles or stood as personifica-
tions of the seasons (*genii*) and hence of the eternal cycle of life. Another
winged figure prominent in Roman imagery was that of Victory; in a funerary
context, the obvious reference was to triumph over death.

The Place of the Antique

Without an established model to draw from, Christian artists relied heavily on pagan models such as these. Though the earliest representations of angels are wingless (indeed, the Bible often refers to angels simply as "men"), wings effectively express the notion of the messenger, the angel's fundamental role. Inspired by Roman images of Victory, Christian artists may also have intended their winged figures to indicate a triumph over the very paganism that inspired them, for the evolution of the winged angel dates to shortly after the official adoption of Christianity by the Roman Empire at the end of the fourth century.

The hierarchy of angels is of an encyclopedic complexity. The Smart Museum's piece can be categorized as a cherub, an angel of an order just below the seraphim and often portrayed as a disembodied head with a single pair of wings. Holes in these wings and a large bolt behind the figure indicate that it was once affixed to a larger object, possibly a reliquary or an altar. The cherub, who usually appeared with a cluster of his fellows, made an iconographically appropriate embellishment to sacred furnishings, as his traditional role was to glorify God in a chorus of praise. —ER

BIBLIOGRAPHY

Maurizio Sannibale and Paolo Liverani, "The Classical Origins of Angel Iconography," in *The Invisible Made Visible: Angels from the Vatican*, eds. Allen Dunston, O. P., and Arnold Nesselrath (Alexandria, Va.: Art Services International, 1998), 62–71.

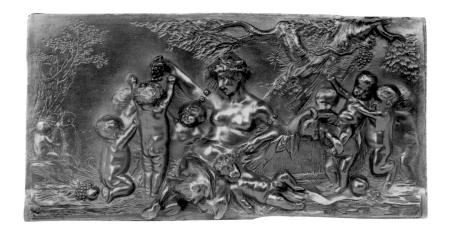

31 **Louis-Félix de La Rue**
French
1731–1777
Casting attributed to Pierre-Philippe Thomire, 1751–1843

Satyress with Frolicking Children and a Young Satyr,
1783 or before

Cast bronze relief
5¾ x 11⅛ in. (14.6 x 28.2 cm)

Purchase, The Cochrane-Woods Collection, 1977.112

The satyress is a relatively untreated mythological subject in comparison with her male counterpart who, part man and part animal, represents the unrestrained urges of nature. In the classical tradition, satyrs are among the principal celebrants of the Dionysiac rites of wine-induced revelry and orgiastic frenzy, subject matter that inspired artists of antiquity and the early modern period alike.

The elegantly treated figures in this eighteenth-century bronze plaquette by Louis-Félix de La Rue present a refined, rococo interpretation of the bacchic revelers. A provocatively recumbent satyress, fashionably coiffed and bejeweled, offers a heavy bunch of grapes to four naked children. A fifth child sleeps with

his head on her lap, while another group, including a young satyr, enjoys a rowdy game of piggy-back. The scene is a sort of bacchic twist on representations of Venus with her flock of putti (p. 16, fig. 2), images of Charity, or allegories of fertility and abundance (cat. nos. 20 and 32), though its graceful forms, bucolic setting, and delicate casting (probably attributable to Pierre-Philippe Thomire) lend a certain air of serenity, a mood not typically associated with the characteristically bawdy images of satyr families.

A lighthearted tone is typical, on the other hand, of the style known as rococo, which flourished in France during the eighteenth century and drew heavily on ancient mythological themes, playfully interpreted. The classical nude remained the supreme source of inspiration, but with a new softening of forms, gracefulness of line, and delicate treatment of proportions. Also characteristic of this period is close attention, even on the part of the most important artists, to the decorative arts of the domestic interior. Far from minor, small works like de La Rue's plaquette were central sites for the reinvention of the classical vocabulary. —ER

BIBLIOGRAPHY

Michael Worley, "Satyrs, Cupids, Bathers, and Dancers: Decorative Sculpture from Rococo to First Empire," *The Smart Museum of Art Bulletin* 5 (1993–94). 8–15; François de Polignac and Joselita Raspi Serra, eds., *La fascination de l'antique, 1700–1770* (Paris: Somogy Éditions d'Art, 1998); Mark P. O. Morford and Robert J. Lenardon, *Classical Mythology*, 2nd ed. (New York: Longman, 1977), 206–7.

32 **Pietro Testa**
Italian
1612–1650

The Garden of Charity,
circa 1631–1637

Etching
15 x 10 7/16 in. (39.5 x 27.5 cm)

University Transfer from
Max Epstein Archive, acquired
1959, 1967.116.108

Testa's hasty etching is intended to evoke a spontaneous drawing, although the foreground group is taken from an earlier print. In the original image, the woman is identified by a flaming heart as Charity. Testa replaced the heart with the star of Abundance, the emblem of Girolamo Buondivisi, who is acknowledged in

The Place of the Antique

the inscription beneath the star ("Ill.mo & Rmo D. Hyeronimo Bondisi D C."). This print is an obvious testimony to Testa's study of Titian's Ludovisi canvases (p. 16, fig. 2), but the scores of putti scampering and frolicking about may also indicate the influence of Pietro da Cortona. The melancholy Testa worked only briefly in Cortona's studio before being fired, and the tendency has therefore been to belittle their association. Yet Nicholas Turner suggests that Cortona's positive, enduring, and "much underestimated" influence can best be seen in Testa's drawings after ancient sculptural reliefs with "myriad small figures." This print certainly belies accusations of classical severity that have been regularly levied against Testa and other artists (such as Poussin) associated with Cassiano dal Pozzo's Paper Museum (cat. nos. 39–42). The proliferation of putti eagerly bounding over the gentle hills reinforces the emblematic conceit of Abundance, while one plunging putto cautions that Abundance can easily be transformed into Gluttony. —MP

BIBLIOGRAPHY

Anthony Colantuono, "Titian's Tender Infants: On the Imitation of Venetian Painting in Baroque Rome," *I Tatti Studies* 3 (1989): 207–34; Elizabeth Cropper, *Pietro Testa, 1612–1650: Prints and Drawings* (Philadelphia: Philadelphia Museum of Art, 1988).

33 **Pietro Aquila
(after Agostino Carracci)**
Italian
Circa 1650–1692

Glaucus and Scylla,
or *Venus and Triton*, 1677

Engraving with hand-coloring
11 3/16 x 17 5/8 in.
(28.2 x 44.5 cm)

University Transfer, 1976.166

Semifero Tritone VENUS Dea vecta per altum,
Aequoreos mulcet fluctus, et numina ponti,
Insequitur CHARITUM, sequitur comitatus AMORUM:
It chorus, et pueri iaculantur spicula flammas

(Carried across the high seas by the half-human Triton, now VENUS
Gentles the billowing main and soothes the gods of the seaway
Following closely the GRACES are flanked by an escort of CUPIDS:
On goes the band, and the arrows of EROS launch flames of love)

Pietro Aquila produced two series of reproductive prints after works by the Carracci. One set of twelve prints and a frontispiece is devoted to the Camerino Farnese. This image belongs to his other set of twenty-four prints plus a frontispiece that depicts the Farnese Gallery in its entirety. Series of prints reproducing fresco cycles became popular in baroque Rome after Giovanni Lanfranco and Sisto Badalocchi engraved the Loggias of Raphael. Although sections of the Farnese Gallery had been engraved previously, Aquila was first to thoroughly engrave all of it, including views of individual scenes such as this one and, uniquely, its decorative elements and ancient sculpture, located in the Gallery's niches. Aquila's endeavor to present the Gallery as a whole demonstrated the cohesion of ancient and contemporary art. The fresco reproduced in this print is by Agostino Carracci, brother to the more famous Annibale who frescoed most of the Gallery.

A masterpiece of baroque art, the Gallery was probably painted in celebration of Duke Ranuccio Farnese's marriage in 1600. Appropriately, its theme is the power of love, represented by scenes from classical mythology, many of

Babies, Banquets, and Bacchanals

BIBLIOGRAPHY

Evelina Borea and Ginevra Mariani, eds., *Annibale Carracci e i suoi incisori* (Rome: École Française de Rome, 1986); Charles Dempsey, *Annibale Carracci: The Farnese Gallery, Rome* (New York: George Braziller, 1995); Dempsey, "*Et Nos Cedamus Amori*: Observations on the Farnese Gallery," *Art Bulletin* 50 (1968): 363–74; John Rupert Martin, *The Farnese Gallery* (Princeton: Princeton University Press, 1965); inscrip. trans. I. D. Rowland.

which were adopted from Ovid. The identification of the scene reproduced in this print has engendered much controversy. Aquila's title of *Venus Riding the Triton* simply followed earlier misidentifications. Ovid's story of Glaucus and Scylla, a tale of unrequited or impossible love between a mortal and a god, is thematically congruous with other frescoes in the Gallery. Charles Dempsey, on the other hand, regards this fresco as "extravagantly luxurious" and "daringly sensual (indeed explicitly sexual)." Indeed, the prominent, groping hand at the center of the image and the impish tail of a dolphin gently caressing a putto's posterior certainly suggest that Cupid may at last succeed. —MP

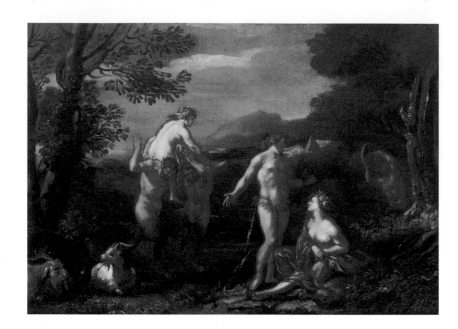

34 Attributed to Filippo Lauri
Italian
1623–1694

Bacchanal

Oil on canvas, affixed to panel
10½ x 15½ in.
(26.7 x 39.4 cm)

Gift of Mr. and Mrs. Fielding
L. Marshall, 1975.43

BIBLIOGRAPHY

Didier Bodart, *Les peintres des Pays-Bas méridionaux et de la principauté de Liège à Rome au XVII siècle* (Brussels: Institut Historique Belge de Rome, 1970); Ann Sutherland Harris, *Landscape Painters in Rome, 1595–1675* (New York: R. L. Feigen, 1985); Lione Pascoli, *Vite de' pittori, scultori ed architetti moderni* (facsimile of the Roman edition of 1736), vol. 2 (Rome: E. Calzone, 1933); Nicola Pio, *Le vite di pittori, scultori et architetti* (Vatican City: Biblioteca Apostolica Vaticana, 1977); Luigi Salerno, *Pittori di paesaggio del Seicento a Roma*, vol. 2 (Rome: U. Bozzi, 1977–78); Andrea Busiri Vici, *Jan Frans van Bloemen "Orizzonte": E l'origine del paesaggio romano settecentesco* (Rome: U. Bozzi, 1973); quotation trans. E. Rodini.

The eighteenth-century biographer Baldinucci described Filippo Lauri as "di faccia allegra sì ma poco bella" (of a lively face, but hardly a pleasing one). Known for his charming personality and engaging conversation, Lauri assiduously read the newssheets to sharpen these very qualities. At different times he was the *principe* of two esteemed Roman academies, the Accademia di S. Luca (1685–86) and the Accademia dei Virtuosi al Pantheon (1665). Despite a somewhat peculiar physical appearance, Lauri was employed by some of the most powerful Roman families, such as the Chigi, Farnese, and Colonna, and his images are, on the whole, elegant, cheerful, and lively. Lauri won artistic notoriety for his small-scale mythological scenes, such as this *Bacchanal*, populated with graceful figures in an idyllic, pastoral landscape reminiscent especially of works by the Bolognese painters Domenichino and Albani. The sweet, classicizing nymphs and satyrs, celebrating with wine and music beneath the shaded protection of lush foliage, are typical of Lauri, as is the central spatial recession which here opens onto an architectural vista that includes what may be the pyramidal tomb of Cestius, then at the outskirts of Rome. Attribution of this canvas to Lauri is based on its striking similarity to his secure *Dance of Nymphs and Satyrs* (Rome, private collection) and *Jacob's Flight from Laban* (Hampton Court, Royal Collection). But there are also parallels of figure type and scale in works where the surrounding landscapes have been tentatively attributed to other artists, such as the *Pan and Diana* (London, Agnew Gallery) and *Venus Chains Silenus* (Rome, private collection), with landscapes given to Jan Frans van Bloemen. Attribution is a recurrent problem because Lauri frequently collaborated with the most famous landscape painters of seventeenth-century Rome, including Claude Lorrain, Gaspar Dughet, and Bloemen. The composition, leafy trees, and receding landscape in the Smart *Bacchanal* do suggest the influence of Dughet or Bloemen, but overall the style is more reminiscent of Lauri. Despite its recent cleaning, the surface of the painting shows wear and deterioration of pigment, making a secure attribution difficult. —MP

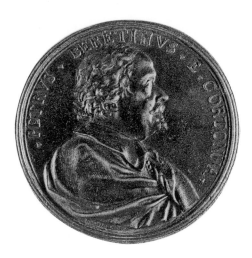

35 Charles-Jean François Chéron

French
1635–1698

Pietro da Cortona (Pietro Berrettini) (1596–1669) (obverse), *Allegory of Fame* (reverse), after 1669

Cast bronze
Diameter 2⅞ in. (7.3 cm)

Purchase, Gift of Paul A. Kirkley, Ph.B. '24, in memory of his wife Martha L. Skinner Kirkley, Ph.B. '24, 1978.134

BIBLIOGRAPHY

Giulia Fusconi and Valeria Di Piazza, "Cortona e l'antico," in *Pietro da Cortona e il disegno*, ed. Simonetta Prosperi Valenti Rodinò (Milan: Electa, 1997), 60–67; Bénédicte Gady, "Una gloria senza fortuna: Pietro da Cortona e la Francia," in *Pietro da Cortona, 1597–1669*, ed. Anna Lo Bianco (Milan: Electa, 1997), 153–63.

Born a Protestant, Charles-Jean François Chéron nonetheless cast portrait medals of three popes and became engraver of medals to two of them (Clement IX and Innocent X). While in the Eternal City (ca. 1655–75), Chéron absorbed the contemporary style of the Roman baroque, then most forcefully expressed in the grand, exuberant images of Pietro da Cortona. The Smart Museum medal is testament to the importance of this Roman sojourn, and of Cortona in particular, to the development of Chéron's art.

This medal features a profile portrait of Cortona on the obverse and the figure of Fame on the reverse, a juxtaposition that attests to Cortona's European reputation during the seventeenth century. Chéron's image became a model for other artists, such as the Roman Carlo Maratta, who adopted it for his own memorial to Cortona (cat. no. 56). Chéron strove to equal the renown of the man he was commemorating, and hoped to do so through this handsome object. He was successful: in 1675 Chéron returned to France at the request of Louis XIV, who enlisted Chéron to record the history of his reign on cast medals.

Chéron's career and the Smart medal indicate the importance of Cortona in seventeenth-century French culture and, significantly, to the continued, vibrant presence of antiquity for French artists. Cortona may seem an odd model of admiration for the cool classicism associated with the French school of painting spearheaded by Poussin, because Cortona's mature style is synonymous with a lavish excess. But this interpretation obscures his study and frequent use of the antique, especially ancient reliefs and architecture. Cortona's ideal views of the Roman *campagna* exalt nature by the presence of antiquities and ruins, which grant historical and sometimes sacred significance to the landscape. —MP

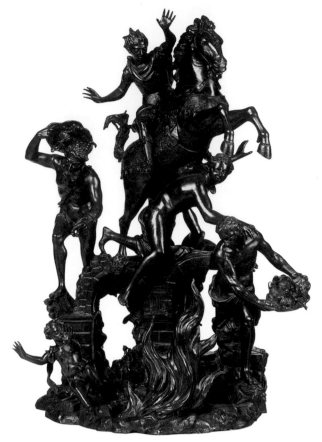

CAT. NO. 36

CAT. NO. 37

Francesco Bertos
Italian, active Rome
and Venice
Active 1693–1739

36 *The Punishment of Dirce
(The Farnese Bull),*
circa 1690–1710

Cast bronze
31¾ x 24½ x 18⅞ in.
(80.7 x 62.2 x 47.9 cm)

Lent Anonymously, 20.1997

37 *Marcus Curtius,*
circa 1690–1710

Cast bronze
29⅛ x 19⅛ x 18⅛ in.
(74 x 48.6 x 46 cm)

Lent Anonymously, 19.1997

A popular but poorly documented sculptor, Francesco Bertos trained as a stone-cutter in Rome but achieved his most spectacular effects in bronze, specializing in elaborate small-scale sculptural groups portraying mythological figures and his own arcane allegories (like his *Triumph of Chastity* at the Art Institute of Chicago). The bronzes exhibited here, however, belong to a different tradition: they reproduce famous ancient Roman marble sculptures from two of the most illustrious collections in eighteenth-century Rome. The massive group depicting the *Punishment of Dirce* was then on display in the grand Palazzo Farnese (it is now in the National Archaeological Museum in Naples), and Bertos has repro-duced the work fairly closely. The original *Marcus Curtius*, on the other hand, was not a freestanding statue, but a high relief, and it was preserved only in frag-ments. It is likely that in 1617, shortly before its installation at the Villa Borghese (where it remains today), it was heavily restored. Bertos, in the same spirit of cre-ative reconstruction, has transformed the relief into a statue group, adding the stately architectural setting and several additional figures to the composition.

Ancient Romans delighted in what they called "tabletop" miniatures of life-size statuary, like the "tabletop Hercules" commemorated in verse by the poet Statius. Inspired by this literary example, Renaissance sculptors began to pro-duce their own small reproductions of ancient masterpieces, though usually of individual figures rather than the complicated groupings in which Bertos would excel. But by the 1690s or the early years of the eighteenth century, when these

bronzes were probably executed, an artist with the ambitions of Bertos responded not only to the inspiration of the ancients, but also to the technical brilliance of a modern challenger—the recently deceased Gianlorenzo Bernini. The original *Marcus Curtius* relief shared space in the Borghese Gallery, indeed, with some of Bernini's most complex commissions: statue groups depicting *Apollo and Daphne*, *The Rape of Proserpina*, and *Aeneas Escaping from Troy*. Bertos could hardly have studied one without studying the others.

The Greek myth depicted in the *Punishment of Dirce* revolves around the brothers Amphion and Zethus, whose mother Antiope had been impregnated by Zeus. The unwed mother entrusted the boys to their great-uncle Lycus, ruler of Thebes, who instead abandoned them to be raised by shepherds. Antiope, in turn, suffered cruel treatment at the hands of Lycus's jealous wife Dirce. When the boys reached maturity, they learned of their mother's suffering, and took revenge by killing Lycus and tying Dirce to a bull, which dragged her to her death. The sculptural group, both in the marble original and in the bronze miniature, shows the moment when the brothers bind a hapless Dirce, while a shocked shepherd boy looks on. But whereas the Farnese group emphasizes the human characters in the violent tale, Bertos shifts emphasis to the magnificent bull.

Instead of spiteful suffering and vengeful torture, the Roman legend of Marcus Curtius stresses the patriotic virtues of the early Republic. Livy's *History of Rome*, as short on credible fact as it is long on moral edification, reports that in the early days of the Republic a fiery chasm opened in the center of the Forum. Oracles informed the Romans that they should fill the abyss with their most cherished possessions; Curtius realized that those possessions must be youth and military strength, *virtus*. Courageous soldier that he was, he armed himself for battle, mounted his charger, and plunged into the chasm, which closed forever behind him. The original Borghese relief shows only Curtius and his horse; Bertos has added two misguided Roman citizens who hurl their treasures into the chasm, a terrified baby, and the elaborate architectural setting of the abyss itself.

The explicitly Roman subject matter of these bronzes, a certain stiffness in their execution, and the fact that they originate as reproductions of ancient masterpieces all suggest that they are early works, when a young Bertos was still working in Rome and sharpening his skills by close observation of old masters. Their patron is as yet unidentified, but a coat of arms on the base of each sculpture, along with the initials GA. D. G. H., confirms that they were a pair or part of a set. By 1710 Bertos had left Rome for Venice, where he created his characteristic mythological allegories for an international set of patrons. —MP/IDR

BIBLIOGRAPHY

Valeria Farinata, "Francesco Bertos," in Jane Turner, ed., *The Dictionary of Art*, vol. 3 (1996), 862; Francis Haskell and Nicholas Penny, *Taste and the Antique: The Lure of Classical Sculpure, 1500–1900* (New Haven. Yale University Press, 1981), 165–67 and 191–93; Leo Planischig, "Francesco Bertos," *Dedalo* 9 (1928): 209–21; Camillo Semenzato, *La scultura veneta del Seicento e del Settecento* (Venice: Alfieri, 1966); Ettore Viancini, "Per Francesco Bertos," *Saggi e memorie di storia dell' arte* 19 (1994): 143–58.

38 **Attributed to Titian
(Tiziano Vecellio)**
Italian, Venice
1487/90–1576

Studies after the Antique,
circa 1520

Pen and ink on paper
5⅜ x 8 in. (13.7 x 53.7 cm)

Jean and Steven Goldman
Collection

This interesting sheet of sketches after antique fragments has not been firmly attributed or dated, and the debate surrounding it remains unpublished. The most substantiated suggestion—that it could be a work by Titian from the early part of his career—was first made in a letter by A. E. Popham, who connected it to other, secure drawings by the Venetian master. The Goldman sketches might be linked to an important visit Titian made to the Este court at Ferrara in 1516, where he could have studied the significant ducal collection of antiquities and models after the antique. This collection, dating back to the mid-fifteenth century, contained coins, medallions, and sculptures, as well as small-scale bronzes and other copies of monumental works. In November of 1519, Titian paid a brief visit to Mantua; his studies of the classicizing works of Andrea Mantegna and the Gonzaga holdings were another possible source of inspiration for the Goldman sheet.

A number of details support this hypothesis, and the Ferrara connection in particular. The application of ink in hatched lines recalls securely attributed sheets in the Cabinet of Engravings of the Staatliche Museen, Berlin and the Städelsches Kunstinstitut, Frankfurt am Main. These drawings show studies for the figure of St. Sebastian in Titian's *Brescia Altarpiece* of ca. 1520–22, a work that Alfonso d'Este (1505–34) sought to purchase. The study of a head at the lower right of the Goldman sheet resembles, in both its features and its downcast, tilted angle, the head of the martyred saint. More striking is the connection with the verso of the Frankfurt sheet, which also juxtaposes studies of feet with

the strong profile of a male head. The inspiration for the profile was almost certainly a classical coin or medallion, of which the Este had a large collection.

The carefully rendered torso at the center of the Goldman sheet might be related to St. Sebastian's muscled body in the *Brescia Altarpiece*. Its Michelangelesque quality is in keeping with the Berlin and Frankfurt drawings, which seem to draw inspiration from the *Rebellious Slave* produced in 1513 by the great Florentine sculptor for the tomb of Pope Julius II (and now in the Louvre). Titian could not have seen this work, which remained in Michelangelo's studio in Rome, but he might have known it from reduced, sculpted copies. The torso at the center of the Goldman sheet is also reminiscent of the renowned *Laocoön*, an antique statue group showing the Trojan priest and his two sons devoured by giant snakes. Very shortly after its discovery in 1506, copies of the *Laocoön* were put into circulation, and Titian himself may have had one in his studio. The Este, who had once tried to buy the original, had a particular fondness for this piece; its form is evoked several times in works commissioned by Duke Alfonso, most famously in Titian's *Bacchus and Ariadne* of 1523 (London, National Gallery). Alfonso's sister, Isabella d'Este of Mantua, acquired two bronze copies of the *Laocoön* and may have considered purchasing one of gold. The London canvas and the other bacchanals painted for Alfonso (p. 16, fig. 2) demonstrate the profound impact of both these influences—the classical and the Michelangelesque—on Titian. Around 1520, he introduced powerful, plastic forms into a Venetian tradition that emphasized light, color, and atmosphere.

Most interesting of all, if we accept the Este connection, is what this drawing reveals about the influence of antiquity during the Renaissance and the rapid diffusion of classical forms throughout the Italian peninsula and beyond. Even as early as 1520, artists did not need to go to Rome to study the Roman past. In addition to coins, medallions, and locally excavated fragments, artists working in smaller, provincial centers had access to prints, drawings, small-scale bronzes, and eventually plaster casts after monumental originals. Ideally, artists did not just copy these models, but used them to develop a vocabulary of motifs, gestures, and poses, as Titian—following Michelangelo's lead—did at Brescia and Ferrara.

Titian's interest in antiquity did eventually lead him to Rome where, at the invitation of Cardinal Alessandro Farnese, he was installed at the Villa Belvedere, which housed the papal collection of antique statues. There he could have studied such famous works as the *Belvedere Torso*, the *Apollo Belvedere*, and the *Laocoön*. Certainly Titian was awed by these sights, but he also took the veneration of classical antiquity with a grain of salt. He famously satirized the *Laocoön*'s popularity in an engraving that showed the three struggling figures as apes.

The attribution of drawings to Titian is notoriously difficult. Other names have been raised in connection with the Goldman sheet, including that of Domenico Campagnola, who employed a similar hatching technique. More tenable is an attribution to Titian's workshop based on studies by the master. For while the sheet resembles Titian's Frankfurt and Berlin drawings in its style and subject, it differs from them in its lack of spontaneity and in the careful *mise-en-page* which is uncharacteristic of Titian. If this is in fact a workshop piece, it represents yet another, critical step in the transmission of classical forms: from original, to cast or printed copy, to drawings after copies which, in turn, served as models for subsequent students of antiquity. —ER/JG/IDR

BIBLIOGRAPHY

Letter from A. E. Popham to Steven and Jean Goldman, Goldman archives; Diane H. Bodart, *Tiziano e Federico II Gonzaga: Storia di un rapporto di committenza* (Rome: Bulzoni Editore, 1998), 32; W. Roger Rearick, catalogue entries in *Le siècle de Titien: L'age d'or de la peinture à Venise*, ed. Gilles Fage (Paris: Réunion des Musées Nationaux, 1993), 615–17; Francis Haskell and Nicholas Penny, *Taste and the Antique: The Lure of Classical Sculpture, 1500–1900* (New Haven: Yale University Press, 1981), 3 and 243–44; Francesco Valconover, "Il classicismo cromatico di Tiziano," in *Tiziano e il manierismo europeo*, ed. Rodolfo Pallucchini (Florence: Leo S. Olschki Editore, 1978), 61; Andrea Bayer, "Dosso's Public: The Este Court at Ferrara," in *Dosso Dossi: Court Painter in Renaissance Ferrara*, eds. Peter Humfrey and Mauro Lucco (New York: The Metropolitan Museum of Art, 1998), 38–39; John Walker, *Bellini and Titian at Ferrara: A Study of Styles and Taste* (London: Phaidon Press, 1956).

CASSIANO DAL POZZO
Italian
1588–1657

Cassiano dal Pozzo, a man who published nothing and who created no works of art, was one of the most celebrated polymaths of baroque Rome. Although he ranks as one of the greatest connoisseurs of ancient art, his collection of antiquities was negligible. Instead he amassed the largest and most comprehensive collection of drawings after the antique. Considered by many to be the single most influential private patron in seventeenth-century Rome, Cassiano rarely worked with artists of renown. Rather, he patronized and employed young, untested talents, many of whom later gained fame and whose works, consequently, quickly exceeded the limits of his purse.

This perceptive and enigmatic man also somehow managed to maintain a close personal and intellectual relationship with Galileo even while the Church, Cassiano's very employer, officially condemned Galileo's work as heretical. For Cassiano there was no contradiction between his membership in the prestigious Accademia dei Lincei, the first serious European scientific academy, and his involvement in historical research for the Counter Reformation agenda of the Oratory of St. Philip Neri. In both capacities, he made momentous contributions: in one to the development of natural history, and in the other to the elaboration of a Christian archaeology. What united his seemingly disparate activities was his emphasis on visual evidence. In natural history he insisted on the importance of direct, personal observation and paid particular attention to minute visual details in the development of taxonomies. He applied identical observational methods to the visual arts in order to attain information about the costumes and customs of the ancient world, including its religion. He even extended his research methods into the medieval period, using visual representations to investigate the rites and rituals of early Christians.

Cassiano is perhaps most famous as a lifelong patron and friend of the French painter Nicolas Poussin. In general, Cassiano favored artists interested in the classical tradition who creatively deployed their knowledge of the ancient world, including its art, in contemporary images. His Paper Museum, the label he gave to his massive collection of drawings after the antique, simultaneously afforded young artists both an opportunity for employment and a training and education in ancient art. Artists such as Poussin, Testa, and Cortona all benefited from their experience with Cassiano early in their careers. In fact, Cassiano acted as a nucleus for several artistic groups in baroque Rome, nourishing the "classical" school while fostering the renewed interest in Venetian art that spurred certain "baroque" tendencies.

The four drawings discussed here are wonderful examples from Cassiano's justly famed Paper Museum. They demonstrate the wide range of object types and subjects encompassed by a project where art from various time periods was brought together. Predictably, the Paper Museum was

loosely ordered according to subject and not medium. Because so many artists worked on this gargantuan project to record the artistic remains found in Rome and its vicinity, many of the drawings are still unattributed; in addition, a certain "house style" inevitably prevailed as artists worked together and studied existing drawings. But Cassiano, it has recently been noted, was always a collector and not simply a scientific cataloguer. Hence, his commissioned drawings are frequently "inaccurate" in that the artists he employed, beyond merely recording data, tended to embellish the all too often damaged ancient originals that inspired them. —MP

39 **Artist Unknown (Pietro Testa? 1612–1650)**
From the Paper Museum of Cassiano dal Pozzo

Study after the Antique (Relief Sculpture, Mask, and Sphinx upon an Iron Foot), circa 1630

Pen and ink with wash over red chalk on paper
7⅞ x 7 in. (20 x 17.8 cm)

Steven and Jean Goldman Collection

This sheet consists of three separate drawings which were later arranged together. The entire sheet is attributed to Pietro Testa. At this point, attribution of Paper Museum drawings to Testa remains necessarily cautious and still somewhat speculative. Filippo Baldinucci, an early biographer of Testa, claimed that

The Place of the Antique

Testa had executed five volumes of drawings after the antique for Cassiano. Although Baldinucci's is a notoriously vague and probably exaggerated assertion, Nicholas Turner reasonably attributes over five hundred drawings from the dal Pozzo collections now in the Royal Library, Windsor and the British Museum to Testa. Due to the variable nature of the objects copied, drawings after the antique, even those executed by a single artist, inevitably exhibit great disparities. To complicate matters further, Testa frequently indulged in arbitrary or inventive reconstructions of damaged objects. Nevertheless, there are certain consistent characteristics that facilitate identification of a general Testa style. All three drawings on this sheet were executed with a fine, sensitive line in brown ink with gray wash. Like other Testa drawings after the antique, these studies reveal deliberate concentration through a highly controlled, precise line that displays acute attention to detail and varied effects of texture.

The drawing at the top of the sheet is a copy of a relief sculpture fragment. A faint dal Pozzo inventory number of 510 is just visible below the figure's right shoulder. The simplified face lacks definition and the shading on the neck and forehead is not entirely successful. Yet the exquisitely drawn hair and earrings, and the masterful rendition of texture lavished on the toga, suggest an attribution to Testa. The anatomy of the *Sphinx upon an Iron Foot* (at the lower right), inscribed with the inventory number 1318, is rendered with slight disproportion and the wash is less skillfully applied. Once again, however, the fine, elegant texture of the wings and the hair similar to that of the relief are reminiscent of Testa's hand. In addition, the adept use of wash to delineate the structure of the iron foot is of the highest quality. Typical of Testa's eccentric personality is the curious, alert facial expression of the sphinx.

Unlike the other two drawings on this sheet, that of an ancient mask (lower left) has double ink mounting lines and no inventory number. Testa effectively employed dark ink to contrast strongly with the wash. He brought minute, careful attention to the mask's hair, but infused this precision with a wild vitality, a combination of effects illustrative of Testa's exhilarating approach to drawing. Supremely defined facial features convey a direct, emotional intensity unexpected in a study after the antique. —MP

40 Artist Unknown
From the Paper Museum of
Cassiano dal Pozzo

*Study after the Antique
(Torso of a Gladiator Wearing
a Breastplate)*, circa 1630

Pen and brown ink with wash
over black chalk on paper
10³⁄₁₆ x 5¹¹⁄₁₆ in.
(25.9 x 14.5 cm)

Steven and Jean Goldman
Collection

41 Artist Unknown
From the Paper Museum of
Cassiano dal Pozzo

*Study after the Antique
(Back of a Torso of a
Gladiator)*, circa 1630

Pen and ink on paper
10³⁄₁₆ x 5¹¹⁄₁₆ in.
(25.9 x 14.5 cm)

Steven and Jean Goldman
Collection

This group of drawings (cat. nos. 40–42) reveals Cassiano's intense interest in
ancient costume. In both the images of the gladiator torso and of the *togato* fig-
ure, very little of the human form is revealed. The gladiator's body lacks muscle
definition, and no attempt has been made to "restore" its missing limbs or head.
In the case of the *togato*, most of the body is encased in the heavy, draping folds

42 Artist Unknown
From the Paper Museum of
Cassiano dal Pozzo

*Study after the Antique (Two
Studies of a Classical Sculpture
of a Togato)*, circa 1630

Pen and ink on paper
5 ⅜ x 8 in. (13.7 x 20.3 cm)

Steven and Jean Goldman
Collection

BIBLIOGRAPHY

Cassiano dal Pozzo's Paper Museum, vols.
1–2, *Quaderni Puteani* 2–3 (1992), esp.
Nicholas Turner, "The Drawings of Pietro
Testa after the Antique in Cassiano dal
Pozzo's Paper Museum," vol. 2, 127–44;
Francis Haskell, ed., *The Paper Museum of
Cassiano dal Pozzo, Quaderni Puteani* 4
(1993); Haskell, *Patrons and Painters: A
Study in the Relations between Italian Art
and Society in the Age of the Baroque*, 2nd
rev. ed. (New Haven: Yale University Press,
1996); Elizabeth Cropper and Charles
Dempsey, *Nicolas Poussin: Friendship and the
Love of Painting* (Princeton: Princeton
University Press, 1996).

of the sculpted fabric. In the back view folds are defined by wash, while the front relies more on the use of line. These thin, crisp, and dark delineations articulate an elaborate flow of constrasting drapery folds. The artist concentrates on the different sections and functions of the toga fabric, and especially on the importance of affecting a proper stance and on the positioning of the arms and hand. Again, one hand is missing and has not been "restored." This detail, along with the inclusion of the pedestal, testifies to the artist's direct encounter with the sculpted model and to an emphasis on accurate observation.

Cassiano was interested in the gladiator costume for what it could reveal not just about dress, but about antiquity more generally. The gladiator was a social type and a profession, and a detailed study of costume was one avenue to a broader understanding of ancient Roman society. For example, these drawings, with inventory numbers 12 and 13, might illuminate ancient forms of combat, sporting practices, and religious or superstitious beliefs evidenced, perhaps, in the protective mask on the breastplate. The meticulous attention to the straps on the back is characteristic of the documentary, almost archaeological character of Cassiano's collection. While the drawings of the gladiator appear to be a pair, they differ in both scale and treatment. In the front view, a shadow suggests the solidity of the original, sculpted model. The back view lacks such references, concentrating instead on the details of the figure itself. —MP/ER

**GIOVANNI BATTISTA
PIRANESI**
Italian
1720–1778

Piranesi is best known for his majestic vision of ancient and modern Rome, which forever altered the perception of the Eternal City. In a dexterous display of erudition and imagination, Piranesi combined both fantasy and historical knowledge to reconstruct both the architecture and the society of ancient, even archaic, Rome. He employed his prolific imagination and unrivaled graphic ability to exceed the available evidence, to transcend mere facts, and to produce a conception of the past and its stony ruins so spirited as to transform thereafter the approach to such evidence. Yet Piranesi's antiquity is always specifically situated in his own eighteenth century, thereby revealing the decay and decline of Rome with an emphasis on time and historical change; beyond his antiquarian and archaeological interests, Piranesi saw ancient art as a limitless inspiration and model for contemporary artists. Through this exhilarating vision of artistic and historical continuity, Piranesi made claims for the power, immortality, and nobility of art in society from ancient to modern times.

The Smart Museum's four prints by Piranesi belong to his *Vedute di Roma* series (1748–78). Because Piranesi continued to produce prints for the *Vedute* throughout his career, and because these prints encompass that chronological range, a brief sketch of Piranesi's intellectual and artistic development is useful. Piranesi was trained as an architect in Venice, where he also absorbed the work of Canaletto and Tiepolo. His architectural background engendered a lifelong interest in construction techniques, building materials, and engineering. Following the dominant example of Canaletto's paintings and etchings, Piranesi perfected the topographical and architectural *veduta*, then immensely popular with tourists Around 1740, Piranesi traveled to Rome, where he was deeply influenced by the city's master of the *veduta*, Giovanni Paolo Pannini (1691–1765). Much like Canaletto in Venice, Pannini painted accurate images of Rome's famous monuments and sites, both ancient and modern, for wealthy travelers, mostly British, on the Grand Tour through Italy (see p. 89). But Pannini also excelled in *capricci,* images in which ancient buildings and sculptures, although represented accurately as individual objects, were assembled and combined in an arbitrary and fantastic manner. In 1744, Piranesi expressed his ardent enthusiasm for antiquity by visiting Naples and the excavations at the recently discovered Vesuvian city of Herculaneum. Financial difficulties prompted a brief return to Venice, where Piranesi seems somehow to have been involved with Tiepolo's studio and was, in any case, noticeably impressed by Tiepolo's style, in both his paintings and his recently published etchings. With Tiepolo as a model, Piranesi increased his sensitivity to light and texture, and evolved a more fluid etched line. A final but substantial influence on Piranesi's early formation, and one that characterizes him more as a baroque than a neoclassical artist, was contemporary stage design. Many of Piranesi's dramatic and oblique perspectives derive from his creative use of Ferdinando

The Place of the Antique

Bibiena's *scena per angolo* technique, originally conceived for stage sets. Indeed, Piranesi's famous *Carceri* (Prisons) series reflects contemporary theatrical and operatic interest in prisons, and its style adopts the current techniques of stage design.

By 1747, Piranesi was again living in Rome, employed by the topographical engraver Giuseppe Vasi (1710–82). Before long, he began to publish his own prints independently and to sell the work of others on commission. In 1748, he released the first fourteen prints of what would become his most popular series, the *Vedute di Roma*, totaling at the time of his death 135 prints, sold individually, like the Smart Museum examples, or in bound sets. The plates and sheets Piranesi utilized for the *Vedute* were so large that, for the first time, etchings could compete in sheer physical presence with *veduta* paintings. In fact, Piranesi would eventually render obsolete the conventional Roman representation of the classical landscape exemplified by the work of Claude (cat. no. 57) and his followers Dughet and Lauri (cat. no. 34). A veritable compendium of eighteenth-century Roman views, the *Vedute* depicted the city's impressive architectural monuments, ancient to modern, and situated them within an urban context complete with gesticulating contemporary figures who seem to have stepped off the stage and onto the streets of Rome. Their urgency and nervous energy contrast sharply with the eternal, magnificent ruins of antiquity. Piranesi's lively use of the *scena per angolo* technique, his virtual elimination of a middleground, and his painterly effects of light and shade heighten the drama and grandeur of the *Vedute*.

Not surprisingly, these prints reflect Piranesi's larger interests and concurrent activities which, during the 1750s, became increasingly focused on archaeological and antiquarian projects, and culminated in the great four-volume *Antichità romane* (1756). Piranesi's interest in ancient Rome had become obsessive, even fanatical. The massive quantities of historical and visual information crammed into the weighty tomes of the *Antichità* were probably inspired by the recent, lavish archaeological publications of the Neapolitan Accademia Ercolanese, documenting the treasures excavated at Herculaneum. The *Antichità* were applauded throughout Europe, transforming Piranesi from a respectable local artist to a figure of international renown. Although neither a systematic treatise nor a concentrated investigation of any single aspect of ancient Rome, the *Antichità* nevertheless produced a lasting, unique, and heroic vision of Roman grandeur and monumentality. Much of this glory rested on the technical accomplishments of the ancients. Piranesi concentrated on Roman aqueducts and drainage, city walls and the defensive system, road construction and urban planning, building methods and structure, foundations instead of superstructures, and building materials such as stone masonry. Piranesi's vision of Rome included not just picturesque panoramas but ground plans, cross sections, cross-references, and technical interior views. The real merit and undeni-

able achievement of the *Antichità*, however, was Piranesi's peerless combination of serious antiquarian knowledge with imaginative and exhilarating reconstructions; Piranesi did not just research ancient Rome, but recreated and animated antiquity for his contemporaries.

A comparison of the work of Piranesi and that of the Veronese antiquarian Francesco Bianchini (1662–1729) provides valuable insight into Piranesi's unique vision and his increasingly patriotic motivations. Bianchini's *Camera ed inscrizioni sepulcrali de' liberti, servi ed ufficiali della casa d'Augusto* (1727) is usually characterized as a sterile, though accurate, record of factual information, in sharp contrast to Piranesi's comprehensive and animated portrait of a lost society. But Piranesi's study of Bianchini was significant. The Veronese was a pioneer of Roman archaeology: he was the first scholar to systematically excavate the Aventine (in 1705) and later the Palatine, and was famous for his devotion to objective documentation and his preference for archaeological and epigraphic over literary evidence. Piranesi purchased and studied the plates to Bianchini's *Casa d'Augusto*. But Piranesi's enthusiasm for the Etruscans and Romans quickly became a transparent vehicle for nationalism and cultural bias, an attitude Bianchini abhorred and discouraged. This attitude eventually fueled Piranesi's belief in the inherent superiority of Rome over Greece. In fact, the entire phenomenon of Italian eighteenth-century Etruscomania, which Piranesi harnessed to support a claim to the continuity of "Italian" culture, was the result of regional or municipal pride, a desire to claim local origins previous to Roman dominance. The increased interest in Greece and Greek art, promoted by the publications of foreigners such as Caylus, Le Roy, Laugier, Dalton, Stuart and Revett (cat. no. 54), and Winckelmann, threatened Piranesi, who depended on Roman architecture for both the subject and artistic style of his prints.

Piranesi promptly responded to these Hellenists, who hypothesized that Roman art was derived and copied from Greek art, with his *Della magnificenza ed architettura de' Romani* (1761) and *Parere su l'architettura* (1765), which supported claims for the originality of Roman civilization and architecture independent of Greek influence. In his *Magnificenza*, Piranesi alleged that the Etruscans were the sole teachers of the Romans who had, he maintained, inherited all that was good about Etruscan civilization. Piranesi also admired Etruscan architecture for what he believed was its simplicity and grandeur, devoid of ornament. He praised the functional structures of the Etruscans, especially those antecedent to contact with the Greek world, and feats of engineering such as the massive sewer known as the Cloaca Maxima.

Surprisingly, Piranesi completely reversed these earlier assertions when, in the *Parere* of 1765, he commended Etruscan architecture for its abundant ornament and exuberant decorative motifs. In opposition to his former interest in the austere antique, Piranesi here concentrates on mod-

ern design and architecture and recommends the study of antiquity in its
entirety, including Egyptian, Greek, Etruscan, and Roman art, as eclectic
sources of inspiration and stimulus. In the *Parere*, Piranesi the modern
artist (inventive, imaginative, and emotional) and Piranesi the antiquary
(technical, archaeological, and factual) are finally united and dedicated to
a single purpose. Rules are now abandoned, especially adherence to
Vitruvius or Palladio, and in reversion to Mannerist sensibilities Piranesi
inverts the normal harmony of architectural elements, urging the domi-
nance of ornament, invention, and an emphasis on decorative detail. For
the remainder of his fruitful career, Piranesi explored the monuments of
Roman and Etruscan civilization outside of Rome, documenting places as
diverse as Lake Albano, Tivoli, and, in his final project, the Greek temples
of Paestum. —MP

Veduta della Piazza di Monte Cavallo

43 **Giovanni Battista Piranesi**

Piazza del Quirinale,
1746–1748?, from the
Vedute di Roma series,
circa 1748–1778

Etching
20 x 27 5/8 in.
(50.8 x 70.2 cm)

University Transfer from Max
Epstein Archive, Gift of
Morton Zabel, 1967.116.148

Piranesi followed local custom when he entitled this plate, which was one of the first fourteen original etchings of his *Vedute di Roma* series, *Veduta della Piazza di Monte Cavallo* after the Roman statues of Castor and Pollux located there. The name alone indicates that the horses (*cavalli*) of the Dioscuri, Roman copies of fifth-century B.C.E. Greek originals, were traditionally the most admired features of both this ancient monument and the piazza as a whole. They are clearly the focus of this print. Moreover, the awesome, exaggerated scale of the ancient statues bathed in the eternal glory of the setting sun, along with the scattered architectural spolia in the center foreground, place an unmistakable emphasis on Rome's ancient past; in contrast, the Palazzo Pontificio or Papal Palace (now the residence of the Italian president) is off-centered and obliquely angled. In fact, the raised fists of Castor and Pollux, who directly face the Palazzo, seem here to be gestures of defiance or at least to evoke a tension between pagan Rome and the Christian city symbolized by papal authority. Even the aristocratic tourists with their elaborate carriages appear more enthralled with the ancient sculpture than with visiting the pope, whose soldiers are in formation in front of their quarters. On the other hand, in a contemporary urban context, the discarded spolia and the only sunset in Piranesi's *Vedute* series suggest that, although antiquity is the foundation of Rome's grandeur and power, it is a past that must inevitably yield to the reality of the eighteenth century. —MP

Veduta del tempio della Sibilla in Tivoli

44 **Giovanni Battista Piranesi**

Temple of the Sibyl, Tivoli,
1761, from the *Vedute di
Roma* series, circa 1748–1778

Etching
20 x 27⅝ in. (50.8 x 70.2 cm)

Gift of Gaylord Donnelley,
1982.6

Executed during Piranesi's polemical, antiquary period when he asserted the primacy and independence of ancient Rome in opposition to the views of Hellenists who degraded Roman work as derivative, this etching is one of twenty-three prints devoted to Tivoli included in the *Vedute di Roma*; Piranesi had, in fact, originally intended to issue a separate series on Tivoli. This is one of three views, each from a different vantage point, depicting the ever popular Temple of the Sibyl (actually the Temple of Vesta, which Piranesi, like most of his contemporaries, incorrectly believed to be that dedicated to the Sybil). Unlike his earlier, panoramic *veduta* of the Piazza del Quirinale (cat. no. 43), Piranesi here emphatically concentrates on the ancient monuments, which take over the print, and carefully renders the masonry, structure, and architectural elements of each building, especially the prominent foundation of the rectangular temple. Most striking, however, is the fusion of decaying architecture and thriving nature. The scene is no longer populated with aristocrats, but with gesticulating genre figures and avid antiquaries. Unruly nature looks poised, prepared to devour what remains of Roman glory, yet both are indissolubly linked as models and fonts of inspiration for contemporaries. Both must be explored, catalogued, and conquered. —MP

Babies, Banquets, and Bacchanals

45 Giovanni Battista Piranesi

Piazza Navona, 1773, from the *Vedute di Roma* series, circa 1748–1778

Etching
21½ x 30¼ in. (54.6 x 76.8 cm)

University Transfer from Max Epstein Archive, 1979.62

In this print, Piranesi returns to Rome and one of the most captivating squares in all Italy. Facing north, Piranesi's view divides Piazza Navona along its central axis, which was the spine of the ancient circus that still defines the form of the piazza. Although the Fontana del Moro by Giacomo della Porta is given prominence in the foreground, Piranesi, in a rare example, concentrates on the middleground, particularly the spatial relation between the church of Sant'Agnese on the left and the Egyptian obelisk at the center of Bernini's *Fountain of the Four Rivers*. The extended shadows stretching to the west indicate that it is early morning, and the rift between the row of buildings on the right allows the dawning glow of the sun to create a new transverse axis, highlighting Borromini's dome of Sant'Agnese and the proud obelisk with its minutely detailed hieroglyphs deciphered for Bernini by Athanasius Kircher (cat. no. 2). Once again, Christianity becomes the successor to pagan culture, though Piranesi had appropriated Egyptian art as a model for his own creative work: it figures prominently in his *Parere su l'architettura* (1765) and in his decorative schemes for the English Coffee House, a popular Roman gathering place for visitors on the Grand Tour.

Piranesi has achieved wonderful effects of tonal gradation, depth, and aerial perspective through the print technique of over-biting (extending the period of immersion in acid to create darker lines), and through the use of a strong, directed perspective that exaggerates the piazza's northern extent. Just as Piranesi populates the piazza with a wide range of social types, from vendors to dignified gentlemen to histrionic actors, so too does he delineate the diversity of urban structures and their attendant functions, such as the popular and necessary public fountains, the family palace of Pope Innocent X Pamphilj (the building directly south of Sant'Agnese), the street shops, and of course a church. Piazza Navona encapsulates for Piranesi the urban structure of eighteenth-century Rome, founded, as always, on ancient design. —MP

46 Giovanni Battista Piranesi

Hadrian's Villa: The Apse of the Hall of the Philosophers, 1774, from the *Vedute di Roma* series, circa 1748–1778

Etching
17⅜ x 22⁹/₁₆ in.
(44.1 x 57.7 cm)

University Transfer from Max Epstein Archive, Gift of Carnegie Corporation, 1967.116.149

BIBLIOGRAPHY

Malcolm Campbell, *Piranesi, Rome Recorded: A Complete Edition of Giovanni Battista Piranesi's 'Vedute di Roma'*, 2nd ed. (New York: Arthur Ross Foundation, 1990); Susan M. Dixon, "Piranesi and Francesco Blanchini: Capricci in the Service of Pre-Scientific Archaeology," *Art History* 22 (June 1999): 184–213; Peter Murray, *Piranesi and the Grandeur of Ancient Rome* (London: Thames and Hudson, 1971); Jonathan Ian Scott, *Piranesi* (London: Academy Editions, 1975); John Wilton-Ely, *The Mind and Art of Giovanni Battista Piranesi* (London: Thames and Hudson, 1978); Wilton-Ely, *Piranesi as Architect and Designer* (New Haven: Yale University Press, 1993).

Piranesi's caption identifies this structure as belonging to the Pretorian Guard at Hadrian's Villa, Tivoli. Apparently, Piranesi was particularly interested in the apse's seven niches; some have thought these contained statues or books, but their proper function has still to be satisfactorily identified. Piranesi makes no attempt to fantastically reconstruct the hall from these crumbled ruins, although he does delineate the precise brickwork of the walls and uses a discreet shadow to articulate the curve of the dome, a marvel of engineering. Once more, antiquity and nature are united, as a gnarled tree is dwarfed by the enormous mass of a distorted wall that, with its two doorways, recalls the form of a triumphal arch. The gratuitous, generic figures are cursory and infinitely less inspired than those in Piranesi's *Temple of the Sibyl* (cat. no. 44), though the man descending on the right suggests the existence of subterranean passages built in the foundation of the villa. Structural interests were typical of the later Piranesi, who documented and mapped the ancient drainage and aqueduct systems of Rome. —MP

SITING THE ANTIQUE

in Nature, the Academy, and Antiquarian Travel

CRAIG HANSON

The negotiation of contemporary needs and values with ideas and cultural practices inherited from the Greco-Roman tradition characterizes the last two thousand years of Western history. Although stylistic categories and schemes of periodization might imply otherwise, the intellectual, literary, and artistic productions constituting the field now referred to as "Classics" have always played a vital role in European culture. Constantine's proclamation of Christianity as the official religion of the Roman Empire in the first part of the fourth century in no way terminated engagement with the Greco-Roman heritage but rather marked a change in its *deployment*, as the pagan tradition came under Christ's sovereignty. In both the Latin and Byzantine worlds, ancient philosophy and even poetry continued to figure prominently in society's intellectual fabric, finding expression in the institutions of the monastery and then, beginning in the thirteenth century, the university. But if the impact of Plato (crucial to Augustine's development, for instance) and Aristotle (translated into Latin by Boethius in the early sixth

century) did indeed persist throughout the Middle Ages, the Renaissance nonetheless initiated a significantly different kind of engagement with the classical past as ancient Rome was explicitly upheld as a model, an archetype on which to build a new future.

Crowned poet laureate in the Eternal City in 1341, Petrarch compared the accomplishments of the poet to those of the caesars; he challenged medieval Aristotelianism as employed by the Scholastics; and he celebrated again and again the ancient orator Cicero, thereby giving unprecedented attention to the field of rhetoric. Perhaps even more importantly, Petrarch formulated the very notion of Antiquity as a distinct historical entity—a construction that simultane-

ously posited both a middle period, which Petrarch himself characterized in terms of darkness, and a "new time" wherein the radiance of Antiquity would shine once more.[1] Increasingly, Rome came to be appreciated as the site of this past Golden Age and thus the legitimate place of its rebirth.

Galvanized during the High Renaissance, Rome's preeminence persisted throughout the early modern period and into the eighteenth century. At the same time, the place of Antiquity was not restricted to Italy and classicizing tendencies repeatedly appeared throughout Europe, from Paris, to London, to St. Petersburg. Moreover, this interest in Antiquity could also be found in conceptual (rather than specifically geographic) locales. Addressing the objects of this exhibition as embodiments of the ongoing lure of the Antique,[2] this essay explores three such sites: the concept of Nature, the institution of the Academy, and the scholarly tradition of antiquarian travel.

Conceptually, Nature structured the majority of artistic theory from Leone Battista Alberti's early fifteenth-century treatise *On Painting* through Caspar David Friedrich's nineteenth-century mystification of the German landscape in the wake of the Napoleonic Wars.[3] Of course, as even these two examples demonstrate, Nature meant very different things to different people. In general, however, understandings of the concept can be divided into two camps. On the one hand, Nature—the world as it is, so to speak—stands as the prime model to copy though, significantly, it eludes perfect mimetic representation in the end. According to this view, Art can never surpass Nature. The difficulty here is that one must still assess just what this "Nature" is, given that artistic depictions vary so radically. This first understanding of the concept often operates as an a priori value judgment rather than as a useful standard for artistic production.

The second possible understanding of Nature sees the natural world as less than perfect (or in decline); it is an ideal that the artist assembles using the *particulars* of real world experience. The prototypical ancient example comes from an anecdote in Pliny's *Natural History*, which recounts how the fifth-century painter Zeuxis chose five Croton girls as models and then combined their features to produce his representation of Helen, the exemplar of beauty.[4] In this scheme, Art surpasses the natural world. Accordingly, artists throughout the early modern period reached a common conclusion: to produce great art, there is needed a pool—a database, in the language of our computerist era[5]—of outstanding models that would provide access to this perfected Nature. Here, Antiquity finds its place. For in addition to the role of the individual's own experiences and to models drawn from contemporary works of art, ancient sculpture offered hundreds of worthy examples of beauty. These marble forms functioned as a canon for both artistic production and aesthetic appreciation.

Horst Bredekemp has argued that ancient sculpture, taken from the ground like fossils, came to be closely tied to the idea of Nature itself (cat. no. 2). Antique marbles occupied a transitional space between divine creation and its human counterpart. And so the notion that "the art of antiquity could mediate between human beings and nature" became "a basic tenet of both the natural sciences and aesthetics" during the sixteenth and seventeenth centuries.[6] On the one hand, ancient statuary was understood as a kind of perfect interpretation of Nature; on the other, it was viewed as being somehow part of Nature (through the physical soil of the earth) and thus, by implication, associated with Nature's divine origins. In both cases, classicism and Nature were intricately bound up together as a much-needed solution to certain early modern problems—historical, aesthetic, and otherwise.

As one might expect given the burden ancient sculpture shouldered, a healthy market for copies began to develop in the sixteenth century, and by the eighteenth century business was

thriving. The prized sculpture of Florence and especially Rome was disseminated across Europe through plaster casts, bronze reproductions, smaller bronze statuettes, engraved gems, and prints. Two copies of the famed *Farnese Bull* demonstrate the range of these imitative forms. For individuals undeterred by the astronomical costs, artists produced competently detailed bronzes like that by Francesco Bertos (cat. no. 36), while for a more modest sum collectors could acquire the same subject engraved on a gem (cat. no. 58). Both objects carried expectations of careful looking; indeed, the small size of the gem necessitated close scrutiny. Alongside impressive collections of books and modern works of art, copies of this sort, both large and small, attested to the connoisseur's erudition.[7]

In contrast to this model of refined learning, the porcelain piece of *Adam and Eve in Paradise* (cat. no. 47) provides a rather different example of what this Nature-Antiquity relationship could look like in an eighteenth-century courtly context. Echoing ancient forms, the progenitors of humanity are placed within an idealized primitive setting where the *animalia* of the natural world still live together in perfect union. Eden stands as the epitome of Nature at its best, just as Adam could be mistaken for an ancient Antinous or Eve confused with Venus. In this light-hearted work of playful creation produced at the Royal Saxon Company (which existed solely to enhance the image and pleasure of the Saxon court),[8] the theme of idealized Nature demonstrates that interest in Antiquity was in no way bound by stylistic categories.

A pair of Viennese ice cream coolers (cat. no. 48) dated 1804 presents the antithesis of this type of aesthetic exploration. In direct emulation of ancient Greek red-figure ware, these remarkable vases depend on the collection of William Hamilton as published by Pierre d'Hancarville beginning in 1768. The figures depicted on the shield-shaped bodies of the coolers are reproductions of forms taken from various engravings

from the *Collection of Etruscan, Greek, and Roman Antiquities from the Cabinet of the Hon.ble Wm. Hamilton*.[9] None of the friezes are copied directly from engravings. Instead, the painter assembled these three-figure groups by extracting individual forms from larger scenes and then bringing them together in coherent, "elegantly simple" compositions.[10] However vast the stylistic variation between these porcelain vases and works of rococo decorative art such as the *Adam and Eve*, there was agreement that ancient statuary had something to contribute to the artistic perfection of the natural world.

Early modern connections between Nature and Antiquity were also based on ancient celebrations of the natural world, most notably the notion of Arcadia as a rural locus of eternal bliss. The acceptance of this "not overly opulent region of central Greece"[11] as a model of bucolic splendor underscores the constructed nature of geographical identity. For it was the Latin poet Vergil, writing of this faraway rocky landscape, who transformed Arcadia into a land of profuse vegetation. Put simply, he invented it from a place that never was.

Irrespective of its faulty grounding in actual topography, this vision has enjoyed a long, rich tenure in Western history. Two pieces of delftware—a Lambeth bowl and plate (cat. nos. 49–50)—suggest the role of Arcadia in the eighteenth-century English imagination, which admired the picturesque as an alternative to the absolutist court cultures of the Continent. With much of the country's power resting in the hands of the land-owning aristocracy, the harmonious integration of Humanity and Nature was appealing to the same men who built Palladian country houses and furnished them with copies of ancient statuary. The Lambeth bowl pictures this interaction of gentleman and natural landscape, while the plate revises a French design to represent the peaceful union of fashionable femininity, admiring shepherd, verdant nature, and, in the background, ancient ruins.[12]

The Place of the Antique

The longevity of the relationship between Nature and Antiquity must be attributed at least in part to the institution of the Academy and its curriculum, which formally established the place of ancient sculpture in training young artists.[13] A mastery of ancient models and the ability to adapt their poses and gestures to the demands of composition was considered essential to the production of history painting (the most venerated genre on a scale that ranged from the "lowly" still life through landscape and portraiture). Such depictions of exemplary moral action demanded Nature's most noble forms.

The Graces Unveiling Nature, designed by Benjamin West as a ceiling painting for the Royal Academy in London, embodies Nature's institutional function. A relative latecomer on the European scene, the Royal Academy was not established until 1768. As if trying to make up for an absence of tradition, the attainment of

Fig. 5.
AFTER WILLIAM HOGARTH
Boys Peeping at Nature, etching, 1782 (from the 1731 subscription ticket for the *Harlot's Progress* series).
Private Collection.

legitimacy and artistic excellence became a national priority. Toward this end, the construction of Somerset House on the Thames in 1780 provided new quarters for the Academy (along with other royal institutions including the Society of Antiquarians). The generous sum of £600 was provided for the decoration of the Academy's interior spaces. West's ceiling painting belongs to this program.

In the Smart Museum's oil sketch of this image (cat. no. 52), and more explicitly in its final version at Somerset, several rows of breasts cover Nature's torso—an iconographical conflation of the goddess Artemis of Ephesus with the personification of Nature. The conjoining of these figures had become standard by the mid-sixteenth century (cat. no. 26). At issue here is not simply the afterlife of Antiquity, but more precisely the codification of early modern conventions regarding its *use*.[14] This codification occurred through the growing institutionalization of the art world as exemplified by the prominent role of European academies. It is fitting, then, that West's personification of Nature with the Graces should adorn the interior of such an establishment, proclaiming Nature's own centrality in the academic project.

The satirist William Hogarth took up the theme of Art's reliance on Nature for the subscription tickets to his well-known *Harlot's Progress* series (1731), further evidencing Nature's privileged position in eighteenth-century culture (fig. 5). Animal lust, here symbolized by a satyr, is turned away by one putto while his two companions legitimately draw upon Nature for artistic production (painting and printmaking). Yet even as Hogarth distinguishes the appropriate use of ideal nudity from prurient gawking (a common rhetorical move), at some level he seems to side with the satyr—challenging the academic system of artistic production. And although these tickets appeared fifty years prior to West's painting, their republication in 1782 attests to both their sustained popularity and their perennial relevance.

Siting the Antique

The codification of conventions regarding how Antiquity was understood and employed was reshaped not so much by satirical probing, but by antiquarian travel. The polymathic antiquarian could often be found hard at work in his study, or meeting with friends amidst the wonders of a *Kunstkammer*, but travel—be it to local ruins, the splendors of Rome, or the more remote regions of Greece—played an equally important role for many antiquarians. Unfortunately, differentiating high-minded intellectual expeditions from sensual, pleasure-driven voyages proves difficult, and in many cases simply impossible. Recent scholarship has demonstrated that the Grand Tour's importance hinged on certain fundamental tensions. Extended travel through the Continent, culminating in tours of Florence, Naples, Venice, and Rome, was expected to punctuate the classical academic training of young Englishmen; at the same time, it provided a period of potentially unparalleled personal license.[15] That an organization such as the Society of Dilettanti, one of England's most prestigious establishments for the promotion of early archaeological research, grew out of the Tour might initially seem to validate the intellectual legitimacy of such travel. That the Society began as a drinking club, on the other hand, underscores the Tour's dual character.[16]

In any case, this culture of travel facilitated the resiting of Antiquity, as antiquarian interests increasingly shifted from Rome to Greece during the latter half of the eighteenth century. The decade of the 1750s, in particular, was a watershed for redefining the Antique in terms of the Greek tradition. Johann Winckelmann published his *Thoughts on the Imitation of Greek Art* and the Comte de Caylus produced his *Collection of Antiquities*, which addressed a range of materials but cast an especially positive light on ancient Greece. Above all, James Stuart and Nicholas Revett undertook their pioneering expedition to Athens (1751–54), where they made careful measurements and drawings of the city's monuments. Though the first volume of their *Antiquities of Athens* (cat. no. 54) did not appear until the following decade, Stuart and Revett nonetheless helped set in motion a keen interest in the archaeological fact of Greece as a topographical reality.

Louis Dupré's 1819 portrait of the French consul Louis François Sebastien Fauvel (cat. no. 55) marks the general acceptance of this new siting. By this point, Lord Elgin had already removed the Parthenon marbles to England. Within another decade, the struggle for Greek independence would command much of Western Europe's attention, and soon after the Germans would dominate the pursuit of the ancient past in this ancient land. Depicting the diplomat within his own domestic context, Dupré's portrait bridges two different moments, as connoisseurship yields to archaeological professionalism; at the same time, it signals a new, subjective potential for Antiquity's presence in the modern world.[17] If the Royal Academicians depended on the ancient past in order to establish their artistic legitimacy, Fauvel, here seated before the canvas both as sitter and painter, likewise required the act of representation; he both complies and resists. While his upper body suggests a sense of openness, his crossed leg serves as a defense; the portrait relates to depictions from the previous century of *savants* even as it evidences a new interest in individual sensibility and psychological probing. Fauvel's eyes engage us as viewers; yet we are denied access to his own painting on which he has presumably just been concentrating. For all its formal clarity, the portrait manifests a dynamic not easily resolved, and ultimately we as viewers must decide where we will place ourselves in relation to this notion of Antiquity.

NOTES

1. Theodor E. Mommsen, "Petrach's Conception of the Dark Ages," *Speculum* 17 (April 1942): 226–42. For a more recent discussion of this thesis, see Marguerite R. Waller, *Petrarch's Poetics and Literary History* (Amherst: University of Massachusetts Press, 1980).

2. This phrase is intended to signal my debt to two extremely useful texts on the subject: the invaluable book by Francis Haskell and Nicholas Penny, *Taste and the Antique: The Lure of Classical Sculpture, 1500–1900* (New Haven: Yale University

Press, 1981), and the thoughtful essay by Horst Bredekamp, *The Lure of Antiquity and the Cult of the Machine* (Princeton: Marcus Wiener Publishers, 1995). By capitalizing "Antiquity," I signal its role as a concept set in relation to that of Nature.

3. Indeed, the concept of Nature figures prominently throughout the course of Western artistic theory. The privileged position historically afforded to mimesis underlies the bulk of this thinking. For an accessible introduction (that does not problematize the mimetic issues), see Rudolf Wittkower, "Imitation, Eclecticism, and Genius," in *Aspects of the Eighteenth Century*, ed. Earl Wasserman (Baltimore: Johns Hopkins University Press, 1965), 143–61. See also A. O. Lovejoy, *Essays in the History of Ideas: Nature as an Aesthetic Norm* (Baltimore: Johns Hopkins University Press, 1948).

4. The story is retold again and again in artistic treatises during the early modern period. Alberti records it in the third book of his essay *On Painting*. In reference to the process of selecting particulars, he writes, "[how] great is the force of anything drawn from nature. For this reason always take from nature that which you wish to paint, and always choose the most beautiful." *On Painting*, trans. John Spencer (New Haven: Yale University Press, 1956), 94.

5. Barbara Maria Stafford has referred to our present era as an "age of computerism," replacing not only modernism but postmodernism as well. See both her *Artful Science: Enlightenment Entertainment and the Eclipse of Visual Education* (Cambridge: MIT Press, 1994), xxiv, and her *Good Looking: Essays on the Virtue of Images* (Cambridge: MIT Press, 1996), 4.

6. Bredekamp, 11–12.

7. Though conceptually foreign to most modern viewers, gem collections were among the most prized possessions of connoisseurs. For their importance, see Martin Henig, *Classical Gems: Ancient and Modern Intaglios and Cameos* (New York: Cambridge University Press, 1994). The *Farnese Bull* was an especially appropriate subject for an engraved gem, since the Farnese collection itself included an outstanding collection of gems; see the exhibition catalogue *Le Gemme Farnese*, ed. Carlo Gasparri (Naples: Electa Napoli, 1994).

8. In 1710, the Royal Saxon Porcelain Manufacture Company at Meissen became the first in Europe to discover how to produce hard-paste porcelain. In the following decades, similar factories appeared throughout the Continent, all heavily subsidized by court funds. The Duke of Württemberg came to see porcelain as a necessity of royal life, stating that "a porcelain factory is an indispensable accompaniment of splendour and magnificence." See J. H. Plumb's useful summary of the subject, "The Royal Porcelain Craze," in his *In the Light of History* (Boston: Houghton Mifflin, 1973), 57–69.

9. The full title is rather unwieldy: *Collection of Etruscan, Greek, and Roman Antiquities from the Cabinet of the Hon.ble Wm. Hamilton, His Britannick Majesty's Envoy Extraordinary at the Court of Naples MDCCLXVI*. Despite this date, volume one did not appear until 1768. The second volume was published in 1770, and volumes three and four in 1776. A less luxurious, French edition appeared in 1787, and a much abridged, even more accessible version was produced in England in 1804—the same year as the ice cream coolers.

10. "Elegant simplicity" is the kind of language contemporaries used to praise pieces like these; such descriptive phrasing is most famously associated with Johann Winckelmann but also was employed at mid-century by the influential Comte de Caylus. For discussions of d'Hancarville, see Francis Haskell, "The Baron d'Hancarville: An Adventurer and Art Historian in Eighteenth-

Century Europe," in his *Past and Present in Art and Taste: Selected Essays* (New Haven: Yale University Press, 1987), 30–45; and Michael Vickers, "Value and Simplicity: Eighteenth-Century Taste and the Study of Greek Vases," *Past & Present* 116 (1987): 98–137. For Hamilton, see the exhibition catalogue *Vases and Volcanoes: Sir William Hamilton and His Collection*, eds. Ian Jenkins and Kim Sloan (London: British Museum Press, 1996).

11. This tactful description comes from Erwin Panofsky's seminal 1936 essay, "*Et in Arcadia Ego*: Poussin and the Elegiac Tradition," repub. in *Meaning in the Visual Arts* (Chicago: University of Chicago Press, 1982), 297.

12. The original design by the French architect François Cuvilliés has been stripped of much of its formal rococo structure. See cat. no. 50 for a summary of specific changes. For the role of ruins within the picturesque, see John Dixon Hunt, "Picturesque Mirrors and the Ruins of the Past," *Art History* 4 (September 1981): 254–70.

13. Although for the purposes of brevity I refer to the Academy as a singular institution, historically academies throughout Europe did not necessarily comply with any one monolithic identity. For the standard text on the history of academies, see Nikolaus Pevsner, *Academies of Art, Past and Present* (New York: Cambridge University Press, 1940); and more recently, Carl Goldstein, *Teaching Art: Academies and Schools from Vasari to Albers* (New York: Cambridge University Press, 1996). For the relationship between the Academy's curriculum and figure drawing, see the recent exhibition catalogue edited by Richard J. Campbell and Victor Carlson, *Visions of Antiquity: Neoclassical Figure Drawings* (Los Angeles: Los Angeles County Museum of Art, 1993).

14. For a study of how these conventions were worked out in the fifteenth and sixteenth centuries, see Jean Seznec, *The Survival of the Pagan Gods: The Mythological Tradition and Its Place in Renaissance Humanism and Art,* trans. Barbara F. Sessions, Bollingen Series XXXVIII (New York: Pantheon Books, 1953).

15. Bruce Redford, *Venice and the Grand Tour* (New Haven: Yale University Press, 1996). See also the recent exhibition catalogue *Grand Tour: The Lure of Italy in the Eighteenth Century*, eds. Andrew Wilton and Ilaria Bignamini (London: Tate Gallery Publishing, 1997). For a recent study of the British dependence on the classical past of Rome, see Philip Ayres, *Classical Culture and the Idea of Rome in Eighteenth-Century England* (New York: Cambridge University Press, 1997).

16. For a general introduction to the Society of Dilettanti within the context of English connoisseurship, see John Brewer, *The Pleasures of the Imagination: English Culture in the Eighteenth Century* (New York: Farrar Straus Giroux, 1997), esp. 256–87. See also Lionel Cust, *History of the Society of Dilettanti* (London: Macmillan, 1898); Cecil Harcourt Smith, *The Society of Dilettanti: Its Regalia and Pictures* (London: Macmillan, 1932); and Shearer West, "Libertinism and the Ideology of Male Friendship in the Portraits of the Society of Dilettanti," *Eighteenth-Century Life* 16 (May 1992): 76–104.

17. Beginning in the mid-eighteenth century, the official residence of the French Consul was located just in front of the gate to the Roman Agora. Stuart and Revett depict this *maison* in the first volume of their *Antiquities of Athens*. In fact, Fauvel did occupy this house from 1806 until Christmas of 1809. However, from 1810, he lived approximately half-way between the Stoa of Attalos and the Hephaisteion (still north of the Acropolis) in the house he commissioned. Dupré's portrait shows the consul in this second home. See C. W. J. Eliot, "Athens in the Time of Lord Byron," *Hesperia* 37 (1968): 134–58.

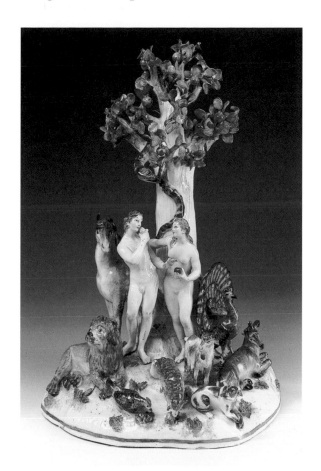

47 Johann Friederich Eberlein (modeler)

German, active Meissen
1696–1749
German, Meissen, Royal Saxon
Porcelain Manufacture
Company (manufacturer)

Adam and Eve in Paradise,
1745 (design),
1774–1813 (execution)

Hard-paste porcelain
with overglaze enamel deco-
ration, model no. 665
Height 13⅝ in. (34.6 cm)

Gift of Mrs. Leopold Blumka
in memory of Leopold Blumka,
1979.55

SEE COLOR PLATE 6

BIBLIOGRAPHY

Karl Berling, ed., *Meissen China: An Illus-
trated History* (1911; reprint New York:
Dover Publications, 1972); Francis Haskell
and Nicholas Penny, *Taste and the Antique:
The Lure of Classical Sculpture, 1500–1900*
(New Haven: Yale University Press, 1981);
Peter Wilhelm Meister and Horst Reber,
European Porcelain of the Eighteenth Century
(Ithaca, N.Y.: Cornell University Press, 1983).

Arguably, hard-paste porcelain epitomizes the body of artistic production dating from the eighteenth century and known generally by the description "rococo." Traditionally, this style has been characterized as light, playful, and decorative; its scale is small and accessible, in contrast to the imposing grandeur of the baroque. Curving lines and fanciful arabesques define compositions, while richly varied pastels imbue surfaces with a lush sensuality. *Adam and Eve in Paradise,* a product of the Royal Saxon Company at Meissen, possesses all of these traits. Yet a profound debt both to classical sculpture and to the larger humanist tradition lies at its center.

In the midst of this Eden, the figures of Adam and Eve are cloaked in the conventions of classical, heroic nudity. Their *contrapposto* stance showcases the human body as a work of beauty, a marvel in its own right. In formal terms of gesture and pose, these progenitors of humanity could just as easily be identified as Cupid and Psyche. Alternatively, Adam bears a striking resemblance to the *Belvedere Antinous* from the Vatican collection, a sculpture that had been held in high regard since the sixteenth century. In the same way, Eve looks a great deal like the *Capitoline Venus.* And significantly, the couple is depicted prior to their fatal act of eating the forbidden fruit; at this point, they retain mastery over this natural world of harmony.

In his study of Meissen porcelain, Karl Berling attributes this piece to Johann Friederich Eberlein, who was hired in 1735 to assist the chief sculptor at Meissen, Johann Joachim Kaendler. Eberlein was recruited for his expertise in modeling animal figures, a talent this piece finely demonstrates. —CH

48 Austrian, Vienna State Porcelain Factory

Pair of Ice Cream Coolers, 1804

Hard-paste porcelain with polychrome enamels
Height 15 11/16 in. (39.8 cm)

The Art Institute of Chicago, Gift of the Antiquarian Society through the Lena Turnbull Gilbert Fund, 1993.344.1–2

BIBLIOGRAPHY

Waltraud Neuwirth, *Wiener Porzellan: Original, Kopie, Verfälschung, Falschung* (Vienna: Neuwirth, 1979); Francis Haskell, "The Baron d'Hancarville: An Adventurer and Art Historian in Eighteenth-Century Europe," in his *Past and Present in Art and Taste: Selected Essays* (New Haven: Yale University Press, 1987): 30–46; Michael Vickers, "Value and Simplicity: Eighteenth-Century Taste and the Study of Greek Vases," *Past and Present* 116 (1987): 98–137.

Complete with covers and liners, this pair of ice cream coolers embodies the intersection of antiquarian interest in the classical past and the delicate porcelain industry patronized by European royalty. Against a chocolate-brown ground, the figures—three on each side of each vase—are painted in orange and brown in emulation of ancient red-figure ware. Several bands of ornamental patterns encircle the vases, including a Greek key on which the figures walk or stand and a border of C-scrolls and orange foliage just above the figures and around the edge of the covers. On the bottom of each vase, shield marks appear in underglaze blue (identifying the pair as a product of the Vienna State Porcelain Factory) along with the numerals 42 (a kind of "product" number) and 804 (signaling the date 1804).

The figures themselves come directly from the most important eighteenth-century publication on ancient vases, the *Collection of Etruscan, Greek, and Roman Antiquities from the Cabinet of the Hon.ble Wm. Hamilton*, written by the Baron d'Hancarville and published in Naples (in a bilingual edition written in English and French) beginning in 1768. This is not to say, however, that the Viennese friezes resemble any single vase from Hamilton's collection; instead, the designer has assembled completely new images from this "source book" of ancient models. This method generally finds little accommodation in post-romantic theories of art, but its promotion was in fact one of the original intentions of d'Hancarville. He writes in his preface to the first volume, "Our end has certainly been to shew a considerable collection of exquisite Models, but we likewise have proposed to ourselves to hasten the progress of the Arts, by disclosing their true and first principles . . . in order that the Artist who would *invent* in the same stile, or only *copy* the Monuments which appeared to him worthy of being copied, may do so with as much truth and precision, as if he had the Originals themselves in his possession. It is by this means that the present work may contribute to the Advancement of the Arts." —CH

49 **English, Lambeth (?)**

Bowl (with European land-
scape frieze decoration),
circa 1770–1780

Blue tin-glazed earthenware
(delftware)
Diameter of mouth
8⅞ in. (22.5 cm)

Anonymous Gift, 1983.61

BIBLIOGRAPHY

Anthony Ray, *English Delftware Pottery*
(London: Faber and Faber, 1968); Michael
Archer, "English Delftware: The Industry at
Lambeth in the Mid-Eighteenth Century,"
Connoisseur 176 (April 1971): 238–46; F. H.
Garner and Michael Archer, *English
Delftware* (London: Faber and Faber, 1972);
Louis Lipski, *Dated English Delftware: Tin-
Glazed Earthenware, 1600–1800* (London:
Sotheby's Publications, 1984); Archer, *Delft-
ware: The Tin-Glazed Earthenware of the
British Isles* (London: Victoria and Albert
Museum, 1997).

In the fifteenth century, while northern European nations were still using lead or
salt-glazed pottery, the clean, white finish of tin-glazed earthenware (majolica)
was to be found only in Italy and Spain (cat. no. 21). By the next century, how-
ever, this tin-glazing had spread north via the Netherlands, to England, where it
was known as delftware. In addition to Bristol and Liverpool, the town of
Lambeth (now a borough of London), on the south bank of the Thames,
emerged as a leading center of production during the seventeenth century. By
the eighteenth century, delftware had become somewhat standard fare for
English middle class households, in contrast to the luxurious porcelain pro-
duced for royalty.

This late eighteenth-century bowl features a landscape border structured by
four dominant elements: two relatively large, sponged trees frame a gentleman
with a walking stick on one side of the bowl, and the rough outline of a building
on the other. Despite his small scale, the man is rendered with much more atten-
tion to detail than either the building or the overall design. The irregular archi-
tectural structure is given a highly simplified, planar character that is antithetical
to the "modern" Georgian country house modeled on Palladian ideals. Its form
calls to mind instead the likes of Syon House, which retained its Tudor exterior
despite eighteenth-century interior renovations.

This trope of the landowner shown within the landscape—presumably *his*
landscape—visualizes the English social structure that drove a persistent interest
in Antiquity. As prescribed by the educational norms applied to young English
gentlemen, learning to survey a landscape differed little from learning to appre-
ciate the *Apollo Belvedere*. Both were a matter of aesthetics and power.
Interestingly, however, this bowl could just as well have belonged to a middle-
class merchant in London as to a member of the landed gentry. The scene in no
way demands congruent ownership; this potential disparity underscores the
degree to which the country estate embodied England's national identity across
different classes. —CH

50 **English, Lambeth**

Plate (with idyllic country scene), circa 1760

Blue tin-glazed earthenware (delftware)
Diameter 9¼ in. (23.5 cm)

Anonymous Gift, 1983.60

Fig. 6.
JEAN FRANÇOIS CUVILLIÉS
(engr. Charles Albert de Lespillez)
Title plate from a set of four prints entitled
Morceaux de caprices, à divers usages,
engraving, ca. 1745.
London, Victoria and Albert Museum.

Whereas the Lambeth bowl (cat. no. 49) depicts an English gentleman in a landscape, this plate takes as its subject the feminine presence in nature. The image on its face is an adaptation of a roughly contemporary print by the French architect Jean François Cuvilliés (fig. 6), whose ornamental designs found a welcome reception in England.

This image provides one example of the way in which the ancient pastoral tradition of Theocritus and especially Vergil took shape in the eighteenth century. Following classical prototypes, the youthful shepherd attends to a fashionable woman in this Arcadian field. The curvilinear, flowing qualities of Cuvilliés's print are heightened to accommodate the rounded shape of the plate as well as the translation from one medium to another (engraving to painted earthenware). Other changes in the original design—including the removal of the elaborate decorative frame and the general reduction in foliage—replace the print's fantastic character with relative calm and stability. The exception to this rule of botanical abridgment is the tree behind the woman's right shoulder: on the plate it is enlarged to become a focal point, leading the viewer's eyes back to a dilapidated arcade, another English addition to the image. The modified landscape accommodates equally well contemporary fashion, bucolic nature, and ancient ruins. A revision of the sensual elegance of Cuvilliés's print, the Lambeth image explores the informal, painterly potential of the picturesque which here unites pastoral leisure and fragmented Antiquity. —CH

BIBLIOGRAPHY

Anthony Ray, *English Delftware Pottery* (London: Faber and Faber, 1968); Michael Archer, "English Delftware: The Industry at Lambeth in the Mid-Eighteenth Century," *Connoisseur* 176 (April 1971): 238–46; F. H. Garner and Michael Archer, *English Delftware* (London: Faber and Faber, 1972), pl. 98A; Louis Lipski, *Dated English Delftware: Tin-Glazed Earthenware, 1600–1800* (London: Sotheby's Publications, 1984); Archer, *Delftware: The Tin-Glazed Earthenware of the British Isles* (London: Victoria and Albert, 1997).

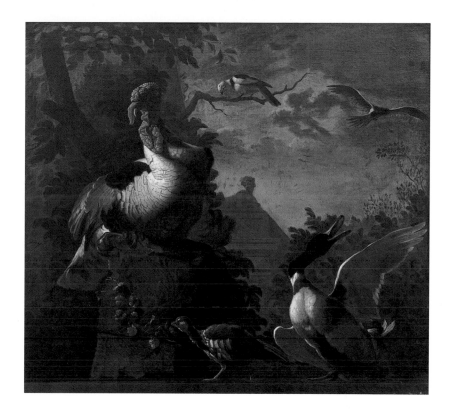

51 Philipp Ferdinand de Hamilton (?)

Born Belgium, active Vienna 1667–1750

Wild Turkey, circa 1725–1750

Oil on canvas
38½ x 42½ in. (97.8 x 108 cm)

Purchase, The Cochrane-Woods Collection, 1982.77

SEE COLOR PLATE 7

Whether they drew their inspiration from the harmony of the artificial landscapes created by the weed-choked ruins of ancient Rome, or simply maintained the habit of turning a critical eye to everything they surveyed, early antiquarians formed a close and lasting alliance with empirical science (cat. no. 2). Nature and antiquity vied jointly for the attention of scholars, artists, collectors, and patrons; this rivalry led to the assembly of eclectic museums indoors and lavish gardens outdoors, where exotic plants and animals kept company with battered antiquities or modern sculpture in the antique style. By the early eighteenth century, painted reveries like this lively portrayal of a wild turkey combined the precision of Dutch still life with the epic sweep of Italian baroque histories to create a truly international European style of genre painting: exotic plants and animals set among classical ruins.

This wild turkey, a New World bird, perches among other birds large and small above a battered fragment of carved stone relief, while in the background an Egyptian sphinx crouches on its high pedestal. The painter may well have had a precise garden in mind, a garden whose owner took pride in gathering the wonders of natural and human history together in one place. A likely candidate for that owner is Prince Eugene of Savoy, whose Belvedere Palace in Vienna boasted a sphinx among its many antiquities, and an aviary as part of its menagerie. The prince's birds, beasts, gardens, and antiquities were all commemorated in a series of twelve engravings by Salomon Kleiner (1734), in which the animals are posed along one of the garden's sculpture-filled paths. In the background of one of Kleiner's images, a crouching sphinx sits on a pedestal very like the one in the background of our painting; another engraving includes

BIBLIOGRAPHY

Fritz Novotny, ed., *Prinz Eugen und sein Belvedere* (Vienna: Österreichischen Galerie Klischees, 1963); Christie's New York, *Fine Old Master Paintings*, Sale No. 234, Tues. Nov. 24, 1981, 80.

a wild turkey among the foreground's artfully posed wildfowl. Prince Eugene also commissioned such stagey views of nature and antiquity from painters like Philipp Ferdinand de Hamilton, a Belgian of Scots family who emigrated to Vienna before 1700, and the Viennese Ignaz Heinitz von Heintzenthal. Like Kleiner, both posed lively images of birds and animals among the antiquities in the Belvedere Garden; of the two, de Hamilton worked in an intimate style closer to that of the Smart painting. The work has also been attributed to eighteenth-century England's most famous bird painter, Hungarian-born Jakab Bogdány. This attribution seems unlikely; Bogdány's birds are less convoluted in their postures, and his careful portrayals of actual English gardens show classical, not Egyptian antiquities. Yet an English setting is not entirely out of the question: sphinxes and other Egyptianate sculptures had become immensely popular in English gardens as a result of aristocrats' travels on the Grand Tour. During their obligatory stop in Rome, Grand Tourists could linger over the statues and obelisks brought back from Egypt by conquering Roman emperors—or executed on the spot in Italy by imported Egyptian workers. By the later eighteenth century, travelers could also see a charming parallel to the *Wild Turkey*'s combination of Egyptian sphinx and precisely rendered birds, frescoed on the walls of the English Coffee House in Rome by none other than the great Piranesi (cat. no. 45). To the *Wild Turkey*'s visual travelogue, even Prince Eugene could have been counted on to add the taste and smell of coffee to the setting in which he might have placed this vignette of exotic times, lands, and creatures. —IDR

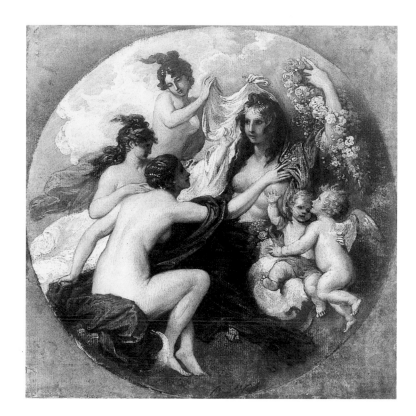

52 Benjamin West
American, active England
1738–1820

The Graces Unveiling Nature,
circa 1780

Oil on paper,
mounted on canvas
Diameter 10¾ in. (27.3 cm)

Gift in honor of Teri J.
Edelstein from the Collection
of Edward A. and Inge Maser,
1991.276

SEE COLOR PLATE 8

BIBLIOGRAPHY

Charles Merrill Mount, "An American in London: Gilbert Stuart," *Country Life* 85 (February 1964): 379; Edward Maser, "An American Modello for England," in *Imagination und Imago: Festschrift Kurt Rossacher*, eds. Leopold Netopil and Franz Wagner (Salzburg: Salzburger Barockmuseum, 1983), 167–71; Helmut von Erffa and Allen Staley, *The Paintings of Benjamin West* (New Haven: Yale University Press, 1986), cat. no. 427.

Benjamin West produced this small oil sketch, or *modello*, in connection with a series of ceiling paintings executed for the Royal Academy's new home at Somerset House. Founded in 1768, the Academy moved into its new quarters (shared with other state institutions including the Society of Antiquarians) in 1780. In addition to the central panel of Nature surrounded by the Graces, West designed four complementary panels depicting female personifications of the elements: Air, Fire, Earth, and Water. For the five completed paintings (all on canvas), West received the handsome sum of £125.

In the sketch, three young women attend Nature, who is shown with a profusion of flowers and two putti by her side. Despite the title, which was attached to the work by Joseph Baretti in his 1781 guide to Somerset House, the action in the painting parallels that of Rubens's picture *Nature Adorned by the Graces*, an image (now in Glasgow) perhaps seen by West after Sir Lawrence Dundas acquired it in the early 1770s. In any case, West follows the standard iconography by portraying this wondrous personification of Nature as having a torso covered with nurturing breasts—a convention based on the ancient representation of Artemis at Ephesus (cat. no. 26). And though in the sketch the additional breasts are only suggested, they are fleshed out fully in the final image. Yet, as asserted by Edward Maser, the carefully finished character of the latter picture suppresses the freshness and immediacy of the sketch. In addition to the ordinary problems of translation in moving from the intimate scale of the *modello* to the larger ceiling panel, Maser accounts for the discrepancy in style by attributing the final version to Gilbert Stuart, who was at the time a student of West. This idea, originally suggested by Charles Merrill Mount, has since been reiterated in the comprehensive study by Helmut van Erffa and Allen Staley.

In 1869, when the Royal Academy moved to its present quarters in Burlington House, the ceiling paintings were also relocated. In 1899, they were installed in the vestibule of the Academy. —CH

**53 Stefano Mulinari
(after Gaspare Celio)**
Italian
Circa 1741–1790

The Forge of Vulcan,
circa 1774

Etching, roulette, mezzotint
11⅜ x 6½ in. (28.3 x 17.3 cm)

University Transfer from Max
Epstein Archive, 1976.145.286

The central scene of figures, hammering out armor at the forge of Vulcan, carries a rich history bound up with early modern efforts to recover the past. The 1693 antiquarian publication *Admiranda romanarum antiquitatum veteris sculpturae* by Pietro Bartoli and Giovanni Pietro Bellori included an engraving of a Roman sarcophagus decorated with the subject. The English painter James Thornhill, working in the late seventeenth and early eighteenth centuries, used the subject to decorate a staircase at Hanbury Hall around 1710. Thornhill's wall painting specifically takes as its subject Thetis in the forge of Vulcan, an event recounted in Book XVIII of the *Iliad*. As the mother of Achilles, Thetis convinces Vulcan to produce a suit of impenetrable armor for her son after his old armor has been captured by the Trojan warrior Hector. Scholars have suggested several proto-types for Thornhill's design including a painting in the Doge's Palace in Venice by the sixteenth-century artist Jacopo Tintoretto and Giorgio Vasari's roughly contemporary decoration of the Sala degli Elementi in the Palazzo Vecchio in

Siting the Antique

Florence. As noted by Dora Wiebenson, Homeric subjects were relatively sparse prior to the eighteenth century, largely because Achilles's behavior was viewed as less than heroic. On the other hand, a scene of military preparation such as this one could serve as a model of physical prowess and bravery.

Informed by this tradition, Mulinari's later eighteenth-century print based directly on a design by Gaspare Celio presents the female protagonist as a Venus figure together with her son Cupid. In contrast to the modeling of the four central male figures, which stresses strength, the modeling accorded the woman emphasizes not muscles but flesh. In stylistic terms, the men are shown in forceful action while static sensuality characterizes the goddess. Thus, even as the central scene adheres to the conventional representation of military and masculine strength, the revision of the female figure marks an iconographic innovation and recasts this image within the "war of love" tradition. —CH

BIBLIOGRAPHY

Dora Wiebenson, "Subjects from Homer's *Iliad* in Neoclassical Art," *Art Bulletin* 46 (1964): 23–37; J. Lees-Milne, "Hanbury Hall, Worcestershire," *Country Life* (January 1968): 66–69; Jacob Simon, *English Baroque Sketches* (Twickenham: Marble Hill House, 1974); Elizabeth Einberg and Judy Egerton, eds., *The Age of Hogarth: British Painters Born 1675–1709* (London: Tate Gallery, 1988), 217–21.

54 **James Stuart**
English
1713–1788
Nicholas Revett
English
1720–1804

View of the Octagon Tower of Andronicus Cyrrhestes, from the *Antiquities of Athens*, Volume 1 (London: John Haberkorn), 1762

14 x 20¹⁵⁄₁₆ in. (35.6 x 53.1 cm)

Department of Special Collections, University of Chicago Library

From the fifteenth century through the mid-eighteenth century, there were several notable points of contact between Western Europe and the territories that had formerly constituted ancient Greece. The Italian antiquarian Cyriacus of Ancona made two trips to Athens, the first in 1436 and the second in 1444. Following two centuries of curtailed interaction due to strained relations between the Ottoman Turks and the nations of Europe, the French reinitiated contact with the East in the latter half of the seventeenth century through diplomatic missions, monastic settlements, and antiquarian travels.

Yet it was two British artists, James Stuart and Nicholas Revett, who, with the publication of their *Antiquities of Athens,* presented the city as a viable alternative to Rome as the locus of Antiquity (see pp. 77–78). Describing Athens in the preface to the first volume as "the mother of elegance and Politeness" and the "fountainhead" of classical architecture, Stuart posited the accomplishments of ancient Rome as derivative of and secondary in importance to the wonders of Greece. Exquisite images and scholarly commentary supported these claims. An acute concern for accuracy permeated not only the rhetoric surrounding the project but the content as well.

Because the Acropolis was occupied by Turkish military defenses and therefore off-limits to foreigners during Stuart and Revett's initial stay in Athens, their first volume included none of the most famous buildings associated with the Periclean era, a problem Winckelmann was quick to point out. However, this volume did present an example of the Doric order (which became a hotly contested controversy in architectural circles) and two especially interesting structures: the Octagon Tower of Andronicus Cyrrhestes from the city's Roman forum (pictured here) and the Choregic Monument of Lysicrates. In the 1760s, with the principal aim of exploring Asia Minor, Revett returned to Greece and

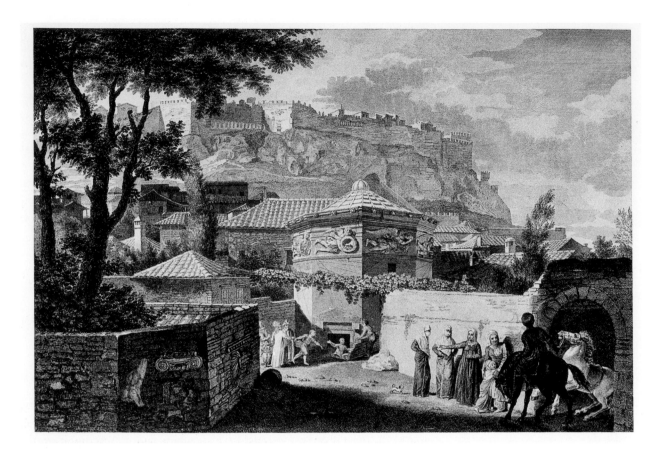

BIBLIOGRAPHY

Lesley Lawrence, "Stuart and Revett: Their Literary and Architectural Careers," *Journal of the Warburg and Courtauld Institutes* 2 (1938–39): 128–46; Dora Wiebenson, *Sources of Greek Revival Architecture* (London: A. Zwemmer, 1969); J. Mordaunt Crook, *The Greek Revival: Neo-Classical Attitudes in British Architecture, 1760–1870* (London: John Murray, 1972); David Watkin, *Athenian Stuart: Pioneer of the Greek Revival* (London: George Allen, 1982).

so was able to finish the field research for the project he and Stuart had conceived fifteen years earlier. Complete with the major monuments of fifth-century Athens, including the Parthenon and the Erectheum, the second volume finally appeared late in the 1780s. Subsequent volumes and translations were produced throughout Europe, into the next century. —CH

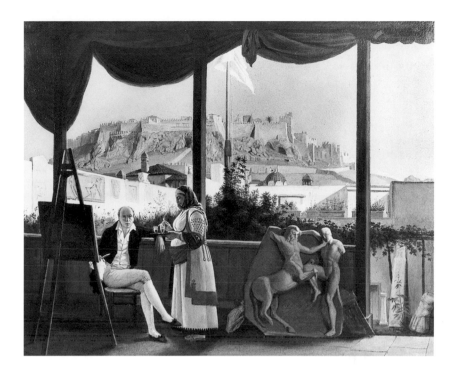

55 Louis Dupré
French
1789–1837

Portrait of M. Fauvel, the French Consul, with View of the Acropolis, 1819

Oil on canvas
20½ x 25¼ in.
(68.6 x 81.3 cm)

Gift of Mr. and Mrs. Frank H. Woods, 1980.33

SEE COLOR PLATE 9

BIBLIOGRAPHY

Ph. E. Legrand, "Biographie de Louis François Sebastien Fauvel," *Revue Archéologique* 30 (1897): 41–66ff., and 31 (1897): 94–103ff.; "Fauvel's First Trip through Greece," *Hesperia* 5 (1936): 206ff.; C. W. J. Eliot, "Athens in the Time of Lord Byron," *Hesperia* 37 (1968): 134–58; C. P. Bracken, *Antiquities Acquired: The Spoliation of Greece* (London: David and Charles, 1975).

This portrait of Louis François Sebastien Fauvel visualizes a common rhetorical trope used in reference to the French consul: the conflation of the antiquarian and his beloved objects. Depicted on his veranda with the Acropolis to the south, Fauvel is surrounded by inscriptions and fragments of sculpture including a cast of one of the Parthenon metopes. Seated behind his easel and waited on by Anette, his Albanian maid, he is the model gentleman-scholar.

Fauvel first traveled to Greece in the early 1780s with Choiseul-Gouffier, who became Louis XVI's ambassador to Constantinople in 1784. These journeys resulted in the publication of Choiseul's *Voyage pittoresque de la Grèce*, which included illustrations taken from drawings made by Fauvel, himself an accomplished artist. Over the next forty years, this multi-talented man would act as diplomat, archaeologist, collector and dealer of antiquities, tour guide, and host for Western European travelers, including Lord Byron and Chateaubriand.

Louis Dupré studied history painting under Jacques Louis David. Under the royal patronage of Jerome—the King of Westphalia and the brother of Napoleon—he then continued his artistic education in Italy. Expanding his travels, Dupré sailed to Greece in 1819, where he met Fauvel. Dupré's depiction of the consul circulated publicly the following decade as a lithograph copy included in his book *Voyage à Athènes et à Constantinople* (Paris, 1825). Including fifty-two pages of text and forty colored lithographs, the imperial folio is unequivocal regarding Fauvel. After praising the richness of the consul's house, described as a "museum," Dupré writes, "What compatriot, what stranger just the same was not to be pleased with the welcome of M. Fauvel! M. Fauvel, man of Athens, inseparable from the monuments of Athens." Visually, the book makes the same assertion; among the lithographs illustrating various settings and costumes of the Turks, Greeks, and Armenians (fueled by growing interest in the exotic), only the image of the consul combines equally the depiction of site and portraiture. —CH

56 Francesco Bartolozzi (after Carlo Maratta)
Italian, active Italy and England
1727–1815

Allegory in Honor of Pietro da Cortona, circa 1764–1771

Engraving
17 x 12 in. (43.2 x 30.5 cm)

University Transfer from Max Epstein Archive, 1981.13

BIBLIOGRAPHY

Jean and Robert Westin, *Carlo Maratti and His Contemporaries: Figurative Drawings from the Roman Baroque* (College Park: Pennsylvania State University Press, 1975), 41; Timothy Clayton, *The English Print, 1688–1802* (New Haven: Yale University Press, 1997); inscrip. trans. R. J. Rodini.

As engraved by Bartolozzi, Maratta's homage to Cortona (along with his *Allegory in Honor of Claude Lorrain*, cat. no. 57) testifies not only to the genius of a single artist but to a rich tradition of Roman classicism with a genealogy running from Raphael through the Carracci and Francesco Albani—a tradition grounded institutionally in the prestigious Accademia di S. Luca.

Still a boy, Maratta (1625–1713) arrived in Rome in 1636, the year of the well-known debate at the Accademia between the advocates of *disegno*, led by Andrea Sacchi, and those of *colore*, led by Pietro da Cortona. Although Maratta entered the studio of Sacchi the following year, scholars generally agree that the depth of his artistic accomplishment lies in his ability to synthesize the strengths of his own master with those of Cortona. This image clearly evidences his admiration for the latter.

In Maratta's original drawing, the elderly, winged figure of Time holds aloft a portrait of Cortona while simultaneously restraining under his heel the personification of Envy. With the tree trunk to the right balancing the pyramid-like structure to the left, Nature and Antiquity frame the central allegory. In his engraved version, Bartolozzi adds the inscription: CHE L'UOM TRAE DAL SEPOLCRO E A MORTE IL FURA ([Art] draws man from oblivion and steals him from [the clutches of] death). As is typical for prints done after drawings and paintings, the engraving reverses Maratta's original drawing.

In the early 1960s, Hugh Honour linked the depicted portrait with a medal commemorating Cortona that was produced by Charles-Jean François Chéron after the painter's death in 1669 (cat. no. 35). Maratta likely executed his drawing around the same time, suggesting a date in the early 1670s. —CH

**57 Francesco Bartolozzi
(after Carlo Maratta)**
Italian, active Italy
and England
1727–1815

*Allegory in Honor of Claude
Lorrain*, circa 1764–1771

Engraving
16 x 10¾ in. (40.6 x 27.3 cm)

University Transfer from Max
Epstein Archive, 1981.11

BIBLIOGRAPHY

Paul-Jean Mariette, "Oeuvre de Carle Maratti, 1771," in the unpublished manuscript *Les grands peintres I: Ecoles d'Italie*, facsimile edition (Paris: Les Beaux-Arts Éditions, 1969); Jean and Robert Westin, *Carlo Maratti and His Contemporaries: Figurative Drawings from the Roman Baroque* (College Park: Pennsylvania State University Press, 1975); Augusto Calabi, "Francesco Bartolozzi," *Print Collector's Quarterly* 14 (1927): 137–62; Timothy Clayton, *The English Print, 1688–1802* (New Haven: Yale University Press, 1997).

Despite the fact that Maratta's original black-chalk drawing commemorating Claude was produced at least seven years after his *Allegory in Honor of Pietro da Cortona* (cat. no. 56), by the eighteenth century the two images had come to be viewed as a unified pair, each depicting the identity of artistic genius supported by Time. The influential French print dealer Paul-Jean Marriette, for instance, specifically referred to them as pendants in his catalogue of engravings after Maratta. Interpreted thus, these prints offered eighteenth-century collectors a means of expressing their own admiration for two masters of seventeenth-century classicism.

The fifty years separating Claude from Bartolozzi had seen the market for such imagery swell in terms of both size and geography. Particularly in England, the growing numbers of young men making the Grand Tour through northern Europe to Italy sparked an infatuation with the cities of Venice, Florence, Rome, and Naples—along with the antiquities, art works, and various other souvenirs to be acquired in each place. During this period, Claude emerged as a particular favorite among young English aristocrats enthralled by the painter's cool land-scapes. Encouraged by the enthusiastic reception of Italian art, Bartolozzi moved north from his native Florence in 1764. With a studio that at its peak employed fifty assistants and pupils, he lived in London for nearly four decades. His inclusion among the founding members of the Royal Academy in 1768, at a time when the institution failed to recognize engraving as a fine art, confirms his reputation. While an exception was made for Bartolozzi, the letter of the law was observed as well: though a printmaker, he was appointed to the Academy as a painter and thus could boast credentials not unlike those of past great artists, men like Cortona, Claude, and Maratta. —CH

58 Luigi Pichler
Italian
1773–1854

Farnese Bull, circa 1798–1818

Cut amber glass (intaglio)
Height 1⅝ in. (4.13 cm)

Gift of Mrs. Ruth Blumka in memory of Professor Edward A. Maser, Founding Director of the Smart Gallery, 1973–1983, 1989.5

BIBLIOGRAPHY

Duffield Osborne, *Engraved Gems, Signets, Talismans, and Ornamental Intaglios, Ancient and Modern* (New York: Henry Holt, 1912); Julia Kagan and Oleg Neverov, "Lorenz Natter's *Museum Britannicum*: Gem Collecting in Mid-Eighteenth-Century England," *Apollo* 120 (August 1984): 114–121 and (September 1984): 162–69; Martin Henig, *Classical Gems: Ancient and Modern Intaglios and Cameos* (New York: Cambridge University Press, 1994).

Modern valuations of aesthetic objects have largely neglected the field of engraved gems, the history of which stretches from pre-dynastic Egypt through nineteenth-century Europe. In fact, from the Renaissance through the eighteenth century it is difficult to overstate the position afforded these artifacts by collectors. Gems, both ancient and contemporary, took their place alongside impressive libraries, print collections, and galleries of ancient sculpture and paintings. Such collections, or *dactyliothecae*, emerged in England in the seventeenth century with large acquisitions made by George Villiers, the first Duke of Buckingham (from the collection of Rubens), and Thomas Howard, Earl of Arundel.

In the eighteenth century, the market swelled to include not only the nation's wealthiest connoisseurs but also the myriad participants in the Grand Tour who were attempting to establish themselves as refined dilettantes. The *Farnese Bull*, which was copied in statuette form for those willing to pay a substantial sum (cat. no. 36), was also reproduced in the extremely accessible form of an engraved gem. Through the metamorphosis instigated by travel commerce, the largest of ancient sculptures was duplicated on the smallest of souvenirs.

Rome was the undisputed center of trade in such objects, and the Pichler family was one of the city's three leading producers. Luigi's older half-brother Giovanni ranked among the century's most talented engravers, and for this skill was knighted by Joseph II, the king of Austria. At the request of Prince Metternich, Luigi—known for his elaborate polishing technique—was appointed professor of gem engraving in Vienna, after having been elected to the Accademia di S. Luca in Rome. The growing frequency of signed gems attests to the rising status of artists working in this medium. Pichler's gem was never meant to be passed off as an antique (though forgery was common); but playing on contemporary interests in the artistic history of Greece, the engraver signed his name and first initial in Greek letters (backward, so that imprints would read correctly), presenting himself as a worthy heir to this ancient tradition. —CH

59 **Feodor Potrovich Tolstoy**
Russian
1783–1873

The Return of Ulysses, 1820

Cast relief, copper plated
with iron crystals
5⅞ x 9⅞ in. (15 x 25.1 cm)

Purchase, Unrestricted Funds,
1993.16

BIBLIOGRAPHY

Dora Wiebenson, "Subjects from Homer's
Iliad in Neo-Classical Art," *Art Bulletin* 46
(1964): 23–37; Elisabeth Kashey and Robert
Kashey, *European Paintings, Drawings, and
Sculpture: Nineteenth and Early Twentieth
Century* (New York: Shepherd Gallery, 1993).

Feodor Tolstoy, uncle of the novelist Leo Tolstoy, established himself as an artist by designing cameos for brooches. In 1804 he was appointed conservator to the Hermitage in St. Petersburg, and in 1810 he became director of the mint. In this position, he designed 21 medals commemorating the events of the Napoleonic Wars (1812–15). Working in metal, Tolstoy was both a competent artist and a brilliant technician.

The narrative of the *Return of Ulysses* comes from Homer's *Odyssey*. After years of wandering following the Trojan War, the hero at last returns to his home of Ithaca only to find a host of suitors attempting to woo his still-faithful wife Penelope. Together with his son Telemachus, Ulysses (in disguise) enters an archery contest; its prize is the coveted woman. The two men kill the unworthy contestants, and the family is reunited.

Homer became a popular source for artists only beginning around 1750. For the next seventy-five years, scenes from the *Iliad* and the *Odyssey* were depicted with unprecedented frequency and with close attention to the pictorial potential of the stories themselves. Toward the beginning of this trend stands a treatise by the French antiquarian Comte de Caylus; his *Tableaux tirés de l'Iliad et de l'Odyssée* of 1757 suggested a number of scenes from the two epics that he considered especially appropriate for visual representation. The publication of John Flaxman's illustrations for the *Iliad* in 1793 further fueled Homer's popularity, even as the style of depiction shifted from French seventeenth-century classicism—exemplified by Poussin, whom Caylus admired intensely—to a smaller format modeled after ancient vase painting that emphasized line. Tolstoy's *Return of Ulysses* comes at the end of this pictorial interest in Homer; the Russian neoclassicist absorbed the compositional lessons of the preceding decades and produced his own design using the latest metallurgic technology. The relief was crafted out of copper by an electrolytic process and then electrolytically plated with crystalline iron of such purity that it does not rust. The result is a smooth, satin-like gray finish. This relief is one of a set of four scenes from the *Odyssey*; the plaster casts are in St. Petersburg. —CH

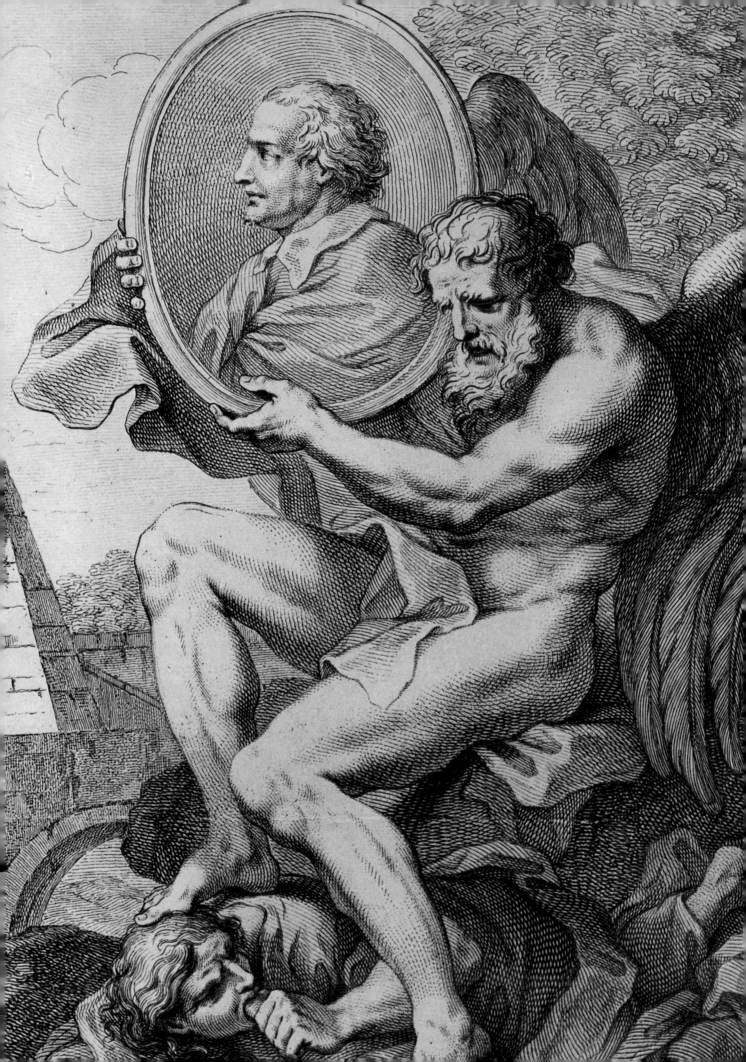

APPENDIX
Supplementary Materials

The following books, coins, sculpture fragments, and selected pottery sherds also appear in the exhibition.

BOOKS

Ovid
Fasti, ca. 1470
11 7/16 x 8 1/4 in. (29 x 21 cm)
Department of Special Collections,
University of Chicago Library

Vergil
Bucolis, Georgics, Aeneid, 15th century
9 1/16 x 5 15/16 in. (23 x 15 cm)
The Newberry Library, Chicago

Serafino Ciminelli (also Serafino Aquilano)
Opera dello Elegantissimo Seraphino, tutta di nuovo Riformata (Works of the most Elegant Seraphino, entirely Revised), Venice: Agostino Bindoni, 1556
6 1/16 x 4 1/8 in. (15.4 x 10.5 cm)
Collection of Ingrid D. Rowland

Serafino Ciminelli, who died in 1500, was the most successful popular musician of his day. Born in the Abruzzi, he traveled to Milan with his patron, Cardinal Ascanio Sforza, and there learned to sing a new kind of Neopolitan song set to a pronounced rhythmic accompaniment, the *strambotto*. It was a medium that made the most of his expressive vocal style and his verbal ingenuity; as a poet, he specialized in vernacular lyrics that worked irreverent, exotic changes on traditional Petrarchan love poetry. Unfortunately, none of Serafino's music is known to have survived; in its own day it was simply too well known to need setting down in notation. The Venetian publisher of this cheap popular edition of his collected works, issued fifty-six years after his death, probably assumes that readers will supply the tunes to Serafino's best-known songs.

Bernardo Gamucci
Le Antichità della Città di Roma (Antiquities of the City of Rome), Venice, 1569
5 15/16 x 4 3/8 in. (15.2 x 11.2 cm)
Collection of Ingrid D. Rowland

This little illustrated guidebook to the ancient monuments of Rome, written in Tuscan vernacular, was originally dedicated to Francesco de' Medici and aimed at the members of the Medici circle. This copy belonged to the convent of San Pietro in Montorio in Rome.

Probably Italian, late 17th century
Istitutionum linguae hebraicae (Book of Rules of the Hebrew Language)
6 5/16 x 4 1/2 in. (16 x 11.4 cm)
Collection of Ingrid D. Rowland

This introductory Hebrew textbook from the end of the seventeenth century is missing its title page, but is most probably Italian. The text itself is in Latin. As a final exercise, the text takes its readers through a closely commented reading of Psalm 34.

Plato
De Rebus Divinis (On Divine Matters),
Cambridge: John Hayes, 1673
6 7/8 x 4 1/8 in. (17.5 x 11.8 cm)
Collection of Ingrid D. Rowland

Edited by John North (1645–83), Master of Trinity College, Cambridge, this parallel Greek and Latin text of a selection from Plato's dialogues is a student edition with marginal notes and comments by some of its various owners.

COINS

Roman
Republican Denarius, 136 B.C.E.
Struck silver
Diameter ⅞ in. (2 cm)
Bequest of Ruth M. Keller, 1970; 1967.115.515

Roman (see p. 31, fig. 3)
Imperial Denarius, 36–37 C.E.
Struck silver
Diameter ¾ in. (1.9 cm)
Gift of Profesor Robert L. Scranton, 1980;
1980.157.26

Roman
Imperial Bronze As, 230 C.E.
Struck bronze
Diameter 1 in. (2.5 cm)
Bequest of Ruth M. Keller, 1970; 1967.115.510

SCULPTURE FRAGMENTS
AND POTTERY SHERDS
(maximum dimensions indicated)

Greek, Hellenistic
*Figurine Fragment: Head of a Woman with Elaborate
Coiffure*, 4th century B.C.E.
Earthenware
Height 2 ¾ in. (7 cm)
The F. B. Tarbell Collection, Gift of E. P. Warren,
1902; 1967.115.390

Greek, Hellenistic
Figurine Fragment: Upper Half of a Girl in a Chiton,
late 4th–3rd century B.C.E.
Molded earthenware
Height 5 in. (12.5 cm)
The F. B. Tarbell Collection, Gift of E. P. Warren,
1902; 1967.115.372

Greek, Hellenistic
Eros Figurine Fragment, late 4th century B.C.E.
Earthenware
Height 2 ⅜ in. (6 cm)
The F. B. Tarbell Collection, Gift of E. P. Warren,
1902; 1967.115.393

Roman, Rome or Environs
*Mural Relief: Youth in Phrygian Hat Feeding
a Griffin*, early 2nd century C.E.
Slip-painted molded earthenware
11 ⅝ x 10 ⅛ in. (29 x 25.6 cm)
The F. B. Tarbell Collection, Gift of W. G. Hale,
1918; 1967.115.407

Roman, Rome or Environs
Mural Relief: Victory Sacrificing a Bull,
1st–2nd century C.E.
8 ½ x 12 ⅜ in. (21.6 x 31.5 cm)
The F. B. Tarbell Collection, Gift of W. G. Hale,
1918; 1967.115.405

Greek, Attic
Black-Figure Vase Fragment, ca. 500 B.C.E.
Earthenware
Height 3 ¼ in. (8 cm)
The University of Chicago Classical Collection,
1967.115.257

Greek, Attic
Black-Figure Vase Fragment, 540–530 B.C.E.
Earthenware
2 ⅛ x 1 ⅞ in. (5.3 x 4.8 cm)
The University of Chicago Classical Collection,
1967.115.261

Nikosthentic Workshop
*Black-Figure Amphora Handle Fragment:
Satyr's Head*, ca. 535–520 B.C.E.
Earthenware
3 ⅛ x 1 ¾ in. (7.9 x 4.5 cm)
The F. B. Tarbell Collection, Gift of E. P. Warren,
1902; 1967.115.268

Follower of Douris?
Greek, Attic
Red-Figure Skyphos: Head and Shoulder of a Woman,
ca. 450 B.C.E.
Earthenware with slip-painted decoration
Height 1 ½ in. (3.8 cm)
The F. B. Tarbell Collection, 1967.115.290

Recalls the Kleophon Painter
Greek, Attic
Red-Figure Vase Fragment, 430–420 B.C.E.
Earthenware with slip-painted decoration
3 ⅜ x 3 ½ in. (8.4 x 7.5 cm)
The F. B. Tarbell Collection, Gift of E. P. Warren,
1902; 1967.115.291

Follower of the Meidas Painter
Greek, Attic
Red-Figure Lekanis Lid, 400–375 B.C.E.
Earthenware with slip-painted decoration
3 ⅝ x 3 ½ in. (9 x 8.5 cm)
The F. B. Tarbell Collection, 1967.115.293

Group of Polygnotos
Greek, Attic
Red-Figure Calyx-Krater Fragment: Battle of Kaineus,
ca. 440–430 B.C.E.
Earthenware with slip-painted decoration
Height 5 ¹¹⁄₁₆ in. (14.4 cm)
The F. B. Tarbell Collection, 1967.115.294

Appendix

Style of the Euaion Painter
Greek, Attic
Red-Figure Kylix Fragment, 450–440 B.C.E.
Earthenware with slip-painted decoration
3 ³⁄₈ x 2 ⁷⁄₈ in. (8.4 x 7.8 cm)
The F. B. Tarbell Collection, Gift of E. P. Warren,
1902; 1967.115.295

The Niobid Painter
Greek, Attic
*Red-Figure Fragment from a Lekanis (?): Warrior
with a Thracian Helmet*, ca. 464–460 B.C.E.
Earthenware
Height 2 ¹⁄₈ in. (5.2 cm)
The F. B. Tarbell Collection, 1967.115.296

Greek, Attic
Rim Fragment from Red-Figure Kylix, n.d.
Earthenware
Height 2 in. (5 cm)
The University of Chicago Classical Collection,
1967.115.299

Greek
Red-Figure Vessel Fragment, 450–400 B.C.E.
Earthenware with slip-painted decoration
Height 2 ¹¹⁄₁₆ in. (6.8 cm)
The University of Chicago Classical Collection,
1967.115.303

Greek, Attic
Red-Figure Kylix Fragment, ca. 440 B.C.E.
Earthenware
1 x 2 ¹⁄₂ in. (2.5 x 6.5 cm)
The F. B. Tarbell Collection, Smithsonian
purchase from the estate of T. R. Wilson, 1904;
1967.115.327a

Greek, Attic
Black-Figure Kylix Fragment, late 6th century B.C.E.
Earthenware with slip-painted decoration
Height 3 ¹⁵⁄₁₆ in. (10 cm)
The F. B. Tarbell Collection, Gift of E. P. Warren,
1902; 1967.115.472

Greek
Sherd of Red-Figure Kylikes: Figurative Decoration,
ca. 430 B.C.E.
Earthenware with slip-painted decoration
2 ³⁄₈ x 1 ³⁄₈ in. (6 x 3.5 cm)
The University of Chicago Classical Collection,
1967.115.478.37

Italic, Etruscan?
Kantharos, 4th century B.C.E.
Earthenware with uniform slip-painted decoration
7 ¹⁄₂ x 6 ¹⁄₂ in. (19.4 x 16.4 cm)
The F. B. Tarbell Collection, Gift of E. P. Warren,
1902; 1967.115.354

Roman
Italian, Arezzo (Arretium), Primus (manufacture)
Krater Fragment: Hercules, ca. 1–15 C.E.
Slip-glazed earthenware with molded and stamped
decoration (Arretine ware)
2 ³⁄₈ x 2 ¹⁵⁄₁₆ in. (6 x 7.5 cm)
The University of Chicago Classical Collection,
1967.115.370